The Brave New World of Publishing

CHANDOS
PUBLISHING SERIES

Chandos' new series of books are aimed at all those individuals interested in publishing. They have been specially commissioned to provide the reader with an authoritative view of current thinking. If you would like a full listing of current and forthcoming titles, please visit our website, **www.chandospublishing.com**, or contact Hannah Grace-Williams on e-mail info@chandospublishing.com or telephone number +44 (0) 1993 848726.

New authors: we are always pleased to receive ideas for new titles. If you would like to write a book for Chandos, please contact Dr Glyn Jones on e-mail gjones@chandospublishing.com or telephone number +44 (0) 1993 848726.

Bulk orders: some organisations buy a number of copies of our books. If you are interested in doing this, we would be pleased to discuss a discount. Please contact Hannah Grace-Williams on e-mail info@chandospublishing.com or telephone number +44 (0) 1993 848726.

Contents

List of figures

About the author

In one capacity or another, Manfred Breede has been involved with printing and books throughout his professional career – first as an apprentice pressman in his native Germany, and then plying his trade as a journeyman in several European countries. Moving to Canada, he embarked on a career in technical education: teaching printing at the secondary school level for some 16 years before eventually arriving at his present position teaching printing at Ryerson University in Toronto.

He is the author of the first and second editions of *Handbook of Graphic Arts Equations* and contributed a chapter to *The Future of the Book in the Digital Age*. Additionally, he makes frequent contributions to academic journals, is an invited speaker at industry conferences and consults on printing quality and efficiency as well as developing software in this area. In 2002 he was recognized by the readers of the Canadian journal PRINT*ACTION* as one of the '50 Most Influential People in the Graphic Arts in Canada'.

Acknowledgements

The author wants to thank Scott Millward for preparing and packaging the illustrations for this book so competently and reliably. Thanks are owed also to Art Seto for the useful information he supplied for Chapter 6. The SRC Committee of the Faculty of Communication & Design at Ryerson University awarded the author a publication grant toward the writing of this book, which is acknowledged here with gratitude. Last but not least, the author likes to thank the copyeditor, Cherry Ekins, for her sharp-eyed editing and for giving the book its final polish.

List of acronyms

BBC	British Broadcasting Corporation
CD	compact disk
CRT	cathode ray tube
CTP	computer-to-plate
dpi	dots per inch
EAN	European Article Numbering system
EPS	encapsulated PostScript
EVA	ethyl vinyl acetate
GATF	Graphic Arts Technical Foundation
GUI	graphic user interface
ISBN	International Standard Book Number
JDF	job definition format
LED	light-emitting diode
lpi	lines per inch
MIS	management information system
PDF	portable document format
PDL	page description language
PUR	polyurethane-reactive
PVA	polyvinyl acetate
RCA	Radio Corporation of America
RIP	raster image processor
SMS	short message service
UV	ultraviolet
VDP	variable data printing

Introduction

The book's remarkable longevity

If a measure of the worthiness of an innovation is how well it withstands the test of time, the book certainly ranks high among artifacts developed throughout the ages. Its aesthetic and functional design has barely changed for some 2,000 years. Hourglasses and sundials to measure time are now distant memories, long since replaced by mechanical timepieces and digital watches which are infinitely more accurate and convenient to use, yet they bear little or no physical or operative resemblance to their predecessors. No ancient mode of transportation resembles, even remotely, a jet airplane. A television set could be thought of as the modern equivalent of a Roman amphitheatre, but it would not be recognized as such by a Roman time traveler. However, the same Roman time traveler would immediately recognize books sitting on the shelves of a contemporary library. Upon picking up a book to satisfy his curiosity, he would have no trouble at all in understanding its utility.

Why, then, has the book survived almost unchanged for such an exceptionally long period of time? Ubiquitous artifacts are often not recognized for their efficacy, because they are used seemingly effortlessly in our day-to-day activities, almost as though they were an extension of our physical selves. Books are such objects, which in spite of their obvious physicality have been regarded as not having a body, but only speaking a mind. To find an answer to the previously posed question it is useful to define a book's functional qualities. Stripped down to the essentials, a book may be defined as 'an economic method to communicate, access, preserve and disseminate information using an architecture that facilitates visualization'. The operative concepts in this definition that made the book the communication medium of choice for most of the last two millennia are communication, information, access, preservation, economy and ease of use. These are the embodiments of

effective visual communication; as such, in the pages ahead they will be used to judge the relative merits of various technologies capable of creating books or book-like media.

The past, present and future growth of book publishing have been and continue to be inextricably linked to literacy levels and technological innovation. When in Europe and North America in the 1700s literacy levels increased because of compulsory education, and reading became a necessity of life in the twentieth century, by far the largest obstacle to book circulation was overcome. For what is the value of a book if it cannot be read? This development continues unabated in less developed parts of the world, such as Africa and the Indian subcontinent, where literacy levels are rising dramatically. Unfortunately, the developed countries are experiencing declining literacy levels – a trend that could spell trouble for the continuing growth of the book publishing industry.

The growth of book circulation since manuscript books were first produced by painstaking manual methods is a direct result of several material and process innovations.

As a physical thing, books and their manufacture are dependent on a secure and economic supply of the raw materials from which they are made. The invention of paper was a godsend for the economic production of books, because paper is made from the cell walls of green plants, which biologists consider to be the most abundant form of biomass on earth.

The invention of movable type by Gutenberg changed the production of books from a manual to a mechanical reproduction method, increasing the productivity of book manufacturing manifold times. Gutenberg's invention was not substantially improved in the ensuing 500 years until the late 1800s, when the mechanical Linotype typesetting method superseded the setting of type by hand. The Linotype typesetting machine was one of the first keyboard-activated manufacturing systems, and as such was at least 70 years ahead of its time. It was not until the early 1960s that keyboard interfaces became a common feature on digital computers. When at the beginning of the twentieth century mechanized book sewing was invented, a significant bottleneck in book production was alleviated and the binding of books could now keep up with production speeds of steam- and electric-powered printing machinery. The paperback book was created as a direct result of new adhesive binding technology in the 1930s. Adhesive binding, also called perfect binding, decreased the cost of book production to such an extent that certain book categories are now sold as commoditized mass-manufactured goods. The general acceptance of offset-lithography,

which superseded the hitherto dominant letterpress printing process in the 1960s, improved the quality of print, especially with regard to image resolution, and remains unsurpassed by any other reproduction medium in this respect. The digitization of image capture and manipulation that has taken place in the last two decades rationalized the printing production workflow by multiple factors and made printed products, including books, more affordable than ever before. In-line finishing processes, such as coating, die-cutting, embossing and foil stamping, added value to book covers, making books ever more attractive and enticing to potential buyers browsing the aisles of a bookstore.

But the most remarkable outcome of this flurry of technological innovations is that none of it changed the book's basic architecture. For example, the ancient craft of hand bookbinding, dating back at least a thousand years, entails such intricately detailed procedures as rounding and backing the spine of a book, turning the corners in case-making and pressing the book to form joints. Every single one of these techniques, including the archaic terminology, is still retained in a modern automatic hardcover book production system, albeit no human hand touches a book in such mechanized systems until it is first cracked open by an eager reader. Could it be that the architecture of the book constitutes the epitome of perfect industrial design, upon which improvements are not possible?

In the past 30 years a plethora of digital printing processes, including electrophotography, electrography, iconography, magnetography, inkjet printing, thermal-transfer printing and elcography, have been brought to market. Interestingly, some digital printing processes, such as electrophotography (better know by its popular name, laser printing) and inkjet printing, have been introduced to both the consumer and the professional print media markets. This has never before occurred in the industrial development of printing and could presage a trend to deprofessionalizing the printing of books, in much the same way that many pre-press operations such as digital photography, image manipulation, text preparation, scanning and page layout are no longer the exclusive domain of professionals.

Ink-jet printing and electrophotography have to date captured the majority of both consumer and professional print markets, but technological developments are still too much in flux to state a trend definitely toward one or the other process or to estimate to what extent they will diminish conventional printing methods. While established processes will still have to be retained for some time to come, new print technology will continue to make inroads in the print media industry and

once again will change the way books are printed, marketed and distributed. As well, new technology may give rise to novel product categories, and will have the potential to invigorate the book publishing industry as it faces for the first time in its long existence competition from a multitude of alternative types of communication media.

The power of the printed word

Given that the book has been and continues to be an effective means of communication, it has the potential to influence public opinion. Consequently, it must also be accepted that a communication medium can be used for both good and evil purposes. As a matter of fact, even ostensibly good and well-intentioned ideas have often caused conflicts that inflicted tremendous suffering on whole populations. The point to be made here is that the seeds for human conflict are often sown by ideas, and these ideas are usually spread in the form of books. Likewise, ideas can result in the world becoming a more civilized, orderly and enlightened place.

The enormous influence wielded by the book on the course of history is exemplified by philosophical and religious texts such as the Torah, the Bible, the Koran, the Analects of Confucius and Buddhist Sutras, which laid the foundations for great civilizations in both Eastern and Western worlds.

Any community, large or small, is in part based on certain common values and self-interests that its members share. It can be said that philosophical and religious texts were in large part responsible for imparting common values to large populations and thereby creating a distinct identity for their members. Nowadays we call these communities countries. Some countries are inhabited by big percentages of the world population, bringing global influence and power. It is indeed hard to fathom that ideas, in large part disseminated in the form of books, were the kernel from which these countries grew.

The diffusion of scientific discovery very much depends on efficient systems of reproducing new ideas, as otherwise their impact will be localized at best, or will go unnoticed by the scientific community at worst.

Nicholas Copernicus's (1473–1543) work caused upheaval in the medieval scientific communities and religious hierarchy of his time, not only because of the radically different heliocentric cosmology it proposed, but also because its wide dissemination was made possible by

the then still new printing process. In his book *On the Revolutions of Heavenly Bodies*, Copernicus challenged the classical geocentric view of the universe held since Aristotle's time. Copernicus's work is of extraordinary importance in the history of human knowledge, in that it radically changed the way man perceived the world and is considered by most historians to have initiated the 'scientific revolution' of the late sixteenth and seventeenth centuries. An interesting facet of this book is that Copernicus's contemporary Rheticus, who oversaw the book's printing, convinced him of this new reproduction method's superiority.

Ideas instilled into people's minds can also have negative effects on the world we live in. Here again philosophical and religious texts play a large role, because these texts are subject to interpretations, some of which advocate intolerance, violence and hatred against those who do not adhere to the same ideas. Disaffected members of virtually every major political philosophy and religious movement have attempted to radicalize their flocks, and more often than not books were the preferred medium to spread their extreme views.

Luther's book of 95 theses, written in 1517 as a critical polemic of the Catholic Church, was one of the first publications widely copied by the relatively new printing process. Within a few weeks of its publication it was distributed in all parts of Germany, giving impetus to the Reformation. A hundred years later, the major European continental powers were at war because religious differences precipitated by the Reformation caused political alliances to shift and triggered the Thirty Years War, which laid waste much of Germany and some neighboring countries.

Economists have proposed radically new economic systems in their writings. Karl Marx's seminal treatise *Das Kapital* comes to mind, as the cornerstone of political and economic policy for countries on three continents, home to nearly half of the world's population. The consequences of these political and economic ideas wreaked havoc with economies, ruined the material wealth of several generations and in the process set back the industrial and economic development of these countries by decades.

Some political movements championed racist theories using books. Adolf Hitler's *Mein Kampf* poisoned the minds of many Germans with racist theories and much of what was written in the book not only came to pass, but was committed with such an unprecedented brutality that the people of the world are still traumatized by these events.

Writers and philosophers, through their writings, left an indelible mark on languages as they are spoken today and also changed the political and religious landscape of whole continents.

William Shakespeare contributed some 2,300 words to the English language, 800 of which still form part of the language. Likewise, such time-honored expressions as 'one fell swoop', 'vanish into thin air', 'tower of strength' and 'foul play', still in common use today, were coined by the Bard of Stratford-upon-Avon. Indeed, part of the very title of this book (*Brave New World*) was first written by Shakespeare in his play 'The Tempest'. Shakespeare's influence went beyond modern English, touching many other languages into which his works were translated. For example, the expression 'all's well that ends well', from the title of a dark Shakespearian comedy, is reflected in the German and French expressions *Ende gut alles gut* and *tout est bien qui finit bien*.

Martin Luther's translations of the New and Old Testaments into the vernacular influenced the religious sensibilities of generations of Germans and also contributed to the standard language spoken in contemporary Germany.

The book *Quotations from Chairman Mao Tse-Tung*, also known as *The Little Red Book* in Western countries, was first printed in 1963. It consists of quotations laying out the political ideology of the then leader of the People's Republic of China. It is estimated that 350 million copies were printed for dissemination to the citizens of that country, for whom it was required reading. Enforced reading of the book was particularly draconian during the so-called Cultural Revolution, a period of time when the economic and educational development of China was brought to a virtual halt.

Public opinions are still being influenced to a large extent by what is written in books. Stephen Hawking awed the world with black holes in the universe in his book *A Brief History of Time*; Robert Atkins influenced people's eating habits with his book *Dr. Atkins New Diet Revolution*; a whole generation of baby-boomers were raised according to the child-rearing advice given by Dr Benjamin Spock in his book *Baby and Child Care*; gossip was dispensed when Paul Burrell, the butler of the Princess of Wales, wrote about the princess's life in his tell-all book *The Way We Were*; and millions of young and not-so-young people around the world line up at bookstores for hours on end to acquire the latest Harry Potter sequel by J.K. Rowling. There is a certain irony in J.K. Rowling's wildly popular novels being turned into movies, because the reverse, movies turned into books, is almost never heard of.

The book as a cultural agent has had major effects on the course of history, be it for the betterment or the deterioration of the human race. It can also be said that civilizations with literary traditions, without which the book cannot exist, still have a voice in contemporary world

affairs, or at the very least they still exist; whereas civilizations without literary traditions, such as many aboriginal communities in all parts of the world, have not been nearly as successful in maintaining their populations or wielding influence commensurate with their numbers. It is a sad fact that many aboriginal communities suffer voicelessly from the effects of cultural denigration, and to the present day face an uncertain future.

Technological change and world population growth

Historians and futurists would probably agree with the statement that, in general, technological change has occurred throughout the ages and is occurring at an accelerating rate as time progresses, even though there have always been intermittent periods of stagnation and regression.

Since technological change can result only from human creativity and toil, it stands to reason that there must be a causal relationship between the accelerated rate of technological change and the quantifiable and proven accelerated rate of population growth. Or, put more succinctly, the more people there are, the greater the chances that clever ideas will be invented and that these ideas are converted into artifacts, because of the increased creative, productive and consumptive capacity of large populations. Periods of stagnation and regression are usually, but not always, caused by human conflict, which can unfortunately also result from human ingenuity and productivity.

Tracing back the progress made in the communication media, the pattern of accelerated technological change coinciding with the growth of the world population is clearly evident. The invention of movable type by Johannes Gutenberg in 1450 occurred at a time when the world population stood at approximately 400 million people. More than any other communication innovation previously, Gutenberg's invention heralded the earliest beginning of mass communication, because all previous means of reproducing text were simply too slow to reach a wide readership. The economic consequence of slow production methods is necessarily a higher price for a product, further limiting the spread of books to a large number of people. Gutenberg's invention reduced the price of books to as little as one-twelfth of the cost of manuscript books, thus lessening the cost factor as an impediment to increased book circulation.

Historians are now in general agreement that Gutenberg's invention had the greatest impact on human development in the last millennium, but it was a long time coming. It took almost all of the history of human development, roughly pegged as having commenced 250,000 years ago, for this first effective means of mass communication to emerge.

It took another 500 years for Gutenberg's invention to be superseded in the 1950s by offset-lithography as the most important printing process, even though Alois Senefelder invented the process in 1798. While this may seem to be a long period of time, it still is an only a fraction compared with the development period of movable type. Simultaneously, the world population increased to approximately 3 billion people, or 7.5 times as large a population as existed during Gutenberg's lifetime.

Since then we have witnessed the development of several digital printing processes with the potential to replace all previous methods of book production, and a world population that more than doubled to 6.7 billion people in a mere 50 years.

Naturally, the volume of book publishing also mirrored technological change. Some major book publishing milestones will be used to provide a measure of the increased output of books due to technological innovations.

Books and other literary architectures, such as rolls, existed long before the invention of movable type, but because book production in the pre-printing era was invariably a manual method, books were usually commissioned in limited quantities – most often only a single copy. This held true even during the incunabulum period when printing was in its infancy and mechanically reproduced books were at first considered to be inferior to manuscript books. There is a fitting historical example of an instance of a single book production order, as well as the low esteem in which mechanically reproduced books were held, when Cardinal Giuliano della Rovere, who later in his life became Pope Julius II, commissioned a handwritten copy of Appian's *Civil Wars* at a time when printing by movable type was already well established in Italy.

Because of the technical limitations to reproducing medieval books in quantity, the sum of the world's accumulated knowledge far exceeded typical university library holdings. Even the renowned library at Cambridge University had in 1442 a very modest collection of only 122 volumes.

Gutenberg's legacy will forever be linked to overcoming the prevailing scarcity of texts by inventing a more efficient system of printing books in large quantities. He demonstrated the genius of his invention by printing not one but 140 paper and 40 vellum copies of the so-called 42-line

bible in just two years (see Figure I.1). Comparing this achievement to the then common method of copying books manually, the significance of Gutenberg's invention becomes palpable. It would have taken an entire year to produce a single equivalent manuscript book. This represented an astounding 90-fold productivity increase. By any measure, a productivity leap of this magnitude is almost unprecedented in the history of technology, and in due course Gutenberg's invention rang in an era of mass communication that had a profound effect on Western civilization.

| Figure I.1 | Gutenberg's 42-line bible (beginning of the Book of John) |

Source: Gutenberg Museum (Mainz) reproduction

With a practical method of efficient book production in place in the mid-1400s, book publishing changed, at least 400 years ahead of its time, from a one-off to a mass-producing enterprise – which as a manufacturing concept did not find general acceptance until the industrial revolution period of the 1800s. For most of the fifteenth century the average edition of books remained about the same as Gutenberg's 42-line bible edition, while print runs of 500 books were near the upper limit until 1490, when the Venetian publisher Aldus, encouraged by a flourishing book trade, printed a series of books with 1,000 copies per edition. Leapfrogging to contemporary times, the proliferation of books continues unabated with blockbusters such as the latest Harry Potter sequel, *Harry Potter and the Deathly Hallows*, which in the USA alone sold more than 8.3 million copies of an estimated 12 million print run in the first 24 hours. The largest academic library in the world at Harvard University has holdings of 15 million volumes in its branches. No longer are libraries disadvantaged by a lack of availability of books; instead the problem has become one of finding the physical space to house an abundance of existing books.

The exponential growth in production and circulation of books would have been unachievable without an accelerated pace of technological progress, enabling printers to produce books quickly and in great quantities; nor is it conceivable that books would have prospered without a sufficiently large readership, which in turn, we must remind ourselves, is directly linked to population density and literacy.

Characterizing technological change of our time

It is always a difficult task to judge objectively the essence of the era one lives in, because in general we tend to have a natural propensity to perceive change as being greater than it is in reality. Recognizing this potential folly, one has to tread carefully so as not to overstate the changes that have occurred in the field of communication, of which, to be sure, the book is an integral part. Also, it is important to evaluate the development of communication technology not in isolation, but in the context of technological and cultural change in general.

The distinctive technological epochs since the beginning of human development commenced with the first use of tools from naturally existing materials, such as the wood, bones and stones from which paleolithic man fashioned dwellings to protect himself from the elements,

flints to make fire and arrowheads to hunt game, or the soot and other naturally occurring pigments he used to create images on the walls of his dwellings for reasons that are not fully understood.

Technological progress continued with man's use of metal for tool-making and his ability to extract it from progressively different types of ore. Accordingly, we name these epochs the Iron, Bronze and Copper Ages. The development of substrates for writing and imaging is in essence also an important achievement in material science, but historians usually do not attach as much significance to the discovery and first use of clay tablets, parchment, papyrus or paper, and certainly no technological epoch is dedicated to it.

The applications of scientific and engineering principles, such as fire-making and the wheel, were ongoing technological discoveries that go back to the earliest phase of human development, but they were made without any conscious theoretical reasoning.

The Hellenistic civilization, geographically situated in the eastern Mediterranean area, lasted from about the death of Alexander the Great in 323 BC until when the kingdom of Ptolemaic Egypt was defeated by the Romans in 31 BC. This was a time of much philosophical and scientific enquiry and is associated with great thinkers such as Aristotle, Archimedes, Euclid and Pythagoras, to name only a few. We commonly refer to this era as 'classical antiquity'. It was a period during which the foundation was laid for most philosophical and scientific development that followed. Unlike any previous time, during the Hellenistic era we witness the beginning of conscious theoretical, philosophical and scientific enquiry, as a result of which practical applications to common problems were often found. Archimedes' screw will suffice as an example of mathematical enquiry finding application in pumping water to higher ground, and as a technical concept it is still in use today.

The aforementioned 'scientific revolution' initiated in the late sixteenth century by Copernicus marks the next significant phase in the evolution of scientific enquiry and technological development throughout the ages. It must be said, however, that the long interim time period was not void of technological achievement, but scientific development continued, albeit in the spirit of the philosophies and scientific enquiry methods laid out in classical antiquity. Neither does the early scientific revolution completely break with the knowledge gained in classical antiquity; rather, it was an age of the rediscovery of ancient knowledge and analytical scientific enquiry which places greater emphasis on specialized branches of the sciences, mathematics and evidence-based research methods.

These precepts of scientific enquiry remain more or less unchanged in modern science, making science in our time the pre-eminent source for technological development, as a result of which we are increasingly defining the modern age by the extent to which science is applied to our physical environment.

The industrial revolution period saw the practical application of many scientific principles in full swing, particularly when first steam and then electricity replaced humans or beasts of burden as a source of power. The increased mechanization and automation of all industrial processes, including book printing, had a profound effect on societies. In essence, those countries affected by the industrial revolution of the eighteenth and nineteenth centuries started to changed from agricultural to industrial economies.

The question as to what defines our age in the twenty-first century must be evaluated in the light of these historical technological developments, because much of what appears to have the air of modernity, when subjected to critical analysis, is in reality a relict from the past.

At the risk of stating the obvious, it must be said that the manufacture of all artifacts requires physical materials. This much has remained unchanged since time immemorial, and the significance of this statement lies in the fact that materials are made from one type of natural resource or another, and such resources are more likely to be in short supply in our age of increasing rates of productivity and population growth. In contrast to electronic media, the physical book in particular, being a material-based communications medium, faces the potential challenge of resource shortages.

Even though manufacturing processes have become much more efficient since the industrial revolution, conceptually these productivity improvements constitute secondary incremental rather than fundamental change, as the most significant groundwork for continued productivity improvements in the twentieth century was laid with the introduction of steam and electric power over 150 years ago.

Recent developments occurring in the area of electronic communication are often considered to be groundbreaking and unique to our age, but if we accept the speed of transmission as a criterion for progress, no fundamental or actual improvements have been made since the invention of the telephone by Alexander Graham Bell about 130 years ago and Guglielmo Marconi's invention of the wireless radio just over 100 years ago. Then as now, electronic signals travel at the speed of light, or 299,792,458 meters per second.

Mechanical calculating devices such as the abacus have been in existence for millennia, and even programmable manufacturing devices were known in the early 1800s, but the full potential of computing technology was not realized until the modern digital computer was first introduced as an aiding technology to manufacturing processes in the 1960s. While not new as a fundamental concept, the digital computer probably had the greatest impact on worldwide industrial development. In a time span of only about 50 years it found application in just about any human activity, and as such may hold the answer as to what characterizes our age.

The defining feature of a modern digital computer is that it can be given instructions that are subsequently carried out by the computer at great speed. If a computer is connected or interfaced with other machines or devices the machine or device becomes quasi-intelligent, as it carries out the programmed instruction without human intervention. At a very high level of application, computer-driven robotic devices can be made to emulate complex human activities with far greater precision and speed than humans can achieve themselves. While it is true that the function of any machine is to emulate a human activity, thus freeing people from having to perform arduous tasks, computers expand the capability of machines to perform increasingly complex tasks by virtue of their abilities to store enormous amounts of programmed information and to respond to information returned to the computer by a dynamic process.

This is no more obvious than in modern book creation and production workflow. The writing of a book usually starts with an idea put down on paper; but unlike in times past, even at this earliest creative stage computer technology aids the writer to become more productive. As the author keys his copy into the memory of the computer a software program accesses information, or to use computer terminology a database, of orthographic and grammatical rules which corrects spelling and grammatical errors at the very moment they occur. Just as remarkable is that this earliest creative writing stage is already integrated into the industrial book production phase, because the author's handiwork is transferred directly to other computer programs to be formatted into book pages as they will ultimately appear to the reader. The book up to this point exists only virtually, as digital information stored in the memory of a computer in a binary coding system that can be accessed to control the engine of a printing device in order to image the book pages on paper. Furthermore, the marketing and distribution of books can occur on worldwide electronic networks: potential customers are made aware of information relating to the existence of a book, upon

which the customers can themselves initiate the manufacture of one or more copies.

The electronic transfer of information is fundamentally made possible by a numeric coding system that makes the transfer and processing of information possible, and thus we speak of the digitization of processes. All modern computers and computer-driven machines or devices that process information are based this binary numeral system, where 0s and 1s are used to describe time, form, motion and sensory information.

On a fundamental level, manufacturing processes always relied on certain stimuli (information) to cause a response. In film photography, for example, a light-sensitive emulsion consisting of silver halides reacts to varying amounts of light (stimulus or information). In digital photography the stimulus is still light, but it is converted to digital information that is readable by subsequent processes such as a digital display or digital printing device.

Paradoxically, in our age quintessential products and information sources, such as books or book-like architectures, are increasingly dependent themselves on digital information for their creation, manufacture, distribution and access.

Fundamentally, digital information and its storage, transmission, subsequent interpretation and application to perform myriad tasks lie at the core of contemporary technological change and industrial activities. As such, digital information is the key concept that sets us apart from industrial methods used in the past. To mark the time we live in, the phrase 'information revolution' has been used by some observers, but 'digital information revolution' may be more accurate to coin the defining characteristic of our age.

Competing communication technologies

Since digital information exists independently of the medium that contains it, it can be used or repurposed for dissemination by an increasing array of communication technologies, some of which have been developed very recently. Consequently, the physical book is facing competition from alternative electronic non-paper forms of communication. E-books, online libraries and the like offer advantages such as automatic search abilities, audio, video, interactivity, customized viewing and readability in the dark, to name some features the physical book inherently lacks. This begs the question of why, in spite of these electronic media advantages, the physical book still has a future.

The simple answer is to counter with some of the disadvantages of electronic reading devices, including the lack of a universal standard allowing interoperability between different electronic reading devices, unknown archival potential, high hardware costs, periodic hardware updates and reliability issues of hardware dependence, coarse image resolution, limited choice of titles, cataloging issues because of poor publishing information, copyright issues and last, but probably most significantly, the average reader's general preference for paper-based materials when reading long documents.

Many if not most of these electronic reading technology disadvantages have the potential to be solved by technological improvements, civil law adaptations, common standard agreements and gradual acceptance of new communication technology, such as we have witnessed so often in the past. The apparent preference for paper-based reading materials, especially when long documents are involved, has led to the development of alternative electronic reading devices that mimic the reading experience produced by ink on paper, and therefore a critical analysis of the advantages afforded by the physical book must be made.

The constant factor in the evolution of the book, from cave drawings to manuscripts to printed books, is that these are reflective display technologies. This is to say, the images on substrates, be they paper, papyrus or any other physically imaged surface, are perceived as a function of an ambient light source reflecting from the substrate to the eyes of an observer, in the same way people perceive their natural environment. Although emissive display technologies such as television screens or computer monitors produce exceedingly brilliant colors, the visual sensation perceived by an observer is unnatural. Given that the reading of books is a sustained activity, any discomfort, however small or subliminal, will therefore be resisted by most people.

The shortcomings of emissive display technology, though it is dominant in today's electronic display products, have been acknowledged by researchers since at least the mid-1970s, leading to reflective electronic display technology, figuratively named e-paper. In e-paper colored liquids are electronically moved against a white background, thus achieving a similar visual effect as ink on paper. One of the earliest adaptations of e-paper technology was found in the Sony e-reader – but this was not received by the reading public with overwhelming acceptance, for reasons the pundits still do not agree upon.

Very recently, in late 2007, the online bookseller Amazon introduced its own version of an e-paper reading device, called Kindle, featuring wireless downloading of over 90,000 titles, including a majority of titles

in the *New York Times* bestseller list, as well as several national newspapers and magazines and access to the online encyclopedia Wikipedia. It remains to be seen if this latest entrant into the electronic reader market will be more successful than earlier electronic reading devices, but the biggest resistance at this time seems to be the high costs of these devices and the relatively small selection of titles when compared to the vast selection that is available in the form of physical books.

Electronic reading devices have the unquestionable advantages of text search capabilities, inbuilt dictionaries, electronic bookmarks and text size enlargements, but their dependence on hardware does not provide the same immediacy to content as is afforded by the physical book and introduces a host of economic, environmental and archival shortcomings. Many of these shortcomings may only be transitory limitations, which in time may be overcome, but the essential requirement for hardware to make content visible to a reader seems to be the biggest obstacle for the greater acceptance of these electronic devices. Any type of hardware, in particular electronic hardware, is subject to obsolescence, which imposes financial burdens whenever a device has to be replaced. There are also considerable environmental implications in the disposal of unwanted electronic devices composed of complex materials, including the toxic materials contained in the batteries that power these devices, which unlike waste paper are not easily recycled.

It is human nature to avoid activities that are unpleasant, cumbersome or uneconomical. That is why, with respect to readability, an aggregate of seemingly small negative factors might be tolerated when reading a few pages, but may be objectionable in the sustained activity of reading a long document like a book.

In some respects this new wave of electronic communication represents a complete discontinuity from the past, because all other forms of graphic communications that preceded it were invariably reliant on some type of physical substrate, whereas the images displayed on an electronic book reader exist as digital data only. Virtually all of our accumulated knowledge is based on the records left to us by our ancestors on some type of substrate communication or other, and our present understanding of history, science and philosophy would not have been possible without the written records that in some instances have survived several millennia from such pivotal epochs as classical antiquity. The same extraordinary longevity is far from certain for digital storage media, and this may have far-reaching consequences for future generations – which, unlike previous

generations, may not be able to elicit vital information from the past because of digital data's potentially fleeting existence.

Unfortunately, electronic media require electro-mechanical devices to retrieve information, which are not only costly but, like most electronic products, are subject to malfunction and obsolescence. A striking example of the intrinsic obsolescence associated with digital preservation came to light with the disclosure in 2002 that an initiative called the Domesday Project, sponsored by the British Broadcasting Corporation (BBC), which recorded a snapshot of British life in the mid-1980s in a then new digital video format, was at risk of being lost. The videodisks holding the records of over a million people, some 200,000 pictures and thousands of maps could no longer be replayed because the video format in which the data were recorded less than 20 years earlier was now outmoded. Subsequently, in order to make these important historical records available to posterity, the entire project had to be reverse engineered by a team of scientists at the University of Leeds. Ironically, the original Domesday Book commissioned in 1085 by William the Conqueror is still in perfect condition and can be viewed at the UK National Archives.

Will book publishing go down the same road as music publishing?

From a perceptual point of view, reading books and listening to music are different, in that listening to music requires no more than the innate human ability to hear, while reading is an acquired skill. Both, however, are true forms of communication in every sense of the word, which is even more obvious when books and music recordings dedicated to entertainment are juxtaposed. Inherent in this analysis is that listening to music is a passive and reading a book is an active form of receiving and interpreting information – which, as we will see, is the underlying reason for the different directions music and books are likely to take since the advent of media digitization.

Similar to Gutenberg's contribution to printing, the recording or reproduction of music had its seminal moment in history with the invention of the phonograph by Thomas Edison in 1887. There is no question that the greatest step forward in the evolution of music delivery to an audience was made when Edison invented a medium that allowed music lovers to listen to music in places other than where it was created.

Since that time the recording of music has progressed to analog recordings on different vinyl formats, magnetic tape and, more recently, as products of sound digitization, compact disks and compressed digital music file formats transferable via global electronic networks, causing a tremendous shift in the way people acquire and listen to music.

The digitization of sound also initiated discussions about whether the quality of analog music is better than digital music recordings, because by definition any analog to digital transformation is an approximation of an original signal's continuum by a series of discrete steps. This discussion is now largely a moot point because the series of steps or sampling rate (44,100 times per second for CDs) is so large in modern digital sound recordings that degradation of sound is miniscule and more than compensates for the physical factors causing noise or static in analog recordings.

Arguably, recorded and reproduced music may not be an exact replication of original music, but the advantage of listening to it anywhere one pleases is so overwhelming that music playback devices are now as commonplace in average households as toasters. Miniaturization of audio devices, largely made possible by microprocessor technology and digitization, further enhanced the portability of audio reception, as exemplified by the enormous popularity of MP3 players like iPods.

The point of this discussion is that, other than some sound fidelity issues, the sensory experience of listening to music from an original source such as a concert hall as opposed to a sound system in one's living room is not significantly different; both are passive activities requiring nothing more than good hearing. The effort expended is no more in one or the other scenario. It also means that listening to recorded music does not introduce additional barriers to diminish the comfort and enjoyment of the listener, but instead affords a listener the advantage of unlimited playback of music in the comfort of her home or while jogging around his neighborhood, at a fraction of a concert admission price.

Thus the intrinsic value of a music CD is not in the physical medium of the disk, but in the sound it reproduces. In fact, the reproduction of music no longer requires a physical medium, as the digitization of sound and its subsequent saving into compressed computer file formats permit its electronic transmission from a digital depository or remote server to a client, such as a personal computer, which, when equipped with sound reproducing hardware, can be used as a sound system.

Effectively, these technological developments are about to change the music recording industry from selling physical products to selling digital information. Consequently, the music recording and publishing industry

is facing the uncertain future of having to compete with pirated products distributed via the internet, because it is relatively easy to copy and distribute digital content on the internet, which is largely unregulated and beyond the reach of national laws. An effective business model for the legitimate sale of digital information via electronic networks is still eluding the music recording and publishing industry.

Since book-like formats for dissemination by electronic networks and use on electronic reading devices already exist, the potential problems for book publishers are no different than those currently experienced by the music industry, as there is no technical difference between digital files containing audio information and those that contain graphic information, save for the fact that electronic reading devices have not nearly found the same acceptance as audio listening devices, although both were introduced at about the same time – which brings the discussion full circle to the previously stated advantages of the physical book. The primary asset of the physical book is thus its user-friendly architecture and paradoxically its low-tech quality, which in today's culture of unadulterated technology worship is indeed an oxymoron.

Moreover, the physical book's appeal, unlike pure digital information, goes beyond its content to include its cover material and design, gold-leaf edge embellishments, bookmark ribbons and of course the high-resolution, multicolored gloss-coated illustrated pages typical of coffee-table books, to mention just some of the tactile and esthetic qualities. These bestow upon some types of books the characteristics of treasured objects and keepsakes.

Book publishing is driven by technology

Historically, it can be said that one of the primary forces shaping the book publishing business has always been the state of printing technology in a given age. In the pre-printing era, the manual reproduction of books in monastic scriptoria was a monopolistic industry largely dominated by the ecclesiastical class catering to the literate élite. The prevailing business model of producing books one-off was dictated by the slow means of production, which necessarily limited the supply of books. Even in this pre-industrial age, entrepreneurial individuals, realizing that the demand for books outstripped supply because of the rise of universities, established large-scale book production scriptoria – some of which, like that established by the Florentine bookseller Vespasiano da Bisticci, employed as many as 50 scribes.

Fairly large-scale printing facilities capable of printing books in quantity rose after Gutenberg's invention of movable type spread throughout Europe. Anton Koberger of Nuremberg in 1470 operated 16 print shops and a distribution system employing agents in almost every city in the Christian world. The aforementioned Venetian Aldus was the first book publisher to release books in editions of 1,000 copies, and William Caxton did much the same in the British Isles. These first printers combined the skills and knowledge of type founder, printer, editor and bookseller, selling for the most part directly to the readers, in one and the same establishment, because printing technology and bookselling in large quantities were still too new for specialized crafts and business models to emerge.

The industrial revolution of the 1800s saw the increased mechanization of all facets of book production, from type founding to typesetting, mechanized binding, photographic reproduction of images and new printing processes such as gravure and lithography. A division between the different technical production phases, editorial and bookselling functions as independent and viable enterprises became more common as the volume of book production increased. Although large publishing houses offering the whole range of technical, editorial and marketing services still exist, they are now the exception rather than the rule.

In so far as the physical book is a relict from the past, the methods by which it is manufactured are now as modern and high tech as any other digital communication medium, having gained as much if not more from digital technology than other industries, and as a result the publishing supply chain is once again facing fundamental changes. The most significant technological changes that will have a profound effect on the publishing industry are new printing processes, commonly classified as digital printing. Digital printing processes, unlike the hitherto common conventional printing methods, are capable of producing books one at a time, or for that matter different books in succession, without compromising the rated production speed of these devices.

For the publishing industry this is a radically new concept, as it at once returns book publishing to its earliest beginning in one-off production in medieval scriptoria and at the same time produces books fast enough for a customer to buy a single unit while waiting for it to be printed. Coupled with the internet, this makes online editorial preparation, marketing and ordering of books possible: books more than most product categories have the potential to be propelled into a new and

golden age never seen before in publishing's long history. These methods are more than a pipedream: they are already implemented by some companies, having sales of tens of millions of dollars, with average run lengths of fewer than two books. These changes will go far beyond productivity issues, and have already produced a vast increase in the number of titles being published. Also seen is an erosion of editorial control by publishers, and progressively more and smaller publishing houses competing to cater for the increasingly diverse tastes of the contemporary readership.

Technological innovation has always had a modifying effect on the publishing industry and, like all momentous events in media history, digitization in general and the digitization of printing processes in particular will cause changes in people's reading and buying habits, as well as changes in the established hierarchies of those who create and produce books and bring them to a marketplace.

The importance of preserving the book

Most children are encouraged by their parents or guardians to read books even before they are capable of deciphering text, which is an indication that in a parent's mind books are intrinsically worthwhile and have a positive influence on their offspring. This phenomenon is incidentally one of the most effective marketing tools, and almost always unintended, as it unobtrusively promotes a habit of reading that often stays with a child for the rest of its life.

It is thus safe to state that books are generally seen as an agent of enrichment in people's lives, and therefore a critical analysis ought to be made as to why the book gained this lofty status, for the same indiscriminate generalization cannot be made for other media types such as newspapers, radio, television, movies or the internet. To be sure, this positive generalization of books is not always deserved, because gibberish, falsehood and bad taste can just as easily be spread by books as by any other media type.

The most probable reason for the book's reputation as a reliable source of information, especially when compared to other media types, is simply its protracted existence as the sole means of communication beyond the oral tradition for most of the history of human development. Books existed long before literacy was near universal, as it is now, and were considered to be a source of wisdom and truth by the illiterate

masses. The average man or woman lacked the education and facility to read in order to be able to challenge what was written by a few learned men, who by privilege or demonstrated brilliance stood alone in their ability to explain the mysteries of the universe and to record their thoughts in books.

Editorial control became a necessity when books were sold competitively, in quantity and for profit. Editorial selectivity also became necessary because of the larger volumes of writing by a greater number of literate people with varying degrees of competency, to ensure an acceptable level of quality in content accuracy, grammar and style. By and large editorial control maintains a measure of quality, but it also enhanced the book's reputation as a reliable source of information and the common perception that 'if it is printed it must be true'.

Arguably, the traditional editorial process puts a publisher in the position of being a gatekeeper of knowledge in a system that ultimately relies on the good judgment of an acquisition editor, for example. As a result, a worthwhile idea may fall by the wayside; but no editorial control at all is not very palatable either, and is probably the worst of the available alternatives.

The free-for-all approach seen today on the internet, where every living man, woman and child, including those with minimal competencies, faces no restrictions to publishing their ideas for a worldwide audience, has effectively eliminated editorial control for this electronic medium, making vast amounts of information that may or may not be accurate available around the world. Rather than being a threat to the book, the feebleness and often fleeting existence of information on the internet actually enhances the relative standing of conventional books as a substantive communication medium.

Aside from different methods of dissemination, by radio, television, internet, magazines, newspapers or books, information can be delivered either as an intrinsic information product, like books, or, as is the case with most other media types, bundled with commercial messages. When information is bundled with such messages it becomes difficult to maintain editorial integrity, because the commercial priority of a publication could conflict with the editorial content. We see this happening especially in the real estate sections of daily newspapers, where the editorial content is little more than thinly veiled endorsements for products advertised on those pages.

Modern consumers have an appetite for specialized products never seen before. While in times past there was only peppermint-flavored toothpaste, in this day and age the shelves of drugstores are cluttered

with bewildering assortments of different toothpaste flavors and even toothpastes purporting to cure a variety of oral ailments. In part, the segmentation of product categories is driven by the greater flexibility afforded by digitally controlled manufacturing methods, which can also be witnessed in the printing industry. Like the toothpaste example, the variety of publications available now is limited only by the variety of human interests, as a visit to a bookstore's magazine stand can attest.

The trend to greater thematic segmentation in the communication media compounds the problem of editorial integrity, because the narrower the focus of a magazine or television channel, the closer it will be associated with a given product category. For example, it would be difficult to present objective information on the relative merits of one or another fishing rod if the magazine or TV channel is specifically focused on angling and the advertisers are always the same angling equipment manufacturers competing for the same customers. On the other hand, an author writing an angling book is not saddled with these conflicting interests, and is thus more likely to write a book that evaluates the quality of angling equipment objectively regardless of the manufacturer.

Because information contained in books is usually not tainted by commercial interests, they are one of the last vestiges of unbiased information. This is not a small concern in a world inundated by rampant commercialism and sophisticated media technology screaming for the attention of an ill-informed public.

It would be a overstatement to claim that information found in a book must necessarily be valid, because, not unlike other human endeavors, the writing of books can be fraught with fallacies and therefore the ultimate decision as to the validity of any information will always have to rest with a reader; but since most books are subjected to some editorial rigor, combined with the fact that for every opinion expressed in one book there are countless more in other books, both a reasonable quality and a diversity of viewpoints are achieved. Notwithstanding some of its shortcomings, now and into the future, the book may yet be the most effective means of recording and disseminating information.

Ultimately no communication technology is the be all and end all of conveying information, because comprehension depends on one's perceptual ability and level of literacy. Each media type has particular advantages to communicate certain aspects of information that may match the preferences and learning styles of a person. Nonetheless, since ideas, especially complex ideas, are in the first instance formulated in a human language, they cannot be expressed more accurately than by a human language. As well, due to the limitations of the human mind in

committing large amounts of information to memory, the written word not only connects intimately with a writer's intentions, but also leaves a permanent record of his ideas, which renders the book unsurpassed as a conveyor and preserver of human thought – without which intelligent human discourse and, by implication, a free and democratic society cannot thrive.

The origins and evolution of the book and printing processes

The earliest evidence of graphic communication

The human desire to seek avenues of communication, so well embodied in books, reaches as far back as the paleolithic cave drawings which are found in most geographic regions that were inhabited by our ancient ancestors. In cave drawings we witness one of man's earliest attempts to communicate human thought by way of graphic imagery. From these primitive drawings would in time evolve an abstract graphic coding system that we now call the alphabet. Surprisingly, it can also be demonstrated that paleolithic man already knew how to reproduce images repeatedly by blowing a very fine pigment powder from the mouth or some type of tube such as a straw or a hollow bone over a human hand, thus reproducing a negative outline of the hand (Breuil, 1979: 271). This technique is a true method of image reproduction because it uses the prototype matrix of an image, in this case a human hand, which as such is an essential element of all modern printing processes. Specifically, paleolithic handprints are the early forerunner of what later became stencils and screenprinting. Blowing a colorant on to a substrate to create an image is also astoundingly similar to the inkjet printing process, save for the fact that in modern inkjet printing, instead of human breath, ink droplets are propelled by virtue of digitally controlled piezoelectric principles.

The essence of human communication is to convey one's thoughts to others, but it is not quite understood what might have motivated paleolithic man to draw images of animals and other scenes of his physical environment, because in many instances these drawings are found in extraordinarily inaccessible locations not likely to be noticed by others. There are some speculations that paleolithic man might have

been spiritually motivated in an attempt to control his environment, or his motives could have been as whimsical as those of people who scrawl graffiti on buildings in our age.

Whatever their motivation might have been, it seems evident that our current practice of communicating graphically, using ever more sophisticated technological methods, is rooted in behaviors that go back to the very earliest stage of human development. Given that such behaviors are not observed in any other species, it may be one of the defining characteristics of the human race.

Substrates and the issue of transportability

The fundamental limiting factor of cave drawings was their immovability, which led to the next evolutionary stage of developing transportable substrates by which information could be disseminated to a larger audience. Aside from the much-proclaimed 4,000-years-old Sumerian clay tablets incised with cuneiform text that mark the beginning of our modern alphabet, the remarkable variety of transportable substrates developed throughout the world includes:

- shaped and incised tokens employed as a system of accounting in the entire Near East in about 8,000 BC (Kilgour, 1998: 12);

- bones and scales of tortoise shells shaped into nearly 2,500 different characters as early as the Chang dynasty (1765–1123 BC) in China (Febvre and Martin, 1976: 71);

- strips of wood and bamboo used in China to image vocabularies, calendars, medical prescriptions and official documents dating from 98–137 AD (ibid.);

- a record-keeping system called Quipu, used by the Incas of Peru, consisting of colored strings and knot patterns (Davenport, 1907: 11);

- palm-leaves dating to the second century of the Common Era and still used in modern-day India (British Museum, 1973: 30);

- the famous Harris Papyrus Roll, a manuscript recording the reign of Ramses III (1198–1155 BC), which is 40.5 meters long by 42 cm broad when unfurled (Hussain, 1972: 17);

- parchment and vellum processed from animal skins, coexisting for much of the time with papyrus.

The fact that people from disparate regions of the world had different types of visual communication systems gives reasons to conclude that each civilization developed its technology independently, reinforcing the notion of man's universal desire to express himself beyond the oral tradition. The wide variety of solutions to an identical problem is principally attributable to the resources available: thus the Chinese used bamboo, Egyptians used papyrus, Incas used ropes derived from vegetable fibers and primitive civilizations, lacking advanced skills, relied on readily available materials such as bones, stones or tortoise shells to create a distinctive system of visual communication.

While with the development of these materials the portability issue was resolved with varying degrees of success, the invention of paper by T'sai Lun in China in 105 AD and its subsequent introduction to the Occidental world several centuries later established paper as the preferred substrate wherever books were produced, because it had several significant advantages over the hitherto common substrates. Paper's transportability was as good or better than several of the other substrates. The ease with which paper could be imaged was far superior to all other substrates, in that it has a relatively smooth surface. Paper's permanence is demonstrated by the fact that some books printed on paper are as strong and readable today as when they were made over 500 years ago. And very importantly, paper is made from an extremely abundant raw material that, if harvested competently, is not likely to be depleted. Combined with the extremely efficient processes now employed to manufacture paper, its costs, though volatile, have historically mirrored the general state of the economy. The ubiquity of paper lets one forget the importance of this common material: it has found utility in countless spheres of human activity, not least of which is the production of books, and hence their continued existence will depend on a secure and economic supply of paper.

Book architectures

The book in its present architecture has existed for about 2,000 years, but other forms of books or book-like objects existed long before and some book forms coexisted for several centuries alongside the modern form – not unlike today, when the physical book shares the marketplace with e-books and other electronic reading devices.

The roll or scroll, commonly considered to be the earliest writing form for long texts, goes back to the earliest classical antiquity in Egypt, when

papyrus was the most common substrate for recording graphic information. Papyrus is made from the inner pith of the papyrus plant; if cut along its stem, it yields thin strips of about one centimeter in width and 40 centimeters in length. Placing these soaked and still wet strips of papyrus slightly overlapping on a flat surface will cause the strips to adhere to each other, owing to their adhesive quality in a wet state, thus forming a sheet of material. The process is then repeated with a second layer of papyrus strips at a right angle to the previous layer to strengthen the material. The forming of sheets is therefore a pasting process for any length of writing material. For longer texts the process of pasting was simply continued in one direction of the material, reaching lengths in excess of 40 meters.

Because of the material's length and the inherent brittleness of papyrus, the roll architecture was the most plausible design concept and continued to be the preferred writing form well into the Christian era, even as substrates changed to parchment, vellum, silk, birchbark or paper, to mention some of the more common pliable writing materials used in the Occidental and Oriental worlds. The simplicity of the roll design leads one to conclude that each culture arrived at the form independently, but this cannot be claimed with certainty. Be this as it may, in its time the roll format was as universal as the modern book form is today. For example, the T'ang dynasty emperor Tai' Tsung (627–649 AD) erected a library that contained 54,000 rolls, and the great libraries of Alexandria, which reached their pinnacle under the reign of Ptolemy II, maintained a library that contained 490,000 rolls – which as such was the repository of knowledge in the known world, somewhat comparable to the Library of Congress in present-day America.

Notwithstanding the roll's principal position, a great variety of other book forms existed in other areas with strong literary traditions, particularly in Central and East Asia and on the Indian subcontinent. There are Indian palm-leaf books that were held together by cords threaded through the center of the fragile leaves. This book form, called *pothi*, was widely used not only in India but also far beyond its borders, including in China. Palm-leaf books resemble the modern book form in that they incorporate the concept of stacked pages, but their design was more likely dictated by structural necessity than by a conscious strategy to arrange the palm-leaves sequentially.

Also unique to the Oriental world is the accordion book architecture. The accordion form probably evolved from the roll and may have been discovered accidentally, as it is a relatively small step, which does not take a leap of the imagination, to fold a long ribbon of material in

accordion style instead of rolling it. The accordion book form was never adopted in the Western world, but we know from historical accounts that it was particularly common in areas where Buddhism was practiced. When the modern book form was introduced to China early in the Sung dynasty (approximately the eleventh century) it was embraced only by Confucian and secular literature, while Buddhists continued to use the folded book form. The accordion book form, by virtue of its unique construction that incorporates the stacked-leaf concept with that of a continuous ribbon, could in fact be printed by digital processes without changing the conventional book form substantially, and in the process simplify the printing and binding of books. These possibilities will be explored in a subsequent chapter.

Nobody knows the origins, inventors or discoverers of the wheel, metal-smelting, fire-making, modes of transportation and edible or medicinal plants, to name but a few innovations and artifacts without which human progress would be unimaginable. Likewise, the book has no known inventor. It may have been invented by an unsung hero or it may have progressively evolved from the roll, but, whatever the case, its structural design was finalized to such an extraordinarily high degree of functional perfection that 2,000 years later it remains basically unchanged. The first stitched book in the Western world cannot be dated exactly, but we know from the Roman writer Martial that small books, then known as codices, were on sale as early as the first century of the Common Era in the Roman sphere of influence. Roman codices were first produced with the more durable parchment, while papyrus, sometimes reinforced with parchment at the spine, became the preferred material for the stitched book form when it was introduced to Roman-ruled Egypt. As the codex was popularized throughout Europe and the Middle East it underwent refinements with respect to materials and formats to reflect the tastes and fashions of different time periods without affecting the conceptual integrity of its design.

Rolls and codices continued to coexist for many centuries, and by some historical accounts the codex was first considered to be of lower quality, not unlike today's resistance by many people to new communication technologies. The benefit of historical hindsight that allows us now to see the codex as overwhelmingly triumphant should give us pause to evaluate contemporary technologies based on their relative merits, rather than on traditional or long-term usage, as we are poised to face critical decisions that may render the physical book obsolete in turn.

An objective comparison between the roll and the codex designs will demonstrate that the roll was not superseded by the codex out of any construction technique considerations, for the codex is by far the more complex of the two designs. It requires two construction phases that are unnecessary in the roll design: the folding of individual sheets into multiple page sections, and the subsequent joining of sections to each other by manual sewing methods. If not for some other compelling advantages over the roll, this factor alone should have prevented the preponderance of the codex. The underlying reason for the eventual acceptance of the codex must be sought in how the functional aspects of reading long documents are facilitated in its design. This is incidentally a rather timely topic, because the current debate on the pros or cons of alternative reading devices *vis-à-vis* the physical book involves similar issues. The primary and single most significant advantage of the codex design over the roll is that any information, regardless of its relative position in the text, is equally accessible. That is to say, it is for obvious reasons no more difficult to access page number 6 as it is to access page number 506 in a long document. This is not the case with the roll, because if a reader is reading the beginning of a text and desires to jump to the end of the text he must unfurl one end of the roll while simultaneously furling the other end, which is cumbersome and time-consuming. There is an interesting parallel development in the evolution of computer memory storage when it changed from tape to disk storage devices for the precise same reasons. Therefore the advantage of the codex over the roll design could be expressed in computer terminology as being one of *random access* capability.

A further advantage of the codex design is the general act of furling and unfurling of a roll as opposed to flipping pages, especially in view of the fact that reading long documents, such as books, is by definition a sustained activity. The compactness of the codex design is another, albeit secondary, advantage: it saves library space and economizes the shipping of books in quantity. The efficiency of imaging rolls or codices was not significantly different as long as manual writing was the sole means of reproduction. By the time printing was invented rolls were already relegated to a minor status, but the roll would have become an untenable architecture in any event, because medieval printing methods required sheet material to be processed, rendering the roll architecture obsolete from the technical production perspective as well. There is potential for ancient book forms to be reintroduced for modern book manufacturing, as digital printing processes are capable of imaging continuous ribbons of any length, which creates possibilities for novel book forms that will be discussed in more detail later.

A fitting expression that best summarizes the advantages of the codex or the conventional book form *vis-à-vis* the roll is *user-friendliness*, to borrow another phrase from computer terminology. These same arguments are also valid, and will be discussed more thoroughly when the physical book is compared to newer electronic reading devices. Ultimately, the critical elements whenever systems for sustained activities have to be designed – and there is no better example than the reading of books – are convenience and ease of use.

Evolutionary developments to improve graphic communication continue unabated to the present day, and are still motivated by the same age-old desire to transmit information faster and to more people. Consequently, the physical book has to compete for readership with the internet, e-books, e-paper and other such electronic and paperless communication systems, which raises questions as to its future viability.

Incunabulum: the dawn of printed books

Until about 500 years ago the best available technology was to copy an original document by hand. Therefore, to increase productivity, the only available option was to increase manpower. This could be accomplished by a team of scribes working on different parts of a manuscript, or by several scribes taking simultaneous dictation from a reader. One way or the other, the manual reproduction of texts was prone to errors and inconsistencies, and had severe productivity limitations which could not be overcome by manpower increases alone. This was not a major concern in the very early period of the book trade when there was a limited demand for books. A typical medieval book transaction started with an individual requesting a copy of a book, which would then initiate a process of producing or copying the book that could take months or even years of intensive labor by one or several scribes. In modern parlance this business model is called *sell and produce*, and it is incidentally being reintroduced with some success in contemporary print-on-demand publishing – more about which will be said in later chapters. Because of the general spread of literacy in the twelfth century, the demands for books increased and gradually shifted book production from monastic scriptoria to more commercially motivated enterprises, creating an environment that was ripe for innovation.

Imaging technologies as such had been known for a protracted period of time, but a technology capable of reproducing long documents eluded man for a long time. Some relief printing can be found as far back

as 3,000 years ago, in the form of circular stamp and cylinder seals used during the Uruk period in Mesopotamia. Cylinder seals were also used to mark the ownership of sealed jars, and the authentication of documents and contracts by seals was widely practiced in most ancient civilizations. While these and other early practices to reproduce images repeatedly from an original prototype matrix meet the criteria of an imaging technology, their applications did not go beyond small images, a few symbols or a few text inscriptions, similar to what could fit on a contemporary coin, which itself is an example of an imaged artifact with a long history.

The earliest mention of long document reproductions are so-called woodblock prints in China during the Zhenguan reign (785–805 AD) of the T'ang dynasty. Woodblock printing is a technique whereby the image is carved on a plain piece of wood with a knife or chisel, thus forming the relief of an image. The imaging of a substrate occurred by applying ink to the raised parts of the relief image and rubbing a substrate against the inked woodblock using some type of burnishing tool, such as a flat piece of wood. In this way both pictorial images and text could be reproduced from the same woodblock repeatedly and for as long as the woodblock could withstand the treatment. Woodblock printing was used for both textiles and publications, and the earliest woodblock prints found were made on silk. Woodblock printing had a strong association with Buddhism, and in fact the oldest known printed long document or book-like artifact is the Diamond Sutra dating from 886 AD. It depicts Buddhist scriptures, which were printed from woodblocks on six two-and-a-half feet long sheets of paper pasted together to form a roll.

Aside from the very advanced stage of development prevailing during the T'ang dynasty (618–907 AD), the crucial factor favoring the advancement of woodcuts in China was the nature of its character set that runs into the thousands. Although movable type, or the use of individual characters, would in time take the world by storm, this technique must have appeared a daunting task, as it necessitates the manufacture of multiple pieces for each of the thousands of characters. Alternatively, carving the letters of an entire text into a solid piece of wood required less initial effort, because the characters had to be carved only as they occurred in the text. A further facilitating factor is the lack of fine articulations in the Chinese characters, which made the chore of carving vast numbers of characters less challenging.

Unlike the invention of woodblock printing, which is shrouded in the mist of history, the invention of movable type can be dated accurately to the Sung dynasty's Ch'ing-li period (1041–1048), when Pi Shêng

undertook the enormous task of manufacturing individual multiple pieces of the basic Chinese characters (Carter, [1925] 1955: 212). The singularity of this invention cannot be overemphasized, in that it represents a complete break with past practices of text reproduction. While woodblock printing was an improvement from manual writing for the purpose of duplicating text, it was an inflexible method because a given woodblock could not be used for works other than the one for which it was carved. Every time new text needed to be reproduced, the cumbersome process of carving woodblocks had to be started anew. The invention of movable type by Pi Shêng changed the process of generating text from writing or carving to the assembly of text, hence the modern term typesetting was coined. Conceptually, since that time text generation has not changed, because even now, as we type text on a computer keyboard, we are still assembling letters, albeit by much more sophisticated technological means. China's splendid isolation prevented the movable type concept reaching far beyond its borders, and so it was that for nearly four-and-a-half centuries the practice of printing by movable type was known only in the Chinese sphere of political and cultural influence.

The Far Eastern monopoly on printing by movable type was broken only when in 1450 AD Johannes Gutenberg of Mainz, Germany, arrived at the exact same solution as the Chinese had over four centuries earlier. Most scholars believe that Gutenberg made his inventions independently of Chinese influences, but ultimately it matters little, because Gutenberg's influence on human communication was by far more significant than that of any other innovator before or after him. There were two reasons for this, the first of which was the incredible speed with which his invention spread throughout Europe and the rest of the world.

Within 25 years of the invention most major towns in Germany had print shops that used Gutenberg's methods, while in Rome the invention took hold as early as 1465 or 15 years after its inception. Other early adopters of the movable type principle were located in Venice in 1469, Paris in 1470, Britain in 1477, Stockholm in 1483, Istanbul in 1503, Salonica in 1551, Moscow in 1553, Goa (India) in 1556 and Kazusa (Japan) in 1590 (Füssel, 2003: 59–70).

The reason why Gutenberg's invention spread so much faster and to more places than the Chinese invention was principally attributable to Germany's greater integration in the international community than the Chinese were for most of their history, as well as the favorable trade conditions that prevailed at the time, which placed no or minimal restrictions on the practice of printing by governments, princely houses,

the Church and the guilds. A further factor contributing to the remarkable speed with which Gutenberg's invention spread to other areas was the volatile political climate of Mainz in the late 1400s that pitched the temporal and ecclesiastical princes of Germany against each other. A full-scale local war erupted in 1462 under the command of Adolph Nassau and destabilized the city, causing many printers, skilled in the new techniques invented by Gutenberg, to seek safety and opportunities in cities and countries far afield.

In the context of present-day concerns about global issues of trade, information exchange and immigration these historical accounts are significant, in that they may allude to some of the advantages of the free exchange of people, ideas and goods.

Historians of the late Middle Ages coined this early period of printing *incunabulum*, or literally the *cradle* period of printing, which by virtue of the novelty of the process still was not demarcated by specialized crafts or businesses. Early printers wore at once the hats of type-founder, typesetter, printer, publisher, editor and bookseller, as vividly illustrated in a medieval woodcut (Figure 1.1). The setting of the woodcut is a print shop, showing a printer operating the screw of the press and an assistant handling the stuffed ball used to ink the type, while a typesetter assembles the type in preparation for printing. Also shown is what appears to be a transaction of a book being sold, or perhaps the editing of a book as it lies open in front of someone examining it. The stockpile of books in the background suggests that they were produced in quantity, ready to be sold. This woodcut, titled the *Le Danse Macabre* and made by Mathias Huss in 1499, or only some 50 years after Gutenberg perfected his invention, is the oldest known depiction of a medieval print shop.

This was also a time before the businesses of printing and publishing consolidated into large, well-financed and established industries. Being in its formative years, this new industry was still characterized by an entrepreneurial type of itinerant printers seeking their fortunes wherever an opportunity presented itself, somewhat reminiscent of the pioneering and entrepreneurial spirit that gave rise to many software and internet start-up companies in the 1970s.

The second reason as to why Gutenberg had such unprecedented influence is the genius of the multifaceted invention itself. With respect to the fundamental concept of their inventions, both Pi Shêng and Gutenberg had the same idea of breaking down a text to its smallest individual components, or individual letters and other typographical symbols, but Gutenberg's methods were based on far more sophisticated industrial processes.

Figure 1.1 *Le Danse Macabre*, Mathias Huss, Lyons, France, 1499: oldest known depiction of a medieval print shop

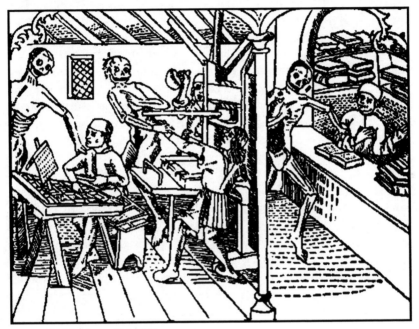

Source: British Library IB.41735

He drew on his experience as a trained goldsmith, who had the long-standing tradition of identifying their work with relief punches. Similar to the practice of goldsmiths punching an identifying mark on to a gold ring, he fashioned the inverse relief image of a letter into a hard metal that served as a punch into a softer material such as brass or copper, which in turn became the matrix of a casting form for metal letters.

These procedures were based on long-established metallurgical and metal-casting principles which he simply adapted to the casting of type, but the uniqueness of his invention lies in the design of an adjustable mold. The aforementioned matrix of a letter was placed on the base of the mold, which by virtue of its adjustability could accommodate matrixes for each letter or symbol of the alphabet and could therefore be used not only for the efficient casting of one letter, but for *any* letter or symbol of the alphabet. The metal letters produced by this method had, possibly for the first time in history, the quality of mass-manufactured items in that, other than the varying width of letters, each piece of type had the exact same dimensions.

Historians specializing in the history of technology usually define mass manufacturing as being a function of interchangeable parts which became common practice only during the industrial revolution period of the 1800s, but as a concept it was already at the core of Gutenberg's invention some 300 years ahead of its time. Interchangeable parts imply that products are built from highly standardized parts that can be assembled without the need for customizing them, as had been in practice in the past. It is not generally recognized that Gutenberg's invention is an early, or even the earliest, example of mass manufacturing, but it perfectly fits the definition, in that each letter cast by this new system of movable type was perfectly interchangeable with any other letter and thereby enabled the production of infinitely variable combinations of letters.

If Gutenberg enjoyed one advantage it was that the Roman alphabet consists of only 26 letters. It took Gutenberg a lifetime to perfect a technically complex system of type-casting which became the standard method of preparing text for printing throughout the world; even more astoundingly, the basic principles did not change for at least 500 years.

The core concept of Gutenberg's invention was thus the adjustable mold for type-casting, but several other innovations were instrumental for his ideas to materialize into a practical method of printing. The composition of the metal used for the type required economic, technical production and printability considerations. The vast number of letters required to reproduce text mandated an inexpensive metal. Also, the metal had to be malleable enough to recreate a facsimile of the compact, sharp and angular style of the Gothic script used in medieval Germany, but had to be able to withstand the pressure of thousands of impressions without causing undue deformation of the letters. Researchers have been able to infer from later discoveries that the composition of the alloy that satisfied these requirements consisted of 83 per cent lead, 9 per cent tin, 6 per cent antimony and 1 per cent each of copper and iron (Füssel, 2003: 16). The sheer constituent variety suggests that Gutenberg must have conducted extensive experimentation, not unlike the trial-and-error approach of the alchemists of his time.

Gutenberg is often superficially credited with having invented the printing press, which is not entirely untrue, but must be qualified with the addendum that the press, albeit an important part of the whole of his invention, was not his main achievement. Presses of varying types were quite common in Gutenberg's time, and he merely adopted the principles of presses used in the agricultural sector of the economy by (probably) converting a wine press to the requirements of printing. Gutenberg's use

of a press improved the quality of printing considerably, and also differentiates his methods from the Chinese method of hand rubbing.

And finally, Gutenberg had to concoct ink that was compatible with his system of printing, because the water-based inks used by medieval woodblock printers were far too runny and therefore unsuitable for application on to metal type. A more paste-like ink was needed, which Gutenberg mixed from boiled linseed oil as a base and lampblack as the pigment (Harris, 1972: 77). In its basic chemical composition Gutenberg's ink is very similar to inks used in modern printing processes. Unlike present-day printing presses that apply the ink by means of separate roller systems for each color, he used stuffed leather balls (see Figure 1.2) which permitted the type to be inked with more than one color, thus enabling multicolored prints in a single pass. It must be remembered that Gutenberg's intention was to create a facsimile of the multicolored manuscript, including those portions of the text that for emphasis were traditionally written by the so-called rubricator in red (the rubrics) (Shailor, 1991: 38).

The techniques used by Gutenberg to print the 42-line bible were not sufficiently developed to reproduce the pictorial decorations of Middle Age manuscripts, and so it was necessary to allocate space for delicate borders and flourished initials to be added by an artist's brush or pen

Figure 1.2 Inking type with a printer's ball

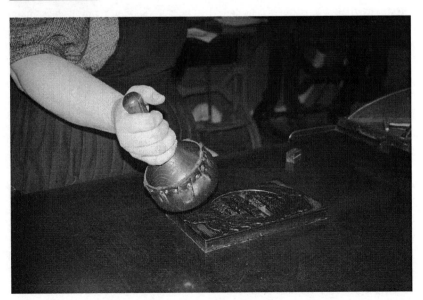

subsequent to printing the text. But the main text matter was printed in black, as had been the manuscript practice for centuries, and thus the poetic German *die schwarze Kunst,* literally meaning 'the black art', came to express an undertaking that must have appeared mysterious and magical to the medieval mindset unaccustomed to industrial efficiency. Given the labor-intensive nature of manual illustration it is perhaps not surprising that Gutenberg may have contributed to the early development of the intaglio printing process, which is ideally suited to the reproduction of pictorial matter; but this claim, while documented by a substantial body of evidence, is not universally accepted (Lehmann-Haupt, 1966).

What Gutenberg could not have foreseen is the remarkable archival quality of his work. Books he printed over 500 years ago have lost none of their visual attractiveness and readability, in stark contrast to some of the newer inkjet reproductions that have a tendency to fade after only a few years.

Although Gutenberg was probably engaged as early as 1436 in the practice of printing during his Strasbourg years, the work he is best known for is the 42-line bible, so called because the majority of the 1,282 two-columned pages consist of 42 lines. The overall page design, typeface design and typography of his work leave no doubt that he attempted to imitate the manuscripts of his time, and it can therefore be reasonably surmised that he was more motivated by a desire to improve the efficiency of book production than to improve the prevailing aesthetics of his time, as he had to fear rejection from conservative detractors and those who had a vested interest in continuing the tradition of the scriptorium.

The fact that the 42-line bible was printed on both paper and vellum is further evidence of Gutenberg's commercial aspirations, because he probably targeted both editions at different socio-economic groups. There are slightly different accounts of the exact quantities, but 140 bibles were probably printed on paper because it was by far the most economical substrate of his time and they were likely destined for the less affluent of his contemporaries, whereas 40 deluxe copies were printed on the much more expensive vellum for liturgical services or for those who subscribed to more conservative tastes and were willing to pay a premium for the privilege of owning a bible printed on this time-honored substrate.

In general, these historical accounts convey a sense of Gutenberg's single-minded determination to make his invention a profitable enterprise. He dedicated much of his life to this end, and as such

a precedent was set for publishing developments that followed, as well as how present-day book publishing came about.

From one-off to mass production

The first organized book-producing ventures emanated from medieval monastic scriptoria where books were manually copied, usually one at a time, for devotional and proselytizing purposes. The increasing demand for books by a growing literate and secular class, in large part impelled by the rise of universities, created commercial opportunities and proliferated the establishment of secular scriptoria capable of increasing the output of books by greater and more efficient use of manpower, but this did not overcome the one-off limiting factor of handwriting.

As long as books were produced one at a time there was little or no risk to the producer in being paid for his effort, because the contract between a buyer and a producer stipulated a known quantity of one, for which a buyer may even have made an advance payment. This was about to change with the advent of printing, as it enabled the production of books in quantity, which required a different business model that at once enhanced but also burdened the economics of the book trade. Mass-produced goods are by definition manufactured in large quantities, which bears the advantage of reduced unit prices, because the cost of manufacturing – that is to say the fixed costs of time, labor, materials and out-of-pocket expenses to operate a business – is distributed over a greater number of units, which can result in exceedingly low unit prices and consequently high profits for the producer. The economic term for this business concept is *economies of scale*, and Gutenberg's printed bible may in fact have been one of the first implementations of this business model. The benefit of economies of scale is, however, only materialized if a sufficient number of units are actually sold, as otherwise the revenues derived from too few units sold will not cover the fixed manufacturing cost, which remains unchanged regardless of the number of units sold. Since it is difficult to predict with certainty how many units of a given product will be sold, the producer has to make an educated guess and the success or failure of a project will depend on the accuracy of this guess. With respect to book publishing, the dilemma of making accurate predictions as to the popularity of a title has been faced by every publisher since Gutenberg's invention permitted mass production of books, and there is no better reminder of these risks than Gutenberg's own business travails.

Gutenberg's publishing efforts are unique in the history of the book in that he had first to invent a process of reproducing books before the business of selling them could commence, but there are also some similarities to present-day publishing endeavors: then and now book publishing was and is at the threshold of radically different means of manufacturing and modes of selling books.

Researchers were able to determine the efforts expended and the economics of producing the 42-line bible from examining some of the 49 still extant copies. Using electron spectrography and interpreting certain typesetting patterns, it was possible to determine that as many as six typesetters contributed to the work, requiring the use of some 100,000 pieces of type. Type-founding alone would have taken at least half a year, while typesetting and printing would have taken more than two years, as well as requiring the labor of 12 printers operating from four to six presses. Expenses for materials included paper imported from Italy for 140 books printed on paper at a cost of about 600 guilders, while the 40 copies printed on vellum, requiring 3,200 prepared calfskins, would have cost some 400 guilders (Füssel, 2003: 20).

Before involving himself in the 42-line bible project, Gutenberg was engaged in gemstone polishing to finance his inventions as well as diverse printing ventures, which apparently never generated enough income to meet his financial obligations. He found himself in frequent need of money, which he secured by offering partnerships or taking out loans from various sources, including his relatives. Faced with expenses of the magnitude required for the production of the 42-line bible, Gutenberg continued on the well-worn path of seeking financial assistance, which he eventually found from a wealthy merchant, John Fust, who advanced him 800 Rhenish guilders for the initial development costs of his invention and then a further 800 guilders for operating costs.

The business collaboration between Gutenberg and Fust was not an amicable one, as some three years into their partnership and before the project could be finished a legal dispute arose, obliging Gutenberg to pay 2,026 guilders. This substantial amount of money, about the equivalent monetary value of four patrician houses, was more than Gutenberg could pay and forced him into bankruptcy. It is not known whether Fust's legal actions were motivated by greed or by a desire to protect his investments, but by all accounts the 42-line bible was a financial success for him and he continued the enterprise based on Gutenberg's invention in a new partnership with Peter Schöffer, an artist and calligrapher who was Gutenberg's prime assistant. The firm so founded became a leading European printing and publishing center which was to last about

100 years, first under the tutelage of Schöffer, who succeeded Fust after his death in 1446, and then run by his son. The venture brought to market several important texts from classical antiquity, as well as making significant contributions to book design.

Gutenberg continued to pursue printing, but he never again achieved the technical perfection of the 42-line bible, nor was he ever able to repay his debts. Although Gutenberg was unsuccessful as a businessman his stature as a great innovator rose during his lifetime. The archbishop of Mainz granted Gutenberg a pension of free clothing and an allowance of grains and wine, as well as tax exemptions for the rest of his life. He probably would have preferred to live out his days on the proceeds of his inventions, but it was not to be.

Tales like Gutenberg's financial failure and Fust's simultaneous success have been retold many times throughout history in different settings, because the genius for innovation requires different temperaments and talents than the genius for commercial success. Both geniuses are needed for innovations to occur and to be successfully implemented, but they are seldom found in one and the same person. It is quite conceivable that Gutenberg's invention might have disappeared into obscurity without the daring investment and astute salesmanship of Fust, who was the first person in history to face the challenge of selling books in great quantities. Selling 180 bibles may by today's standard of multimillion blockbuster hits appear to be insignificant, but in medieval times it was a staggering quantity that required a completely different sales strategy from the hitherto common single book sale transactions. Realizing that selling books in quantities required a greater customer base than a local economy could support, Fust had the foresight and energy to find markets for his bibles beyond the immediate vicinity of Mainz, and traveled far afield to sell this unprecedented quantity of books. At the same time his sales strategy did not saturate the town of Mainz with books, which surely would have cheapened their value.

As is always the case, success inspires imitation and in time, by his example, Fust changed the publishing industry for good. The concept of producing books in quantity lasted until modern times and only very recently, with the advent of digital printing technologies, is the book publishing business on the verge of reverting to the 'sell and produce' business model of the medieval scriptoria. But now, unlike in the past, this business model is not dictated by the limitations of the available means of book production, but by enabling digital technologies that came to the fore in the 1980s, holding the promise of new opportunities for the printing and publishing of books. Consequently, once again, and

just like Fust who had to find new ways to bring his 180 bibles to the market, the book publisher of the future has to seek new sales strategies and channels of distribution for an ancient product manufactured by new methods.

Then again, the best strategy and salesmanship are bound for failure if the product sold is not worthwhile. There is no question that Gutenberg's invention was worthwhile and, to his lasting credit, written communication advanced from a relatively solitary to a mass-communication medium. Nowadays, certain unique digital technology capabilities could see the book's continuing existence as a principal conveyor of information.

Other printing processes

The fundamental reason why Gutenberg's invention was accepted universally in relatively short order lay in the method of type-founding, even though at its inception the process was limited to the reproduction of text. Unlike all other printing processes known at the time of Gutenberg's invention, his was the only method that required no carving, cutting or other manual methods of fashioning a prototype matrix of a letter. Medieval printers quickly found applications other than books for the new printing process, of which indulgences were among the more profitable type of work produced for the ecclesiastical hierarchy of the day; but, due to its early history, movable type was employed almost exclusively for the reproduction of books. The German term for the process invented by Gutenberg is *Buchdruck* (the English term is letterpress), which literally translates as book printing. This close association of printing and the book continues in present times and remains printing's lasting legacy.

The other printing processes which existed before and after Gutenberg's lifetime will not be accorded the same emphasis; they are discussed here briefly in the interest of relative comparisons and comprehensiveness, as none acquired the status of a book printing process.

Silk screenprinting or serigraphy has its origins in the aforementioned paleolithic handprints, and in more modern times it had a long tradition in Japanese stencil prints known as *katazone*. In the Western world it started to find application in industrial imaging and fine arts printmaking in the early 1900s. In screenprinting, image and non-image areas are differentiated as an area that is permeable to ink and an area

that blocks the ink, respectively. The process can be characterized as a *push-through* method of imaging, as the ink is forced through the permeable image areas on to a substrate by a tool such as a squeegee.

The origins of gravure, also known as intaglio derived from the Italian word for carving or incising, have not been determined with certainty, but there are good reasons to believe that Gutenberg himself may have had a hand in its development, as mentioned previously. The principles of gravure are the exact opposite of Gutenberg's relief process: in the gravure process the lower areas of an image carrier are the image areas and the higher areas are the non-image areas. Gravure is well suited for the reproduction of extremely fine image details and has a long tradition as an artistic printmaking medium; among others, the seventeenth-century Dutch painter Rembrandt van Rijn developed it into a high art form with his etchings and copper engravings. As a modern commercial printing process gravure or rotogravure has found applications in publication printing and packaging. It is considered to be the most productive of the conventional printing processes, but because of its high image carrier cost it is usually profitable only for extremely high-volume printing.

Unlike China, where woodblock printing was used for centuries as a precursor to movable type, it is now believed that the same development did not take place in the Western world, where woodblock printing or xylography was introduced about 20 years after Gutenberg's invention. The production of block books lasted only for a brief period of about ten years as a cheaper alternative to printing by movable type for semi-literate readers more interested in pictures than the brief captions they contained, which moreover had to be limited because of the laborious chore of carving letters (Steinberg, 2001: 70). Printing pure pictorial information from blocks of wood, known as woodcuts, lived on, however, and reached its peak when the fifteenth-century Renaissance painter Albrecht Dürer and other visual artists developed woodcut printmaking into an artistic medium of the highest pictorial quality. Woodcuts and engravings were often used in combination with movable type to produce illustrated books, because, it must be remembered, Gutenberg's methods could be used only for the reproduction of text, thus demonstrating medieval printers' awareness and use of mixed-media concepts to accomplish their goals.

In spite of the different principles underlying these and other conventional printing processes introduced at later dates, they all shared two fundamental commonalities: requiring a physical medium or an image carrier to transfer images on to a substrate, and the inalterability

of an image in the course of a print run. From the medieval point of view these attributes were of course not perceived as limitations, and the ability to reproduce text mechanically must have appeared to people of that period just as wondrous as the first variable image-producing laser printer did to a person of the twentieth century. Back at the turn of the fifteenth century, printing was only beginning to be exploited as a new means of producing books, and as such was still much too early in its infancy for medieval man to contemplate or imagine obscure concepts such as the alterability of an image during a print run, or for that matter any fundamental changes to the basic principles of Gutenberg's invention.

The early type designers

During the first 100 years after the invention of printing almost the entire range of technical and business activities to produce and sell books were found under one roof. Specialized services to printers were still not warranted as there were too few printers, and consequently the technical and business expertise for services such as type-founding, contracting authors to write new books or selling books in quantity did not exist. The exceptions were papermaking and bookbinding. These crafts, pre-dating the invention of printing by several hundred years, were at the time of the incunabulum already mature industries with the technical expertise and financial infrastructure to offer services to printers.

Among the first specialized production phases of book manufacturing to develop into a separate industry was that of type design and founding. Type-founding, being an activity more at home in a smithy, was somewhat alien to the typical work performed in a print shop, which was probably the reason for its early entrance as a service industry to printers.

The Frenchman Nicolas Jenson, who probably learned the new type-founding technique in Germany, was the first type designer of international renown. He started to practice his craft as early as 1470 in Venice. There are even suggestions that he may have been sent to Germany by King Charles VII on an industrial espionage mission to bring the secrets of Gutenberg's invention to France. Whatever the case, the mere fact of foreigners learning the techniques of printing so shortly after its invention suggests that this new technology attracted a lot of international attention and a keen interest to duplicate it elsewhere. Jenson's contribution to

typography is his introduction of the roman typeface, and he can rightfully be considered the father of the many permutations of this typeface created by other type designers who followed him.

Claude Garamond, inspired by Jenson's roman typeface, rose to fame as an eminent type designer in 1540. He was the first entrepreneur to operate the business of type-founding on a large scale, and in the process influenced type design and typography internationally, as his matrixes were traded in Italy, France, Germany, Switzerland and the Netherlands. Garamond's lasting typographic influence is poignantly underscored by the current usage of his typeface in a leather-bound hardcover edition of the runaway bestseller *Harry Potter* (Rowling, 2002), which was set in a typeface based on his design (12-point Adobe Garamond, redrawn by Robert Slimbach in 1989).

Other notable type designers of the period between the late fifteenth century and the end of the eighteenth century, who directed type design away from the black-letter design of Gutenberg's time and had a lasting impact on typography that is still felt today, are the Frenchman Robert Granjon, who set out to design Civilité as the French national typeface, but it later became a popular display-text font; Francesco Griffo, who by virtue of being the house designer of the Venetian printer Aldus Manutius gained international exposure and recognition for his type designs; the Englishman William Caslon, who in bringing printing technology to the British Isles also introduced new type designs to his homeland; John Baskerville, who designed typefaces that were compatible with the technical requirements of printing; and finally, to round off this group of famed type designers, there is the great Giambattista Bodoni, who, inspired by Baskerville's type designs, created classical typefaces that still find expression in the corporate identities of the multinational computer technology corporation IBM, the pharmaceutical giant Pfizer and the international hotel chain Hilton, to name but some of the many applications of this typographic monolith.

The interesting parallel to our age of computer-assisted communication are the monopolies enjoyed by the early type designers of the Middle Ages and present-day computer operating systems, in particular MS Windows, which has become a *de facto* worldwide standard. The book of the Middle Ages was no less an internationally distributed interface to access information than the MS Windows GUI (graphic user interface) is today, and therefore it can said that Bill Gates, the co-founder of Microsoft, and Claude Garamond were similarly influential in their respective lifetimes.

The book gets a new 'interface'

The typographic design of a book page and the logical arrangement of the book experienced a metamorphosis of their own. The objective of the earliest printers was to imitate the manuscript, including the intricate embellishments such as flourished initials and rubrics, which necessitated time-consuming and expensive artistic manual labor, because the printing process was not yet capable of reproducing pictorial matter. Certain features of the contemporary book taken for granted today, such as an index, a table of contents, a title page, pagination, a colophon, an impress including an acknowledgement of the printer and even a book's author, were notably absent in the medieval manuscript, and this continued to be the practice in the early incunabulum period.

Peter Schöffer, the heir to Gutenberg's legacy, was the first printer to give some form to book design that developed into permanent book features. He is believed to be the first printer to have made use of a colophon where the printing process is described. He was probably more motivated by a desire to promote the new process than to create a useful book element. As well, Schöffer was the first printer to use a title page, in a papal bull published in 1463 (Steinberg, 2001: 67). He also managed to print rubrics rather than drawing them manually, by inking the main text and the rubrics separately, thus creating a multiple-color print in a single pass. As a result of these extraordinary efforts to imitate medieval manuscripts, which were achieved to the detriment of efficiency, book design over the centuries became increasingly simple, eventually giving way to unembellished single-color text which could be reproduced by mechanical methods alone.

Pagination or sequencing pages numerically was in time also introduced, and replaced a curious system whereby only the first page of every folded section was identified with letters of the alphabet for the benefit of the binder to assemble the folded sections in the correct order, rather than for any reading comfort considerations. Alternatively, a system of so-called catchwords was used to ensure that folded sections were assembled in the correct order. In this system a phrase or word, matching the same last word or phrase on the folded section that preceded it, was repeated on the bottom of a page.

To understand the changes in typographic design of the book one has to understand the prevailing attitude of a given time period. Medieval man was still too much fettered in primitive beliefs, and with a reverence of the Divine that was beset by superstition, to appreciate functional efficiency considerations such as readability of religious texts and easier

access to information by simple concepts such as a table of contents or an index. He attached a much greater value to the spiritual significance of the book, which was best expressed by lavish embellishments of the text. Also, the concept of efficiency was not as ingrained in the medieval mindset as it is in modern times, because the rhythm of the agricultural milieu in which people subsisted was governed more by the cycles of nature than by artificial systems. The spiritual aspects of books diminished as later generations adopted a more rational and enlightened concept of the Divine and the proliferation of secular texts took its course.

There is, however, also an interesting and timeless technical reason as to why design in general and book design in particular changed with the adaptation of new technology. For example, the medieval manuscript that early printers tried to imitate could be written in multiple colors without much more effort than writing the text in single colors, as all that was required from the scribe was to dip his quill into different-colored ink. In early printing methods, however, the reproduction of multiple colors, though possible, was much more laborious than printing in single colors and, because practicality often prevails over aesthetics, the austere, unembellished page became the new standard of book design. Thus successive technologies create new potentials, but they also introduce new limitations. This concept holds true also for type design, and early designers, among them Baskerville, were well aware that their designs had to be compatible with the then prevalent relief letterpress printing process. Likewise today, when text is viewed on computer monitors, the Bodoni typeface with its characteristic alternating thick and thin strokes and hairline serifs may not be the best choice, whereas typefaces such as Times New Roman, Georgia, Verdana, Arial or Trebuchet are much preferred, as they do not suffer undue legibility degradation when viewed on a monitor.

These historical accounts provide some insight into the dynamics of innovation, which in their enduring qualities are as valid today as they were in the past. The most important lesson learned is that a good idea cannot be suppressed, and if the idea is good enough it will travel as fast and as far as technological means permit. In our age, speed and distance have become meaningless, because with the advent of digital electronic communication systems, speed and distance as barriers to information transfer have for all intents and purposes disappeared. The impediments to technological change have always been cultural, social and political biases, as well as the vested interests of the established hierarchies. This still holds true, but the mitigating factor today is the much greater

interconnectivity of the world. We should therefore expect change to be occurring at a much faster rate. And technological change almost never represents a complete break with older technology, as it is inevitably layered on to past aggregate knowledge and developments, modified by prevailing attitudes and the technological possibilities of the day.

The spread of printing and the book

At the beginning of the sixteenth century the printing processes became sufficiently efficient that books could be sold at just 1 per cent of the price of a handwritten copy only 50 years earlier, thus rendering the medieval scriptoria all but obsolete. This no doubt caused hardship for the scribes who lost their livelihoods, but for those who could adapt to the new technology of printing it was a godsend, as it provided them with continued employment or business opportunities. Some, like the Brothers of the Common Life, who had a long tradition of operating scriptoria in the Netherlands and Germany, seized the opportunity by leveraging their literary knowledge and existing ecclesiastical network to make the change to printing. They operated no fewer than 60 different printing plants, producing 25 per cent of Europe's pre-Reformation books (Harris, 1972: 137; Wertz, 1994).

Some printers in the incunabulum period conducted their businesses on a fairly large scale, using numbers of workers and presses that even by contemporary standards would qualify as a big company. The German printer Anton Kohberg, who declined to become Martin Luther's publisher, must not have repeated such blunders often, as otherwise his establishment could not have grown to operate 24 presses. Kohberg established his printing, publishing and bookselling business in the city of Nuremberg in 1470, employing at the height of his tenure as many as 100 staff performing all facets of producing and selling books, and expanding the business to Basel, Strasbourg and Lyons to cope with the enormous demand for books in Germany and abroad.

In the Netherlands, Christophe Plantin established in 1549 a printing and publishing emporium where he produced a wide variety and an impressive number of books on 22 presses. Plantin held a near monopoly on books of a religious nature, and is best known for the polyglot bible in eight volumes for which he received subsidies from King Philip II of Spain, who in 1570 appointed him to be his court printer (Steinberg, 2001: 85). The other great Dutch book publisher is Elzevir, which was founded in Leiden by Louis Elzevir in 1580. Louis, who himself gained

entrance to the book trade in Plantin's establishment, concentrated from the very beginning on publishing rather than on the technical side of book manufacturing. Printers and publishers parting ways would in time become the norm, as it is today, when publishers operating their own printing facility are the exception rather than the rule. An early discounter, Elzevir sold 500-page volumes for the uniform price of one guilder, which was unusual for the 1600s when bargaining was still the common mode of negotiating a price. Several generations of the Elzevirs established themselves as international wholesalers, retailers and second-hand booksellers, until the business declined and ceased to exist in the early 1700s. The name Elzevir survives, however, in one of the largest contemporary publishers of academic scientific and health publications in the world. Founded in 1880, the later Elsevier, with its head offices still in the Netherlands, is a living example of the power of tradition to establish and maintain new industries centuries after the seeds for their existence were sown.

No history of book publishing is complete without a mention of the great Venetian printer of international prestige, Aldus Manutius, who was the largest supplier of Latin and especially Greek classical texts in sixteenth-century Venice and beyond. Aldus also upped the ante in the risky business of printing books in large quantities, by producing the hitherto unheard-of number of 1,000 books per edition, when the norm in the Middle Ages was 500 books per edition at the most. The Aldine Press, as the printing office of Aldus Manutius was known, started in 1494 and continued for two generations until 1597. Its tremendous success in marketing classical texts internationally at prices that even less affluent people could afford, and its innovative typography, including the introduction of italics, found many imitators in the European centers of printing.

In France the Estienne family, in particular Robert Estienne and his son Henry II, distinguished themselves as eminent scholar-printers of the sixteenth century, publishing a wide range of books of such advanced scholarship that some are still not superseded. The Estienne firm introduced the Aldine principles to France and also solicited the services of the great type designer Garamond as punch-cutter and typographical advisor, which is a testimony to its high standards of design and typography. The close relationship Robert Estienne enjoyed with King François I, under whose reign France made tremendous cultural advances, led to what amounts to the first beginnings of the principles of copyright. The king ordered Estienne to provide his royal library with every Greek book he printed, thus establishing a record of intellectual ownership.

England's relative geographic isolation delayed the introduction of printing by about ten years compared to some of the other continental European centers. The delay might well have been longer if not for one William Caxton, an English businessman with 30 years' residency in Bruges. Caxton's interest in printing was motivated more by his desire to publish books of his own French and Latin translations than by technical curiosity. Nevertheless, during the years 1471–1472 he set forth to learn the craft in the nearest center of printing, Cologne, and upon his return to Bruges in 1473 he set up a print shop there, because of the good demand for his books. Caxton's return to England in 1476 marks the year that printing arrived in the British Isles. In that year he established a print shop in the abbey precincts of Westminster. In England, with its great tradition of vernacular literature (unlike continental Europe, where the language of literature was mostly Latin), there certainly was a pent-up demand for books if the 16 translations and 74 English books Caxton published during his lifetime are any indication.

In England the book trade business was carried out by stationers, who had a tradition of producing and selling books going back to the early thirteenth century. Stationers may have been trained in one of the four crafts whose combined efforts produced the book of the pre-printing era – the scrivener who copied the text, the parchminer who prepared the parchment, the lymner who added the illustrations and the bookbinder – but his main function was that of a contractor who, after receiving the order for a book, coordinated its manufacture (Blagden, 1960: 22). This was a classic sell-and-produce business model that worked fine as long as books were produced one-off, but with the arrival of printing came wholesaling, which has been the book trade's mode of sales and distribution ever since. It caused disruptions to the individual crafts in the way they conducted their business, requiring realignments of their business relations and workflows, but it affected the stationer most in that his made-to-measure trade was stood on its head, compelling him to make greater investments to finance the much larger volume of books that the printing process could produce. Today's publisher is again confronted by disruptions caused by new technology, but paradoxically the challenges are the exact opposite of those faced by the stationer of the Middle Ages, because digital technology mandates a publishing business model that reverts back to that of the stationer, producing and selling books one at a time.

It is not by omission that early printers in the Americas are not accorded the same emphasis here, but the relatively underdeveloped physical infrastructure of a fairly recently settled continent and its

colonial status rendered the New England colonies more or less dependent on the mother country for innovative technology. Suffice it to note that printing reached the shores of New England in 1638 with an imported press from England for use by Harvard College, by the efforts of one Joseph Glover, who unfortunately died on the voyage to America. The first book printed on this press, and thus the first book printed in the colonies, was entitled *The Whole Booke of Psalmes*, published two years after the press was imported. The slow progress in the New England colonies is underscored by the fact that 20 years went by before the arrival of a second press, again in Harvard College. America's moment in time for innovation would come much later, in the twentieth century, when important developments in the field of graphic communications were made, not least of which was the development of computer technology in the latter half of the century.

The extent to which the output of books increased after printing became established is seen in the graph in Figure 1.3 showing the yearly output of books in the German language from 1517 to 1525. One obvious reason for the remarkable growth rate of new titles was the new and infinitely more efficient printing process as opposed to copying text manually. The other reason is the flurry of publications emanating from Martin Luther's Reformation movement, which elicited strong opinions that found an expression in numerous books. In the year 1525, for example, of the 498 books published, 183 were publications by Luther himself, 215 by other reformers and 20 by opponents to the Reformation movement, thus leaving only 80 books dealing with secular subjects (Steinberg, 2001: 57).

In continental Europe the increasing circulation of books in the vernacular was a primary force contributing to greater standardization of national languages, reducing linguistic differences of the regions,

Figure 1.3 Number of books published in the German language, 1517–1525

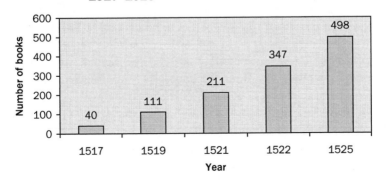

which further helped to solidify national identities. This process was accelerated by the declining use of Latin as the lingua franca of Europe. While the greater availability of books was a unifying intellectual force that allowed the aggregate knowledge of classical antiquity and more enlightened interpretations of the physical world to be shared by the populace of an entire continent, it also tended to cause a deepening of divisions between peoples of different cultural and linguistic backgrounds.

Again, there are striking parallels in the way the mass media and newer communication devices influence languages in our time. Television has tended to homogenize national languages, causing the use of regional dialects to decline, while simultaneously English-language usage is increasing worldwide because of an overwhelming domination by the American entertainment industry, which in and of itself is also an influential communication phenomenon. Short message service (SMS) communication, also called text messaging, on portable communication devices such as mobile phones and other wireless handheld systems is spawning an abbreviated shorthand of written languages popularly called 'text speak', and the general de-emphasis of text in favor of a graphic user interface (GUI) on most electronic communication displays is an outgrowth of both expanded possibilities and inherent limitations of new communication technologies.

The growth of new book titles in the early days of printing and the reasons for this growth are also mirrored in our time, when the number of titles published is increasing dramatically, in part because of the inherent capabilities and coming to the fore of digital printing methods in recent years.

Although it is not possible to recreate the exact mood of an age, the historical accounts surrounding the early days of printing seem to convey a general feeling of excitement and entrepreneurial opportunity brought on by a new and groundbreaking technology, somewhat reminiscent of the heady days of the high-tech boom in California's Silicon Valley in the early 1970s when start-up companies were making forays into the still young computer industry – which also sparked the imagination of an entire generation and in its aftermath changed human communication beyond recognition. In short, technological change and the outcome thereof continue throughout the ages in the same timeless pattern.

The answer to the often-asked question of whether the proliferation of books contributed to improved literacy, or if higher levels of literacy produced by a progressively growing education system caused a greater demand for books, is that both the quantity of books in circulation and

literacy are mutually dependent on each other. The usefulness of books is almost entirely dependent on people's ability to read, and the more effortlessly people read the more likely they are to buy books. Higher circulation of any product – including books, especially if available at low cost – according to economic theory increases the likelihood for people to purchase the product, thus the relationship between book circulation and literacy is one of mutual dependency.

Therefore, literacy is a key element on which the continuing viability of the book depends. Until recently books were, if not the sole, certainly the main instrument of conveying information in schools and other educational settings, resulting in a near-monopoly position for textbook publishers. With the advent of digital electronic communication, however, information can be conveyed in non-text formats such as animated graphics, video clips or virtual-reality video games, which makes the description of reality by means of the abstract text format not only unnecessary but also unattractive for people raised on a diet of television viewing, video-game playing and text messaging. While the effectiveness of non-text teaching aids is debatable and the subject for another book, for those who root for the book as a worthwhile and effective means to convey information, the inextricable link between literacy and the book must be heeded.

During the incunabulum period literacy was an unquestionable virtue, not because of its intrinsic value but because, short of verbal communication, it was the only available option to gain information; today the options are many and the book is only one of them. This will have long-term implications for the type of books that will be marketable in the future, and for the very future of the book itself as a major mass-communication medium.

A new printing process is born

Gutenberg did in the strictest sense of the word not invent a new printing process, but he developed an effective industrial process by which already existing relief or woodblock printing was made more efficient. It speaks for the genius of his invention that for some 350 years after its inception it was practically unchanged and remained by far the most common printing process, especially with respect to text and book printing, where it was used almost exclusively. No new printing process emerged during this time – a state of affairs that only changed with the invention of lithography by Alois Senefelder in 1798.

What makes Alois Senefelder's achievements even more noteworthy is that lithography is the only conventional printing process which can be attributed to an individual. Senefelder developed a completely different concept for the reproduction of images than all other traditional printing processes, in that it did not rely on physical differentiation between image and non-image areas, such as permeability or topographic variations: in lithography, the differences between image and non-image areas are a function of chemical dissimilarities.

If Gutenberg's method had one shortcoming, it was its intrinsic limitation to reproduce text only, which was the reason why printed works with pictorial matter had from the very beginning to be illustrated manually or were complemented by other printing processes that were more suitable to reproduce graphics. There was a strong commercial incentive for printers to produce illustrated books, as they could easily fetch twice the amount than books without illustrations (Steinberg, 2001: 97). But manual illustrations became increasingly hard to justify when the readership included a broader spectrum of the public, many of whom were not prepared to pay the hefty price of intricate and laborious work, thus manual embellishments to text soon became a thing of the past. This left the relief and intaglio processes, woodcuts and copperplate engravings respectively, as the only practical alternatives to reproduce illustrations. Although woodcut carving was elevated to a superior art form by artists such as Albrecht Dürer, the relative roughness of wood did not permit the reproduction of extremely fine details. Copperplate engravings, on the other hand, were not afflicted by the limitations of woodcuts, especially if they were processed by chemical etching methods, which can produce exceedingly minute detail. Thus copperplate engravings became the most highly valued method for quality reproductions of pictorial matters, including those found in books. This use of mixed print media consisting of movable type and another printing process to reproduce text and pictorial matters respectively was the common practice for book printing during Senefelder's lifetime.

Senefelder's intentions were not to improve the well-entrenched text printing method initiated by Gutenberg, but to create a printing process capable of reproducing music scores. The hitherto common way to print these scores was by using the expensive and technically complex copperplate engraving process. In order to substitute the expensive copper metal used in the engraving process, Senefelder experimented with a much more economically available type of stone slabs known as calcareous slate, found along the banks of the River Danube in

Senefelder's home country of Bavaria. Often referred to as Solenhofen stone, named after a village where the stone was processed into thick plates, it is of a chemical composition that renders it dissolvable in nitric, muriatic and other acids (Senefelder, [1818] 2005: 102). Senefelder was thus intent on replicating an existing printing process by using a less expensive image carrier material, which he found in stone, and henceforth the printing process was named etymologically by the compound word lithography, from the Greek words *lithos* (λίθος) and *graphy* (Υραφία) meaning stone and writing respectively.

His circuitous travails to find a workable printing process led Senefelder to use chemical etching methods to print from stone in both relief and intaglio manners. Other than using stone rather than the then common wood, copper or zinc, he did not up to this juncture invent a new printing process, as image and non-image areas were still defined by different topographic heights. It was not until he experimented with transferring original drawings from paper, because of the difficulty of writing backwards directly on stone, that he noticed different affinities for an oil-based ink, not because of topographic height differences but on account of the different chemical compositions of image and non-image areas. In essence, he treated image areas with soap and proceeded to moisten the stone with a gum-water solution, which caused the image area to repel the water and in turn accept the ink, while the wet non-image areas repelled the fatty ink as oil and water are immiscible.

Some essays on Senefelder's invention recount a eureka moment of him discovering the principles of lithography when writing a laundry list at his mother's instruction on a stone for want of a piece of paper. While the incident is based on facts and can be verified in Senefelder's own writing, it was still very early days in the development of lithography and more indicative of an inquisitive and observant mind than being any decisive event (ibid.: 9–10). By his own account, from this time onward he conducted several thousand experiments before gaining more insight into the behaviors of ink applied to stone and developing a workable printing process (ibid.: 31).

Senefelder always considered that printing from stones (see Figure 1.4), or lithography, was merely a branch of a greater category he called chemical printing, and he conceived the idea of stone-like materials such as prepared metal plates and paper to substitute for the unwieldy stones (ibid.: 338–42). In this regard he foresaw the use of metal plates for lithography as they are now in general use, and in the case of paper plates his ideas were almost 200 years ahead of their actual implementation in modern offset-lithographic printing.

Figure 1.4 Lithographic stone

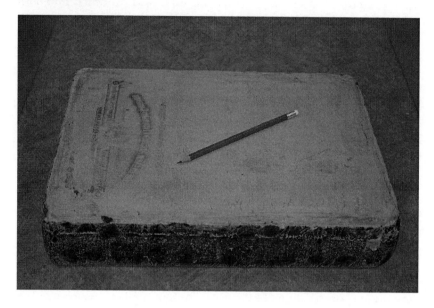

There is a sense that Senefelder considered the print quality of intaglio etchings as the standard to be equaled. His emphasis on the etching procedures of his own process invited comparisons with intaglio printing, even though the underlying principles of his invention were not dependent on topographic profile variations. The height differences between image and non-image areas caused by chemical etching, though minute and not essential for the process to work, were considered by him an important element of lithography, and accordingly he differentiated between the engraved and the elevated manners of lithography, the former of which he considered to be 'nearly equal to the best copper-plate-printing' (ibid.: 276).

Certain so-called waterless computer-to-plate (CTP) systems used today also produce image areas that are slightly below the printing plate's surface. These systems use laser diodes with a wavelength in the thermal range to ablate a three-micron silicon layer, plus a one-micron heat-absorbing layer, to expose an ink-accepting polyester base. The fact that the image is slightly recessed is emphasized by the manufacturers of such systems as enhancing print quality, not unlike Senefelder's assertions more than 200 years earlier.

Although Senefelder set out to develop a less laborious process than copper engraving, which he thought he had found because of the ease

with which the stones could be engraved, the chemical principles underlying the method were quite complex and the intricate procedures were not easily mastered. The reasons for the acceptance of the process were related to the relatively low cost of the stones, which could be reground and imaged again an infinite number of times, as well as an image quality that was practically indistinguishable from an original piece of art and the large number of impressions that could be obtained from a stone. While the image quality of copper engravings deteriorated after several hundred impressions, the lithographic process could produce thousands of impressions without noticeable image degradation.

Lithography as it was originally conceived by Senefelder continued to be used as an artistic medium, especially in nineteenth-century France, by notable artists such as Renoir, Cézanne, Gauguin, Degas, Toulouse-Lautrec, Goya, Matisse and others. In more modern times Oskar Kokoschka, Pablo Picasso and Edvard Munch stand out as prominent artists of the twentieth century who produced art in the tradition of Senefelder.

Lithography as a commercial printing process has undergone several technical refinements, the most fundamental of which was made independently by Ira Rubel and Caspar Hermann in 1904 with their invention of the offset principle (Kippan, 2001: 1030–1). Rubel and Hermann turned the lithographic printing process into an indirect imaging method by transferring the image from a lithographic plate first to a cylinder covered by a rubber blanket before printing the image on paper, which produced a superior image. The exact same reasoning is used in today's late-generation electrophotographic printing devices, better known by their popular name of laser printers, which also incorporate an intermediate blanket cylinder that has proven to produce better print quality on a wider range of papers.

Since Rubel and Hermann introduced the blanket cylinder to the printing press, the process is known by the term offset-lithography or the abbreviated term 'offset'. Although lithography and later offset-lithography were long recognized as superior printing processes, the letterpress method continued to be the most widely used printing process until the middle of the twentieth century, partly because of a resistance to change by an industry that had heavily invested in letterpress technology, but also because of the chemical complexity of the process that did not always produce repeatable print quality. Incremental improvements to plates, chemistry and imaging methods have to date led to a highly standardized and reliable printing process, as well as to hybrid waterless printing plates that require no dampening to keep the

non-image areas ink-free, because certain materials such as silicon were found to have a natural resistance to the oily inks used in the lithographic process. Also, digital computer technologies and advances made in physics, notably the development of laser light-emitting devices, led to systems that image offset-lithographic plates directly from a digital image file, both off and on the press.

An interesting aside is the fact that Hermann also conceived multicolor printing and two-sided printing by the blanket-to-blanket principles; in present-day commercial and publication printing this is still considered to be the most productive printing machine design using the offset-lithographic process. Also, Hermann's tireless soliciting of printing machine factories in the USA and Germany was instrumental in the American company Harris Automatic Press and the German company Vogtländische Maschinenbau, now under the umbrellas of Goss International and MAN Roland Druckmaschinen respectively, becoming dominant international web-offset equipment manufacturers.

The importance of the offset-lithographic printing process, though declining in relation to digital printing processes, cannot be overestimated. Measured by the proportion of its output of printed matters, it had a market share of 43 per cent in 2007, which is projected to decline to about 32 per cent in the years 2012–2015, mainly because of the increased use of digital printing processes (PrintCom Consulting Group, 2007). If these predictions hold true, the offset-lithographic printing process will still remain the most common method of printing worldwide and its commercial impact, as well as the legacy of Senefelder's invention, will be felt well into the twenty-first century.

General industrialization improves all facets of book production

A major shift for all industrial processes occurred during the industrial revolution of the eighteenth and early nineteenth centuries, when it was found that coke extracted from coal, instead of the dwindling supplies of charcoal, could be used to smelt pig-iron (Klemm, 1964: 252). When James Watt's work between the years 1763 and 1775 finally resulted in a practical external-combustion or steam engine, the last major obstacle to greater productivity was overcome, ringing in a new technological era with less dependence on manpower to drive machines, including printing presses.

Printing presses

Wooden presses gave way to sturdier and more robust and precisely functioning cast-iron presses; but other than a toggle lever mechanism instead of a screw system to apply pressure to the print forme (see Figure 1.5), the basic design of the printing press remained unchanged from Gutenberg's time. All operative functions of the press – placing of the sheets, inking the print forme, lowering the platen to make an impression and removing the printed sheets – were still manual operations, much as had been practiced in the intervening 350 years. These presses produced about 240 sheets per hour, which was not significantly faster than the productivity rates during Gutenberg's time.

The relief printing press design advanced from the platen press to the automatic cylinder press invented by Friedrich König in 1811/1812, when the flat pressure element of the platen press used since Gutenberg's time was substituted by a cylinder rotating over a flat type forme. This improved productivity and allowed printing of larger formats. König was also the first press designer to use steam power to drive his presses, which increased output to about 1,100 sheets per hour. Far from being obsolete, the platen press design was also further automated and fitted

Figure 1.5 Iron Washington press, invented by Samuel Rust in 1829

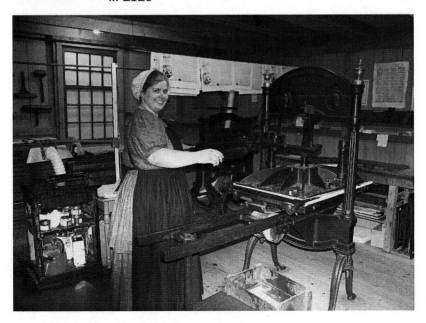

with automatic sheet feeding and delivery, as were most of the cylinder press designs toward the first decade of the twentieth century. Fitting presses with automatic sheet feeding and delivery was the last mechanical function to be automated in printing presses, improving productivity to about 5,000 impressions per hour.

Friedrich König also conceived the idea of a web press, or printing on continuous ribbons of paper rather than individual sheets, for which he received a patent in 1811. Before true web printing could be implemented, however, the flat printing formes had to be manufactured in curved shapes in order to be mounted on printing cylinders. The credit for inventing a wet flexible mold from which the first cylindrical print formes were made in 1856 goes to Jean B. Genoux of Paris, France, who in 1829 invented the process that later came to be known as stereotyping (Kippan, 2001: 1039). This process of making a mold from flat print formes made it possible to print from cylindrical surfaces on to a ribbon of paper. All conventional and digital printing processes now utilize the web press design for high-volume printing, some attaining productivity rates of 3,000 and 1,000 feet per minute respectively.

The name König lives on, like those of so many of the early printing pioneers, in the world's third-largest printing machinery manufacture, König & Bauer, manufacturing sheet-fed and web-fed presses for all major printing processes (Hauser, 1993).

Simultaneous to the developments in letterpress technology, offset-lithographic and gravure technology also experienced improvements in materials and mechanical design, eventually evolving into high-speed web presses with similar productive capacities as letterpress machines. But gravure and particularly offset printing did not come to the fore as general, commercial printing processes until the mid-twentieth century, when offset-lithography superseded letterpress as the dominant printing process while rotogravure became a niche printing process serving the packaging, high-circulation periodicals and catalog markets.

Until the mid-1950s almost all books were printed by the letterpress process and only occasionally would some illustrated books be printed in the offset-lithographic or gravure processes. Since that time letterpress has all but disappeared from the printing scene, continuing only as an offshoot in the form of flexography, which is also a relief printing process. Flexography is a niche process specializing in packaging printing, where it is competing with the rotogravure process for market share.

The slow acceptance of offset-lithography and gravure was in part caused by the lack of a typesetting system that could be used directly for printing, as was the case with sheet-fed letterpress printing. Although movable type

was already archaic in the 1800s, as it had remained practically unchanged since Gutenberg developed it 350 years earlier, it had the advantage of being directly functional for letterpress printing. In the lithographic printing process, illustrations and text were drawn manually directly on to the stone or transferred to the stone from a transfer paper. Either way, both illustrations and text were created manually – which was acceptable for the illustrations, as the drawing of original art is necessarily a manual process, but text could be reproduced by the movable type principle much more efficiently and accurately in the direct letterpress process.

It was not until the transfer of images and text to stone or metal plates was made possible by photographic procedures that the imaging of text was automated in the lithographic process. But even with the introduction of photolithography, offset printing was still not as efficient as letterpress, in that it introduced additional transfer steps which were not required in direct letterpress printing. This gave the letterpress process an earlier start, causing it to grow into the most important printing process and maintain its status as the pre-eminent printing process well into the middle of the twentieth century.

Book printing

The vast majority of books are currently printed by offset-lithography, with digital processes being a distant second in terms of the total number of pages printed. But projected long-term trends indicate steady increases for digital printing. It should be noted, however, that even at the present time, in terms of the number of titles printed, digital processes have a much larger market share than the total number of printed units alone might suggest.

Current trends toward a substantially increased number of released titles, accompanied by drastically lower run lengths per title, tend to favor the growth of digital printing processes. The steady increase in numbers of new books published in Britain during the twentieth century (see Figure 1.6) is in part attributable to the growth of the population (Steinberg, 2001: 243). But the doubling of titles released in the period 1985–1995 can only be accounted for by increased workflow automation, shorter set-up times for conventional presses due to greater automation and the introduction and wider use of digital devices for book printing during this time period, since the population in Britain certainly did not double in a single decade. The enormity of this publishing upsurge becomes more obvious considering that there are 675,000 books in print in Britain and over 150,000 titles per year are released in the USA alone (Rosenthal, 2004: 1).

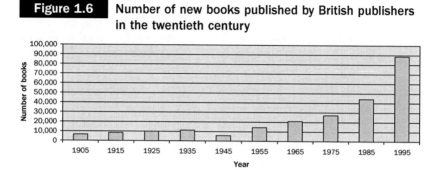

Figure 1.6 Number of new books published by British publishers in the twentieth century

Photography

The invention of photography had a tremendous impact on printing, because it enabled the communication of pictorial content in a more realistic manner than the artistic techniques used since prehistoric times. In due course photography would develop into a distinctly different graphic communication medium from printing, but ironically its creation was prompted by experiments conducted in France by Nicéphore Nièpce and his son Isidore to improve the techniques employed to image lithographic stones. Their focus shifted, however, to creating images on substrates other than stones, and in 1826 they finally succeeded in producing the world's first fuzzy photograph, showing Nièpce's second-floor window, captured by a camera and reproduced by bitumen on pewter (Davis, 1972: 4). Nièpce's experiments attracted the attention of the Parisian painter Louis Jacques Mandé Daguerre, who also worked with light images. He entered into a partnership with Nièpce, which he continued with his son after Nièpce's death. Daguerre developed a photographic process that produced high-resolution images on polished iodized silver plates, processed by mercury vapor, and later expanded the process to be usable for paper. But by virtue of being a positive process, the daguerreotype, as it came to be known, lacked the ability to produce multiple copies from a camera exposure.

At about the same time as Daguerre conducted his experiments, William Henry Fox Talbot in England also claimed to have made similar progress with silver nitrate coatings on paper, but probably exaggerated his achievements. Spurred by Daguerre's success and by input from the German-born astronomer and mathematician William Herschel (who is generally credited with coining the term photography), he succeeded in fixing photographic images by the use of hyposulphite of soda. Fox Talbot's process, patented as calotype, did not achieve the same image quality as

the daguerreotype process, but since the positive image was generated from a negative master image it could be reproduced as many times as required, and conceptually photography changed to what it is today.

Photographic principles soon found application in printing, particularly in lithography, when photographic imaging of lithographic stones and metal plates underwent numerous iterations of change and improvement. Though Alphonse Louis Poitevin of Paris, France, was not the first to image lithographic image carriers photographically, in August 1855 he coined the word photolithography, which became the universally accepted term for the process (Shapiro, 1974: 1:7).

Printing gained from the invention of photography twofold: by the ability to replicate deceptively realistic pictures, thus enhancing printing's reputation as a trustworthy medium capable of illustrating content with manifest authenticity, and by facilitating the means of production through the agency of light alone, instead of the hitherto imprecise, inconsistent and time-consuming material techniques.

Halftone

With the advent of photography it was possible to illustrate the physical world with a degree of realism that fascinated people of the 1800s, but printing processes were still incapable of reproducing the infinitely variable tonal variation of photographs, because of their inherent limitation to reproducing only the two extreme tones of black and white. Ancient printmakers were well aware of this limitation, using techniques such as crosshatching or pointillism to create the illusion of tonal variation in their copperplate engravings or woodcuts. In order to reproduce photographs truthfully by means of a printing process, a similar technique to those used by the printmakers of the past had to be found, or else the lifelike quality of photographs would be lost. Rescue from this dilemma came in the form of a reproduction technique we now call halftone, which in principle is similar to the crosshatching techniques used by artists to create the illusion of tonal variations.

Although there are different claims as to the origins of the halftone process, there is general agreement that it was first fully adopted in letterpress printing. Toward the end of the 1800s and for more than 50 years thereafter it was the undisputed and pre-eminent printing process, and because of its dominant position it received more attention than the other printing processes. Talbot suggested as early as 1852 that tonal variations could be reproduced by means of photographic screens, but in the USA Frederick Eugene Ives is credited with inventing the

halftone process in 1886, while Max Levy of Philadelphia perfected the invention by precision manufacturing the glass cross-line screens and making them commercially available in 1890 (ibid.: 1:7–1:8).

In essence, the invention consisted of two panes of glass which are incised with lines at a uniform distance apart and laminated in such a way that the incised lines on both glass panes are at right angles to each other, thus forming a grid pattern of intersecting lines. When this assembly of incised glass panes is put in the path of reflected light from a photograph to a light-sensitive material, such as photographic film, an image of the photograph consisting of a series of dots is captured, where the size of the dots varies according to the tonal values of the photograph. Light tonal areas produce larger dot sizes than dark areas owing to the varying shadows cast at the intersections of the incised lines. A negative thus produced is then contact printed on to the light-sensitive emulsion of a metal plate and, by chemical etching, the image is transferred in positive relief, producing variably smaller dots in the highlights and larger dots in the shadow areas.

The invention of the halftone process was as ingenious as it was useful to the reproduction of photographs, and would in due course be adapted by all other printing processes. The ability to reproduce photographs became a major factor in the growing popularity of illustrated magazines and newspapers, reinforcing the already strong position of the print media at the turn of the nineteenth century. Multicolored high-resolution pictures continue to be one of the most attractive features of the print medium, especially in coffee-table books, illustrated cookbooks, travelogues, textbooks, how-to books or any other publication where the essence of a subject matter is enhanced by pictorial content. The halftone process remains in principle unchanged in today's conventional and digital printing, which still rely on dot patterns to create tonal variations in photographs and other pictorial matter.

Typesetting

The last great technological frontier to be conquered was the labor-intensive method of generating text, which in the 1800s was still not substantially different in its manual procedures to Gutenberg's movable type. It still required the typesetter to pick up individual pieces of metal type from a type case, and assemble them in a composing stick. There was no lack of readily available type, however, because by the end of the eighteenth century the casting of type had developed into a mature industry producing an abundance of different fonts.

The English engineer William Church received the first patent for a typesetting machine in 1822, while the first workable typesetting machine, called the Pianotype, was designed by James H. Young and Adrian Delcambre and patented in March 1840, also in England (Kippan, 2001: 1043–4). Literally hundreds of attempts to automate typesetting were made, but most were unsuccessful, mainly because the hot and relatively soft type tended to cause obstructions. The justification of lines was another technological problem that was not solved satisfactorily, requiring manual finishing interventions to fill the lines into uniform column lengths, thus rendering the designs not fully automatic.

The most successful typesetting machine design was conceived by a German immigrant to the USA, Ottmar Mergenthaler. He thought of a system in which female matrixes instead of hot molten lead type circulated in the machine. An improved version of the machine, called the Blower model, produced fully justified lines of type, cast in lead, which accumulated on a delivery tray to form columns. Mergenthaler's typesetting machine brought enormous productivity improvements and, only two years after founding the National Typographic Company, his typesetting machine went into operation at the *New York Tribune* on 3 July 1886. A book entitled *The Tribune Book of Open-Air Sports* (Hall, 1887) was entirely machine typeset in the following year, setting the stage for machine typesetting to become the norm in the book and publication business (see Figure 1.7). The final improvements to Mergenthaler's design produced the Linotype-Simplex model, which found several imitators and never changed its basic design until it was made obsolete by computer typesetting technology a full century later.

Mergenthaler's company continued to exist through mergers and acquisitions as a pre-eminent international typographic firm, and today, under the name Linotype GmbH, it has one of the world's largest digital font libraries.

Letterpress printing became even more competitive, especially in the text-intensive book sector, because the bottleneck of slow manual typesetting methods had finally been overcome, and direct printing from first-generation Linotype remained the most efficient workflow in printing for the next 50 years. Offset-lithography benefited to a lesser extent, as machine typesetting still did not eliminate the requirement for a two-phase conversion from hot-type proofs to printing plate, which resulted not only in a more complex workflow but also in third-generation text reproduction and the potential for font facsimile problems.

Figure 1.7 The first machine-typeset book, *The Tribune Book of Open-Air Sports*, published in 1887

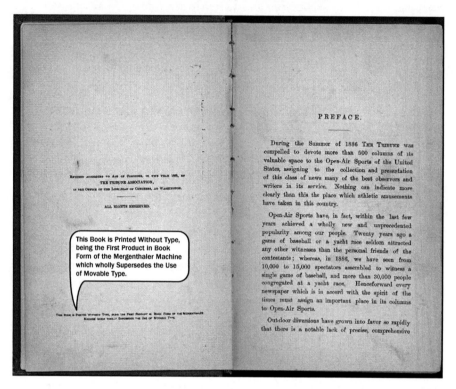

The idea of using the principles of photography to generate text goes back to 1898, when W. Friese-Green, better known for his work in cinematography, applied photographic techniques to reproduce text; but this did not have a lasting impact. Several other attempts in Germany and France in the 1930s, 1940s and 1950s to generate text photographically were equally fruitless in gaining wide acceptance.

When established hot-type typesetting machine manufacturers, such as Intertype, Monotype and Linotype, showed interest in phototypesetting around the mid-1960s, the momentum for research and development accelerated. The first generation of phototypesetting machines were in essence converted hot typesetting machines, using photo-matrixes instead of physical mold matrixes. These machines were soon replaced by designs dedicated to photographic text imaging. A third generation of phototypesetting machines included photographic storage when pre-press manufacturers Crosfield, Compugraphic, Hell and others started to participate in the typesetting field. Computer technology and

the associated electronic storage capability of computers made the application of light beam/CRTs (cathode ray tubes) for phototypesetting possible in the mid-1960s (Kippan, 2001: 1045–6).

The 1970s and early 1980s saw the last fundamental improvements to imaging technology, which made it possible to image both text and pictures simultaneously via a RIP (raster image processor) and utilizing lasers as a light source to image film or printing plates by way of CTP (computer-to-plate) systems. A common workflow in today's advanced printing operations allows software-imposed book signatures to be imaged directly on to printing plates, thus eliminating the intermediate transfer phase from film to plate, which effectively produces a first-generation reproduction not unlike the first lithographic stone reproductions of old. Computer-to-press systems afford still more automation by imaging plates within the printing press, eliminating printing plate mounting by the operator during the make-ready phase, and virtually assuring perfect fitting or registration of multicolor images.

Text and image preparation have now been transformed from physical operations into pure software functions, executed by word processing and image manipulation software respectively, whereby both text and images are ordered and integrated in page imposition and layout programs in order to be processed in a RIP as a unit, prior to the imaging of printing plates, off or on the press, in a near seamless electronic sequence. The tremendous reduction of process steps in text and image preparation, as well as in the pre-press phases, has resulted in considerable productivity gains, keeping conventional printing processes very much in the running for a wide variety of print jobs and run-length scenarios.

Paper

The most defining characteristic of the print medium is its utter dependency on paper to disseminate information, and therefore its continued existence is intricately linked to the economic availability of this ubiquitous material. More efficient printing machinery increased demand for paper, which was met by improved technology that changed papermaking from a manual sheet process to a mechanized roll-paper process.

The papermaking machine was invented in 1798 by Nicolas Louise Robert in France, but it is more closely associated with the brothers Henry and Sealy Fourdrinier of London, England, who financed the construction of the first efficient papermaking machines based on

Robert's design in 1803, and to this day certain types of papermaking machines are still called Fourdrinier. This mechanization meant that by 1843 the price of paper had decreased by almost half (Steinberg, 2001: 138). However, the combination of an increased demand for paper coupled with the use of technology to meet this demand threatened a serious shortage of raw materials for papermaking. In the early 1800s paper was still made from recycled linen and cotton rags, the supply of which came nowhere near what the increasingly popular paper-based communication media needed for their continuous growth, thus bringing the printing industry precariously close to a drastic decline.

The raw material shortage for papermaking was averted by the invention of the first practical method to produce paper from wood fibers, by Friedrich Gottlob Keller of Germany in 1843. But unfortunately the production of paper from wood pulp introduced a new problem, which was not realized until much later in the twentieth century, when paper made from wood fibers showed tendencies to deteriorate, while paper from prior to the invention of wood pulping remained as pristine as when it was first made hundreds of years earlier.

The problem of paper deterioration is related to the unstable lignin in mechanical pulp and the natural acidity of wood fibers. While chemical pulping processes remove the lignin from the pulp, it still contains the naturally acidic wood fibers and acidic chemicals, such as seize, which are added to the pulp to improve the printability of paper. In the USA it is estimated that of the approximately 305 million volumes in the nation's academic libraries, 25 per cent are at risk of being lost due to physical deterioration (Hayes, 1987), thus compromising the cultural heritage and accumulated knowledge of several generations.

Today, paper can be produced acid free by treating the pulp with a mild base to neutralize the acidic constituents and switching from china clay to chalk for the main filler component, thus similar archival quality to books printed during the pre-wood-pulping period can be expected. Also, paper waste has become an important raw material for papermaking, thus reasonably assuring the continued economic availability of paper and long-term ecological sustainability of the wood and pulp industries.

Bookbinding

Perhaps fittingly, bookbinding is discussed here last, because in the chain of events the binding is the final manufacturing phase before a book goes

on its journey to someone's bookshelf. Bookbinding has never attracted the same attention as printing, probably in part because it is not associated with a heroic figure such as Gutenberg, yet without binding, books would be little more than a jumble of unattractive loose sheets. It is in the binding phases that a book is given its prominent face and the very essence of its architecture is realized.

The basic architecture and method of construction of the book were established with the Roman codex: folded sections of paper were sewn to each other as a functional requirement, followed by covering or casing of the book with some type of sturdy material such as wooden boards, discarded and glued-together sheets and more recently thick cardboard as a protective component. The sewing of book sections changed only with regard to sewing patterns over the next 2,000 years and remained a manual process (see Figure 1.8) until the late nineteenth century, when the American David Smyth invented the thread-sewing machine in 1865 (Lyman, 1993: 27). Despite its ancient standing, thread sewing is still considered to be the most durable and user-friendly form of bookbinding, albeit more expensive than the adhesive binding methods that became popular in the 1930s.

Since the protective casing material is inherently unsightly it has to be covered with visually attractive materials such as cloth or leather, the decoration of which gave bookbinding its reputation as an art form. It must be remembered that books of the pre-printing era were a substantial

Figure 1.8 Manual book sewing on a loom

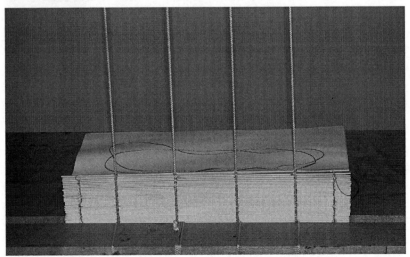

investment that only the very wealthy could afford, and as a rare commodity books had to be given an appearance commensurate with their value. Therefore, a wide range of techniques including embossing, gold-leaf embossing, painting, burnishing, embroidering and jewel decoration were used to embellish the covers of books.

Although contemporary books are rarely decorated as extravagantly as the medieval book, modern finishing technology can recreate some of the ancient techniques at considerable production rates. In modern book publishing the visual appearance of book covers is still a major concern, but the motivation for cover design has shifted from exclusivity to marketability, because the timeless truth is that the cover of a book is still the first thing that meets the eyes of a potential reader.

From the very beginning of the book trade, technological innovation was accompanied by a corresponding reduction in the price of books, in the process begetting greater readerships with each successive technological improvement, such as the change from the manuscript to mechanical printing, greater production speeds afforded by steam power or the change from hand typesetting to machine typesetting. The last technological innovation which had a substantial effect on lowering the price of books was the introduction of adhesive binding. Although thread sewing was already a fairly automated process by the early 1900s, it was, and to a large extent still is, a binding method that requires relatively expensive materials and a time-consuming manufacturing process, because not all of its production phases can be integrated in a continuous workflow.

An alternative method is the adhesive binding process, which was invented in the late 1880s but only gained popularity in the early 1930s. In adhesive binding, the bond of the pages to each other is not by a thread, as had been the practice since the very first codices of the ancient Roman era, but by an adhesive. Using glue as the agent for adhering pages to each other permits extremely efficient manufacturing methods that incorporate the assembly of folded signatures, preparation of the spine, gluing of the spine, attachment of the cover to the book block and three-knife trimming in one continuous operation. Furthermore, the cover is typically made from a homogeneous material such as paper, which simplifies the cover-making process and reduces the material costs for covers.

In the USA, Sheridan Bookbinding developed an adhesive binding method in 1911, which it named 'perfect binding', a term that became synonymous with all adhesive binding methods; but far from being perfect, it was merely a popular, low-cost binding method prone to falling apart with heavy and continuous use (Rebsamen, 1983). The early use of adhesive binding in the 1930s was limited to cheap

paperbacks, or pocket books as they would come to be known, resulting in phenomenal sales, because reprints of popular novels and the previous year's bestsellers (Epstein, 2001: 106) could be purchased for a fraction of the price of hardcover books. In the USA the publisher Pocket Books, as an early pioneer of this new format, became successful by leveraging its existing network of non-traditional bookselling venues of some 4,000 cigar stores, news-stands and drugstores with a long-standing record of selling periodicals. The economies of scale allowed paperbacks to be sold like periodicals by accepting returns at the end of a month (Schiffrin, 2000: 27), once again demonstrating that technological innovation and new product development go hand in hand with a requirement for novel business concepts and channels of distribution.

The term 'pocket book' is now a bit of a misnomer, in that adhesive-bound books are presently produced in as many formats and sizes as their hardcover counterpart, which was made possible by improvements to hot-melt adhesives, notably by DuPont in the 1940s. Further adhesive technology developments in subsequent years led to polyurethane-reactive (PUR) hot-melt glues, which are 30–50 per cent stronger than the traditionally used ethyl vinyl acetate (EVA) glues while maintaining excellent page flexibility, as well as new adhesive binding processes such as Otabind or RepKover binding systems (Tedesco, 1999: 65–6), which improve a book's ability to stay flat when opened, thus to a degree overcoming the inherent shortcomings of adhesive-bound books.

Today, paperbacks are the mainstay of publishers, as a walk through the aisles of a super-chain bookstore demonstrates. A preponderance of paperbacks dwarfs thread-sewn hardcover books, which are increasingly published only in certain value-added genres, such as coffee-table or art reproduction books.

The development of digital printing

The underlying principles for most digital printing processes are based on pure scientific discoveries made several centuries before their efficacy for printing materialized in the latter part of the twentieth century. For example, magnetography was a known concept over a hundred years ago, but like the other processes it has found application in digital printing only in the last 20 years (Nothmann, 1989: 67).

The first digital printing process, which had an indelible effect on the field of printing, is known generically as electrophotography. The popular term

'laser printing' has stuck ever since electrophotography was transformed into its present form by laser technology in the 1980s, although technically it is incorrect to refer to digital printers categorically as laser printers, since imaging on these devices could occur by laser light as well as by light-emitting diodes (LEDs).

The scientific and technical concepts with the most direct link to the electrophotographic process, as it is known today, are based on an invention made by the American physicist and patent attorney Chester Carlson, who came upon the idea for an improved document duplicating process because his job at a patent office required frequent copying of legal documents. The common methods to duplicate documents in 1930s' offices were to type them in duplicates using carbon paper, retype existing documents or use slow and expensive photostat machines, which was essentially early 1900s' photography-based technology.

In his quest to develop a copying process that was not hampered by the vagaries of photography, Carlson sought solutions in the scientific literature of his public library, and by sheer force of will found them in some of the pure scientific discoveries of a much earlier age. The key to Carlson's invention was the scientific phenomenon of electrostatic charges and the behavior of certain photoelectric materials. The German scientist Georg Christoph Lichtenberg was able to make electrostatic charges visible as early as 1777, using fine powders, thus demonstrating to Carlson the potential application of electricity as an imaging agent. Certain photoelectric materials were shown to conduct electricity selectively depending on the presence or absence of light by the German physicist Heinrich Hertz in 1887. Carlson saw this as a method to control the distinction between image and non-image areas. In addition to useful pure scientific research, Carlson found inspiration in the work of the Hungarian physicist Paul Selenyi, who also conducted experiments with electrostatic images.

An interesting aside with regard to photoelectric materials is that Albert Einstein received a Nobel prize in 1921 for explaining the phenomenon of photoelectricity, which became one of the cornerstones for a branch of physics called quantum mechanics; even more baffling is the coincidence that both Carlson and Einstein made their discoveries while working in patent offices.

After years of tireless work and against all odds, Carlson brought his research to a stage of completion that permitted the copying of images by way of scientific principles that were radically different from all previously used printing processes. Carlson filed a patent application for

a new duplicating process he called electrophotography on 4 April 1939, and in 1942 he was granted patent number 2,297,691 (Broudy and Romano, 1999: 64).

The commercial potential of Carlson's invention was initially not realized by the two dozen companies, including IBM, Eastman Kodak, GE and RCA, which he solicited for support. In the autumn of 1944 researchers at Battle Memorial Institute, a not-for-profit private applied science and technology company in Columbus, Ohio, continued to refine Carlson's invention, in part funded by Haloid, a relatively small photo-paper maker seeking to diversify by investing in new technology. This in turn attracted interest from the US Army Signal Corps in mid-1948, which began to sponsor the project. When Haloid was granted a license to develop electrophotograpy further, it not only renamed the process xerography, derived from the Greek words for 'dry writing', but also created the kernel for a new corporate name. In so doing, the future giant multinational Xerox was launched.

The first commercially available copier was released by Xerox in 1950. Like all early copiers, the first Xerox copier was based on analog light lens technology, which means that imaging occurred by light reflection from an original copy via an optical lens system. Xerox's monopoly on copier technology lasted only until 1954, when Radio Corporation of America (RCA) announced its entry into the copier market with the release of the Electrofax electrophotographic copier. This was followed by other US companies, such as 3M in 1958 and IBM in 1970. Japanese companies started to enter the fray for copier technology acceptance after 1972 (ibid.: 65–6).

Up to about the year 1978 the common term for electrophotographic imaging technology was 'office copier'. The implied message conveyed by the term was the overwhelming application of copiers in offices, as opposed to commercial printing companies. Notwithstanding electrophotography's dominance in office environments, a new category of printing firms, that came to be known as 'quick' or 'instant' printers, started to establish themselves by offering relatively low image quality, short-run copying services on electrophotographic copying equipment.

The first company to use laser light to charge the photoconductor of an electrophotographic printing device was the Xerox Corporation with its 300 dots per inch (dpi), 90 pages per minute 9700 laser printer. The introduction of the 9700 printer in 1979 also marks the arrival of true digital printing, for now the image signal was not transferred by direct optical projection from a hard-copy original, but by digital image data

used to modulate laser light impulses in order to charge the photoconductor.

The 9700 laser printer was priced at about $400,000; five years later, in 1983, Canon introduced the 300 dpi LBP-CX laser printer with a productivity rate of eight pages per minute and a price tag of less than $5,000. The drastically lower price of the LBP-CX signaled the acceptance of digital printers as an output device for personal computers, which initiated adaptations of Canon's printing engine by Hewlett Packard and Apple Computers. The first PostScript controller in the Apple LaserWriter, introduced in late 1985, improved print quality to levels never seen before, and is generally seen as a major factor for the burgeoning desktop publishing field to come into its own.

PostScript has become the *de facto* standard for digital printers, which are now competitive in many product categories traditionally served by offset-lithography. Since image resolution for most digital printers increased from 300 to 600 dpi, digital press image quality is nearly equal to that of offset-lithography and practically indistinguishable for text and line art. Consequently, a great many short-run printing projects, in particular books printed in single-color text and line art, are ideally suited for output on digital presses. But although digital press output has doubled since 1979 when the Xerox 9700 laser printer was introduced, the 180 pages per minute of the latest Xerox DocuTech printers still does not come close to the printing speeds of conventional rotogravure or web-offset printing presses.

While electrophotography is the most widespread digital printing process, especially with regard to books, there are a number of other digital processes that are currently used for book printing.

- *Inkjet printing* is nearly as common as electrophotography, and is currently the fastest digital printing process. It has the advantage of the shortest possible path for a colorant to reach the substrate and requires a minimum of moving parts.

- *Magnetography* principles have been used in digital printing, and devices based on these principles have been on the market since 1985.

- *Ionography* utilizes a stream of ions (i.e. charged gas molecules), modulated by a digital input signal to charge an intermediate image carrier.

- *Elcography* is an electrocoagulation process which requires uniquely formulated inks with a nanosecond range reaction time, potentially resulting in very high printing speeds.

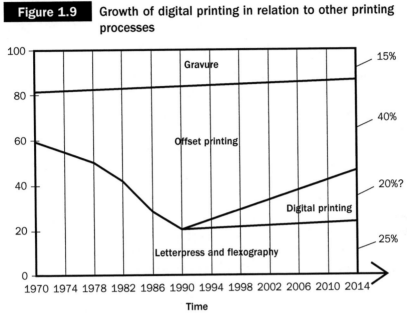

Figure 1.9 Growth of digital printing in relation to other printing processes

Source: redrawn from Kippan (2001: 979)

The electrography and thermal-transfer printing processes are mentioned here only in passing, as they are unsuitable for book printing. These digital printing processes require special substrates and, owing to their slow processing speeds, they find application in limited-run products, such as digital proofs, signage, transparencies, geodesic and related mapping applications, and other such computer-assisted drawing output.

Digital printing devices began to make inroads into commercial printing applications, including book printing, in the early 1990s, and since then their growth has continued unabated. Growth rate predictions for the next ten years surpass those of all other conventional printing processes (see Figure 1.9).

Predictions for the future and the acceptance of new technology

In the course of history many scientific and technological inventions have failed because they were based on concepts contrary to scientific laws and were therefore doomed from the very outset. Perpetual-motion machines violated the laws of thermodynamics, flying machines with

floppy wings were not in accordance with the laws of aerodynamics and medieval alchemists were inconsonant with the law of the conservation of mass when they attempted to transmute lead into gold by chemical reactions. Unsuccessful as these and other endeavors were in achieving their immediate goals, their constructs nevertheless led to improvements in subsequent inventions in later periods.

Likewise, currently less popular digital printing technologies cannot be dismissed any more than past intrepid but ultimately futile attempts to unlock the secrets of science. Digital print technology is too early in its infancy to draw definitive conclusions as to which existing, new or hybrid technology will prevail. What can be predicted with some confidence, however, is the continuing trend away from physical to digital electronic processes, because of their greater flexibility to accommodate changing manufacturing demands, their minimal physical space requirements, their ability to be activated via electronic networks and the ease with which digital electronic equipment can be operated by way of programmed instructions. The growing trend toward digital electronic processes can be observed in all industrial sectors, particularly in the automotive industry, where digital electronic manufacturing concepts such as robotics were introduced long before equivalent methods were implemented in the printing industry. The current state of digital printing presses shows particular promise where manufacturing flexibility and remote network activation are required, but their relatively slow processing speeds render them less suitable for high-volume production.

Because the prediction of technological trends is fraught with uncertainties and has often proved to be inaccurate, the leading American information technology research and advisory company Gartner devised in 1995 a tool to analyze the maturity and adaptation of new technologies systematically, according to five developmental phases that new technologies must invariably experience before they become accepted by users at large. The method can be visualized by a graph with the five phases sequentially ordered on an x time axis and the perception of the technology by the various stakeholders on a y axis. Owing to emerging technologies' predictable behavior, the curve will have a typical shape, while a plot on the curve will signify an emerging technology's stage of maturity.

The name given to the method and the graph is the Gartner Hype Cycle of emerging technologies, and the definition of its five phases as they occur sequentially when new technology is first introduced to the marketplace is as follows (Gartner, 2006, 2007).

- *Technology trigger.* The first phase of a hype cycle is the 'technology trigger' or breakthrough, product launch or other event that generates significant press coverage and interest.

- *Peak of inflated expectations.* In the next phase, a frenzy of publicity typically generates overenthusiasm and unrealistic expectations. There may be some successful applications of a technology, but there are typically more failures.

- *Trough of disillusionment.* Technologies enter the 'trough of disillusionment' because they fail to meet expectations and quickly become unfashionable. Consequently, the media usually abandon the topic and the technology.

- *Slope of enlightenment.* Although the press may have stopped covering the technology, some businesses continue through the 'slope of enlightenment' and experiment to understand the benefits and practical applications of the technology.

- *Plateau of productivity.* A technology reaches the 'plateau of productivity' as its benefits become widely demonstrated and accepted. The technology becomes increasingly stable and evolves in second and third generations. The final height of the plateau varies according to whether the technology is broadly applicable or benefits only a niche market.

Recent research specifically conducted by Gartner on the current status of digital printing processes and print-on-demand, the latter of which is essentially made possible by certain enabling technical features of digital printing processes, positions both digital printing processes and print-on-demand firmly on the slope of enlightenment (see Figure 1.10), thus inferring that digital printing processes have found practical applications and their benefits are at the present time understood by some users (ibid.).

Figure 1.10 essentially reaffirms what has been stated on these pages, and reiterates the opinions of experts stated elsewhere. But so far as the fifth and final phase in the Gartner Hype Cycle is concerned, it cannot be predicted with certainty if digital printing processes will become broadly applicable or if they are destined to benefit niche markets only. At the present time digital printing cannot be categorized as a general-purpose printing process, for its applications are limited to certain niche markets. Digital printing processes are currently too slow to become general-purpose processes, but their processing speeds will likely increase as the technology evolves. Until such time that the printing speeds of digital processes approach those of conventional printing, both printing processes will coexist for the foreseeable future.

Figure 1.10 Gartner Hype Cycle of emerging technologies

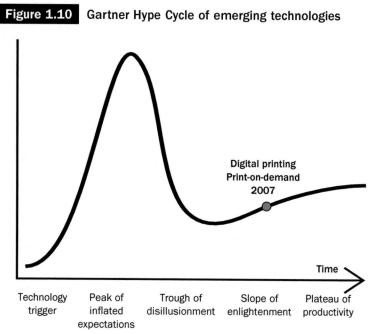

Source: redrawn from original at www.gartner.com

With regard to the usefulness of digital processes in book printing, however, there are strong indications that digital may become the technology of choice. Digital printing processes are much more flexible than conventional printing in accommodating the increasing segmentation of the book market. Furthermore, new business models to produce, market, distribute and sell books are predicated on the technical features of digital printing.

Why conventional and digital printing processes will coexist for some time to come

Conventional printing processes

Images can be reproduced on to a wide variety of substrates, such as paper, paperboard, plastic, metal, textiles, leather, glass and more. As well, substrates may be smooth or rough, wieldy or unwieldy, angular or curved, round or flat – all of which are factors that call for different printing processes. The older conventional printing processes, as opposed to the more recently developed digital processes, account for over 80 per cent of market share (see Figure 1.9) and are consequently still very much in the running for a majority of product categories, including the printing of books. Each individual printing process must be evaluated for its strengths and weaknesses in terms of image quality and economics before deciding to employ it for a given printing project.

The defining characteristic of conventional printing processes is their dependence on a fixed physical image carrier, from which a facsimile of the image is reproduced; the differences between individual conventional printing processes are a function of the image carrier's physical structure.

Prior to the instant when a physical image carrier is created, the technical procedures for all conventional printing processes are fundamentally similar, as they involve the digitization of image information. The technical procedures for digital printing are also fundamentally similar to conventional processes up to the workflow phase, when digital information is used to control the print engine of

a digital printing device. This means that image information existing in a digital format can be repurposed for any conventional or digital printing process.

Although the term 'digital printing' is now universally accepted, it is a somewhat unfortunate term: both conventional and digital printing processes involve digital manipulation in the pre-press production phases, and thus using the term 'digital' to differentiate the two printing categories is rather deceptive.

The printing processes belonging to the conventional category are screenprinting, gravure and rotogravure, letterpress, flexography and offset-lithography. Screenprinting is not used for book printing except for some cover reproductions; letterpress is a nearly obsolete printing process for any product category; gravure is used rarely for book printing, and then only for extremely high-volume book editions; a small amount of relatively low image quality books are printed in flexography (phone books and some newspapers among them); while offset-lithography is currently the dominant printing process for most product categories, including books.

Other than the good image quality produced in offset-lithography, the fundamental reasons for its dominant position are the relatively low image carrier material and processing costs. With respect to image quality and productivity, rotogravure equals offset-lithography's image quality and surpasses all conventional printing processes in terms of image carrier durability and printing speed. Flexography has not yet reached the image quality of either rotogravure or offset-lithography, especially with regard to halftone reproduction.

An offset-lithographic image carrier, called a printing plate, consists most commonly of a thin sheet (0.004–0.012 inches) of surface-treated aluminum, ranging in area from a single letter size to 16 letter-sized pages. Offset-lithographic plates can be mass manufactured very cost-effectively in roll form, and subsequently the rolls are cut down to the desired press size. In comparison, the photopolymer image carrier material used in flexography is three to four times as expensive as offset plates; while rotogravure cylinders, consisting of a steel core with electroplated layers of nickel, copper and chromium, far exceed the cost of the thin aluminum sheet material used for offset plates. Image carrier processing, handling and storage are also more labor-intensive for flexography and rotogravure than for offset-lithography, which in book printing is further compounded by the multiple image carriers that a typical book requires.

Image carrier cost analysis

For an image carrier cost analysis that compares the web-offset and rotogravure processes when a 320-page single-color book is printed, the price schedule of a North American publication printer is used:

Web-offset plate (16 pages)

Trim size 8 × 10 inches

Cost of plate = $1,336.06

Rotogravure cylinder (16 pages)

Trim size 8 × 10 inches

Cost of cylinder plus one proofing = $9,891.55

The rotogravure cylinder is thus about 7.4 times more expensive than the offset plate. To make a cost comparison for a 320-page book the following calculation is made.

Web-offset plates

320 ÷ 16 = 20 plates are required

20 × $1,336.06 per plate = $26,721.20 for 20 offset plates

Rotogravure cylinders

320 ÷ 16 = 20 rotogravure cylinders are required

20 × $9,891.55 = $209,891.55 for 20 rotogravure cylinders

The image carrier price difference is $209,891.55 – $26,721.20 = $183,170.35

Thus printing the book on a rotogravure press results in an additional outlay of $183,170.35, which reduces potential profits accordingly if this amount is not added to the price of a unit (book). But if this amount is added to the price of a unit it will be priced less competitively than the same unit printed on a web-offset press. The only way for the rotogravure process to equal web-offset economically is to increase the run length, as this will result in the higher image carrier cost of the rotogravure process being absorbed by a greater number of units.

Consider the following 100,000 and 1,000,000 web-offset and rotogravure run-length scenarios respectively.

Web-offset: 100,000 run length

26,721.20 ÷ 100,000 = $0.27 image carrier cost per unit

Rotogravure: 1,000,000 run length

209,891.55 ÷ 1,000,000 = $0.21 image carrier cost per unit

The cost of image carriers as a proportion of the price per unit is thus about equal for both web-offset and gravure if the run length for web-offset is 100,000 and that for rotogravure is 1,000,000. But since book editions of 1,000,000 are relatively rare, the rotogravure process is not often used for book printing. As can be seen from this cost analysis, image carrier costs and run length are important factors when deciding in favor of one or the other printing process. Furthermore, these cost and run-length factors should be borne in mind when digital printing processes are a possible option, because they require no image carrier at all.

Offset-lithographic presses

Given the dominant standing of the offset-lithographic process and the fact that currently the great majority of books are reproduced by this printing method, it merits closer examination.

The two broad offset-lithographic press categories are sheet-fed and web presses. Sheet-fed presses print paper (and other types of materials) in sheet form in a great variety of sizes, while web presses print on paper that is dispensed from a roll which is cut into sheets with a constant dimension in the machine or a process subsequent to printing. Both sheet-fed and web presses are available with as many printing units as given production circumstances may require. Two-sided printing (also called perfecting) is an option with sheet-fed presses, while most web presses are inherently designed for two-sided printing.

Sheet-fed offset presses

The reason why a majority of commercial printers prefer sheet-fed offset presses is the great flexibility they afford with regard to substrate sizes, thicknesses and types that can be processed on these machines. Just about

any flat and pliable material, such as coated, uncoated and synthetic papers, metallic and lenticular foils, laminates, pressure-sensitive paper and paperboard, can be imaged on a sheet-fed offset press, while the thickness of substrates can range from thin onionskin paper to thick 0.04 inch board.

A typical mid-sized sheet-fed offset press can accommodate sheet formats ranging from a maximum of 19×25 inches down to a minimum of 5.5×8.5 inches, and every conceivable size in between. In practical terms this means that a printer can accept a wide variety of different work, such as letterheads, business cards, brochures, annual reports, books, book covers, postcards, labels etc., thus maximizing the capability of a single piece of equipment. Furthermore, sheet-fed presses can be purchased with a single printing unit or as many as 12 units, and at a price to match the additional capacity of a multi-printing-unit press.

Some sheet-fed presses print only on one side, which is commonly referred to as straight printing, and others provide the option of printing on one or both sides of a sheet, which is called convertible perfecting. Sheet-fed presses can also be specifically designed to print on both sides of the sheet (perfecting).

The press configuration that is appropriate for a given printer depends on the type of work that is typically received. If, for example, the majority of work orders received by a printer are single-color one-sided flyers, then a press with four printing units is an unnecessary investment, as the high price paid for the four-color capacity of the press is not fully utilized. Likewise, a printer who consistently receives work orders for four-color postcards with single-color printing on the reverse side would not be competitive with a single-color press, as this would entail five print runs to complete the postcards, whereas a five-color press (see Figure 2.1) with a sheet-reversing (perfecting) device between the first and second printing units completes the postcards in a single pass.

Figure 2.1 Five-color offset-lithographic press

Source: redrawn and adapted from a Heidelberg Druckmaschinen AG product poster

A book printer might consider the press shown in Figure 2.1 if the majority of books he produces are paperbacks with four-color covers and a single-color imprint on the reverse side. However, the same press would be underutilized for the text pages of books, as they require only two printing units. If the printer's book printing volume is relatively low and is supplemented with other commercial four-color work this might be a satisfactory choice, but if the printer produces exclusively book work he should consider the purchase of an additional perfecting press which is specifically designed to print single-color two-sided work.

In addition to printing text and images in multiple colors, modern sheet-fed offset presses can also be equipped with functionalities that enhance the quality of a printed image or otherwise add more value to a printed product, which for book printing is especially relevant to the printing of covers.

A common printing press configuration consists of four printing units, because the reproduction of colored originals such as photographs requires the so-called *four-color process* in which the colors cyan, magenta, yellow and black are printed in succession in order to reproduce the infinite colors of an original. Beyond these standard process colors, however, there are some colors, in particular metallic colors, which cannot be reproduced adequately by the four-color process. Hence, additional printing units may be required if the job is to be completed in a single pass. There are now sheet-fed presses with as many as 12 printing units, which enable four-color-process reproduction as well as two special colors on both sides of the sheet in a single pass.

Coating a printed image with print varnishes, water-based varnishes or UV (ultraviolet) varnishes enhances the saturation of colors and protects the printed surface. Coating can be applied via a printing unit or a special coating unit. When coating is applied by a printing unit, an unpigmented offset ink called print varnish is applied via the inking system and an offset plate in a similar way as an image is printed. Although print varnishes do increase the gloss of printed images, they tend to yellow and their gloss is diminished somewhat, because the varnish mixes with the still-wet inks. Superior gloss and better protection of the printed surface are achieved when water-based or UV varnishes are applied by a special coating unit. For the utmost gloss two coating units can be used, where the first unit applies a primer and the second applies the actual varnish on to the previous dried primer coat. Alternative, UV varnishes can be applied by special coating units followed by subsequent UV radiation curing, which produces exceedingly high gloss values and surface protection. These and other

varnishing technologies enhance the visual attractiveness and physical durability of book covers without requiring additional offline procedures, as the application of varnish is achieved efficiently inline with printing in a single pass through the printing press.

Embossing, foil stamping, hot-foil stamping, die-cutting or a combination of these were in the past produced in separate processes after the image was printed, thus increasing the costs of the printed piece considerably. These techniques are among the more luxurious imaging technologies, in that they add a third dimension to a printed piece and create metallic and luminous color effects that are not possible with printing inks. Because it is now possible to produce these special visual effects on a sheet-fed offset press inline and simultaneously with the printing phase, the manufacturing costs of richly decorated covers are sufficiently reduced to permit their use for mass-market paperbacks.

The wide spectrum of applications and the print quality produced on sheet-fed offset presses set the standard by which print is judged in general. Sheet-fed offset press maximum productivity rates of 18,000 impressions per hour and sheet size capacities of up to 110 × 160 cm (43.375 × 63 inches) (Kippan, 2001: 333) make sheet-fed offset presses formidably productive machines that are surpassed only by web-offset and rotogravure.

The economics of operating an offset-lithographic sheet-fed press

The set-up (make-ready) of a sheet-fed press requires printing plates to be mounted on each printing cylinder, and if a job has a different paper format from the last job completed, the feeder and delivery guides have to be adjusted, the positions of the paper travel guides have to be changed, the ink fountains have to be pre-set to deliver the correct amount of ink to every zone and the inking units may have to be washed if the colors have changed from the previous job.

As recent as 20 years ago these operations were performed manually, requiring hand tools and visual judgment. Although this may still be the case with presses of an older vintage, on presses that are equipped with the full range of automatic functions very little manual handling is required. Fully automatic plate-loading devices mount the printing plates without human intervention, and the feeder, delivery and paper travel guide adjustments are made remotely from a press console. At an even higher level of automation all job specifications are transferred from an

electronic job ticket, which activates the servo motors of the respective press components to be adjusted. Likewise, pre-setting of the ink fountain no longer requires visual assessment and manual adjustments, but digital pre-press image data are converted to spatial ink fountain adjustments that dispense the correct amount of ink for each ink zone almost instantly and with a high degree of accuracy. Just about the only function that has not changed significantly is the washing of the inking units, which is the reason why the scheduling of jobs in such a way that unnecessary wash-ups are avoided has become an important productivity factor.

Once printing commences, a closed-loop quality control system measures the color of the printed sheets using densitometers or spectrophotometers and compares the values against an acceptable standard. If some measured values are beyond acceptable tolerances the system makes the necessary correction by opening or closing the ink fountains of the offending zones.

Automatic pre-setting of the ink fountains and the closed-loop monitoring of press output have reduced waste tremendously. Where in the past 500 sheets were required to achieve an acceptable color balance, today this can be achieved with 50 sheets or less. In the recent past the make-ready phase for a typical four-color-process job took on average 60–90 minutes; this has now been reduced to 20 or 30 minutes, while less complex jobs without any paper format or color changes, such as the text pages of a book, can be readied in ten minutes. As well, a typical four-unit sheet-fed offset press was as recently as 20 years ago operated by a crew of four, which was reduced to three operators as automation advanced and is now almost never more than two operators.

These advances led to tremendous productivity increases, but more automation also increased the cost of printing machine equipment. For example, the hourly budgeted rate for a Heidelberg Speedmaster SM74-8-P sheet-fed press with eight printing units is US$361.72 at a productivity rate of 75 per cent in a company running two shifts and operating 37.5 hours per week (Andrukitas, 2004a: 425). While an hourly rate of $361.72 can be absorbed easily in a long-run job scenario of 150,000 impressions, it would be quite another matter for a run length of 350. Running the press at its maximum rated speed of 15,000 impressions per hour, it takes ten hours to print the longer job, while 30 minutes to set up the press brings the total time to 10.5 hours. Based on the $361.72 hourly budgeted rate, $3,798.06 (10.5 × 361.72) would have to be charged. Dividing these charges into 150,000 units results in a cost per unit of $0.025. For the 350-impression run, the half-hour or $180.86 it costs to set up the press can be used alone, as the running time

for 350 sheets is negligible. Dividing these charges into 350 units results in costs per unit of $0.52, which is over 20 times higher than the cost per unit in the 150,000 press run.

Since these calculations do not yet include pre-press charges, where the same run-length principle applies, it can easily be seen that offset-lithography is a prohibitively expensive printing process for short runs.

By far the two most significant annual costs for this press are the fixed charges or manufacturing overhead, in part represented by depreciation costs of $275,375, and the variable charges, in part represented by direct labor costs of $177,827; these account for 39.5 per cent and 25.5 per cent respectively of total annual manufacturing costs of $698,022 (ibid.). The $275,375 depreciation costs are a manifestation of the expensive purchase price that such a sophisticated piece of new machinery commands, and the $177,827 labor costs are the result of relatively high-skilled wages that the two-man crew receive for operating an intricate and complex multicolor printing machine.

The end product of a sheet-fed offset-lithographic printing press is always in sheet form, which may or may not require further processing. A poster printed on a sheet-fed press could conceivably be shipped to the customer without further processing if it was printed one-up, but most products require at the very least subsequent four-side trimming or separation cuts on an industrial paper cutter capable of cutting reams of paper at once.

With regard to book printing, the printed pile in the delivery of the press consists of sheets that contain the same range of book pages. The number of pages on a sheet depends on the size of the pages and the size of the press sheets, where small page sizes and large press sheets result in the maximum number of possible pages. The exact number of pages on a press sheet will furthermore depend on how the sheets will be folded on a folding machine in a subsequent manufacturing phase. There are a large number of folding patterns, the most common of which for book printing is the so-called *right-angle fold* where the sheets are first folded through the middle of the long sheet dimension followed by a fold at a right angle to the previous fold where the fold is again made through the middle of the dimension and so forth. A sheet so folded will have double the number of pages with each successive fold, thus one, two, three and four successive right-angle folds will result in four, eight, 16, 32 and 64 pages respectively. Thus a 320-page book printed on a perfecting press, having a maximum sheet size large enough to accommodate 16 pages on one side of the press sheet, will require 20 printing plates and ten press runs, where every press run produces a different range of pages.

Subsequent to folding the folded signatures are gathered in a dedicated gathering machine or in the gathering section of a binding system to form individual book blocks, which are then bound into saleable books in one of the several adhesive or thread-sewing binding systems in existence.

Web-offset presses

Unlike sheet-fed presses where sheet materials are processed, web-fed presses print on a continuous ribbon of paper (see Figure 2.2), dispensed from a roll at the in-feed section of the press.

There are several advantages to the web-fed press design, not least of which is that the roll is the original format in which paper is manufactured. Using rolls eliminates the process of sheeting the paper into various sheet formats, and consequently the costs associated with an extra manufacturing phase are avoided. Additionally, processing ribbons of paper simplifies press design, because, unlike sheet-fed presses, web presses do not require complex gripper and cylinder transfer components to forward the substrate from the in-feed to the delivery sections of the press. Instead, the web travels through the press by virtue of the rotating printing cylinders and the friction they provide.

Figure 2.2 Web-offset presses, with press console in foreground and printed webs visible in the background

Significantly for book printing and other products consisting of multiple pages, which invariably require folding operations, web presses provide inline folding capabilities and consequently deliver folded signatures that are ready for subsequent binding operations. In some product categories, such as newspapers or magazines, which do not require further processes beyond folding, a web-fed press can deliver a finished product. Web-fed printing speeds of approximately 15 m/s, as opposed to sheet-fed maximum speeds of 4 m/s (Kippan, 2001: 154), make web-offset printing presses and the other web-fed printing processes of rotogravure and flexography indispensable for timely production of large-circulation daily newspapers, periodicals and other high-volume and time-sensitive products. Most daily newspapers and 70–80 per cent of books are now printed on web-offset presses (GATF, 1996: 3).

Web-offset presses are further subdivided into the two categories of *heatset web-offset* and *non-heatset web-offset*, sometimes also called *coldset web-offset*. The most common printing unit configuration is the so-called *blanket-to-blanket design* (see Figure 2.3), which in essence is a press design that permits both sides of the ribbon to be printed by upper and lower rubber-blanket-covered cylinders exerting pressure against each other. Additionally, there are a number of other printing unit configurations that are beyond the scope of this book and do not contribute to the topic of book printing.

The distinction between heatset and non-heatset offset printing is important in the context of publication printing, as it affects the type of book that can be produced in either of these two web-offset categories. In heatset web-offset the web passes through a long (over seven meters) high-velocity hot-air dryer subsequent to printing on both sides of the web (see Figure 2.4). The dryer causes volatile solvents in the printing ink to evaporate under the influence of hot and turbulent air (500°F or 260°C); less than a second later, when the web passes through chill rollers, the ink is cooled to about 75°F (24°C), causing it to set on the paper's surface with sufficient rigidity to make further finishing processes such as folding possible without smearing the printed image (ibid.: 89–90). Since freshly printed images on coated papers are particularly susceptible to smearing when subjected to the abrasion in the web press in general and the folding section in particular, a heatset web-offset press must be employed when printing coated papers. Coated papers are the preferred substrates for many book categories that contain pictorial matters and four-color-process reproductions, because of the minimal pictorial degradation and the

Figure 2.3 Blanket-to-blanket web-offset configuration

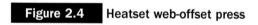

Upper inking unit

Upper dampening unit

Upper plate cylinder

Paper web

Upper blanket cylinder

Lower blanket cylinder

Lower dampening unit

Lower plate cylinder

Source: redrawn and adapted from Kippan (2001: 269)

Figure 2.4 Heatset web-offset press

Heidelberg Web – 16

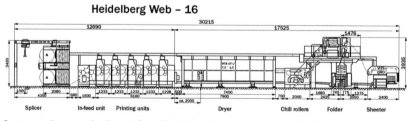

| Splicer | In-feed unit | Printing units | Dryer | Chill rollers | Folder | Sheeter |

Source: redrawn and adapted from Heidelberg Druckmaschinen (1986)

relatively good color fidelity they produce. In web-fed printing, the only available option if this type of work has to be produced is the heatset web-offset method.

Heatset web-offset print quality is characterized by very high gloss values without requiring additional gloss coating overprints, because the chill-roller phase leaves a very smooth ink film on the paper surface. The image resolution and color fidelity achieved on late-generation heatset web-offset presses approach that of sheet-fed offset print quality.

Non-heatset presses are normally not equipped with dryers or chill-roller sections and are therefore not suited for printing coated paper. But since the vast majority of books, in particular text-based books, are printed on uncoated paper, non-heatset presses are widely used for high-volume book printing. Uncoated papers are porous enough for low-viscosity non-heatset printing inks to be absorbed into their internal structure and prevent smearing, marking or other damage to the printed image without requiring dryers and chill rollers.

The print quality of non-heatset printing is not as good as heatset web-offset print, because the combination of relatively rough uncoated paper surfaces and the low-viscosity inks used in the process tends to spread the printed image under the printing pressure applied by the blanket cylinders. This is particularly noticeable in halftone reproductions, and as a consequence halftone line screen rulings of 120 lines per inch is near the upper limit of screen ruling frequencies, which diminishes pictorial image resolution and the color gamut of four-color-process reproductions. Owing to the typically simpler non-heatset web-offset press design, they are a less costly investment than a heatset web-offset press; also reduced energy consumption, because neither dryers nor chill rollers are required, makes non-heatset web-offset presses more economical to operate.

The blanket-to-blanket web-offset press design gained wide acceptance for commercial printing applications, because it permits the web to travel through the printing units in a number of different paths, which creates the opportunity to produce varying page and color configurations. For example, if a press with four printing couples can accommodate 16 letter-sized pages (eight pages on the upper unit and eight on the lower), the end product will be folded signatures containing 16 letter-sized four-color-process printed pages. If, however, the same press was equipped with four roll stands, then each of the four webs emanating from these rolls could be directed to a different printing couple, which results in a quadrupling of pages, in this case 64 (4×16) single-color letter-sized pages. For a book half that size the page count is further doubled to 128, and on even larger presses substantially more pages could be printed in a single pass.

Compared to the sheet-fed offset printing book production workflow, web-offset printing is more efficient because of the inline folding capabilities that web printing provides (see Figure 2.5), and significantly higher printing speeds add even more productivity to web-offset presses.

With regard to optimization of the printable area, web-offset presses are not as flexible as sheet-fed presses, because in the process direction of the web the printable area is fixed by what is called the *cut-off length*. In the direction perpendicular to the process direction, the printable area can be varied if different roll widths below the maximum roll width capacity of the web press are used – bearing in mind, however, that roll widths smaller than the press maximum reduce its productive capacity. The fixed cut-off length of a web press requires book printers to select page sizes that fully maximize this dimension, as otherwise the unprinted area that is produced with every printing cylinder revolution results in costly paper waste. For this reason some web presses are built to accommodate common magazine formats, and other presses, specifically designed for book printing, have cut-off lengths that fit the more common book page sizes, which in turn requires a certain amount of book format standardization.

Along with all of the sheet-fed press automation described earlier, web presses have additional automation which keeps the press supplied with paper continuously by way of automatic *splicers*, which join an expired

Figure 2.5 Workflow of book production on sheet-fed and web-fed presses

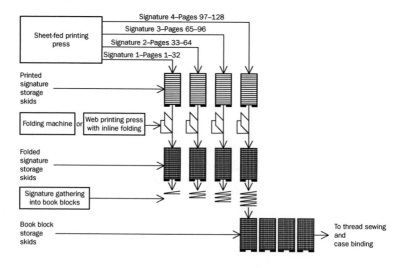

roll to a new roll while the press is running. Barring mishaps such as a web break, a web press can therefore run uninterruptedly for many hours on end.

The economics of operating a web-offset press

When a printer signs a multi-year contract with a publisher to print a series of letter-sized, four-color-process books, he must weigh his options as to whether a sheet-fed or a heatset web-offset is the better economic choice. The aforementioned sheet-fed Heidelberg Speedmaster SM74-8-P press will be compared to a web press, because it has similar capabilities. It is an eight-color-unit press plus perfector, which allows four-color-process printing on both sides of the sheet in a single pass. With a maximum sheet size of 20.5 × 29.13 inches, the press produces eight-page letter-sized signatures when folded. According to *Budgeted Hourly Cost Studies for Sheetfed Press Operations*, the press has a price tag of $2,203,000 including installation (Andrukitas, 2004a: 425).

An approximately equivalent web-offset press is the Heidelberg Web Systems Printstream 100S. The press has four printing couples (an upper and a lower blanket cylinder per couple), a cut-off of 17.75 inches and a maximum web width of 26.5 inches, and also produces eight-page letter-sized folded signatures in full color. The purchase price of this press including installation is $2,393,443 (Andrukitas, 2004b: 4).

The productivity of web presses is usually stated in the linear feet printed per minute (or meters per second), while the productivity of sheet-fed presses is always specified in sheets printed per hour. Therefore the web press productivity must be converted from linear feet per minute to sheets per hour for a valid comparison. This is done by multiplying the speed of the press in feet per minute by 12 to get the number of inches processed per minute, and then dividing the product by the cut-off of the press to get the number of impressions per minute. Multiplying the resulting quotient gives the number of impressions per hour (Breede, 2006: 52). For this particular web press, which has a maximum rated speed of 1,100 feet per minute, the calculation is $\frac{1100 \times 12}{17.75} \times 60 = 44,619$ folded signatures per hour, or almost three times more sheets per hour than the maximum rated productivity of the 15,000 unfolded sheets that the sheet-fed press can produce in the same time.

The budgeted hourly rate of $361.72 for the sheet-fed press is already known from previous discussions, and the budgeted hourly rate of $408.91 for the web press at equivalent production parameters was obtained from

Budgeted Hourly Cost Studies for Web Press Operations (Andrukitas, 2004b: 4).

The higher budgeted hourly rate for the web press is attributable in part to its higher labor costs, because unlike the two operators required for the sheet-fed press, the web press requires three operators. Also depreciation costs are higher because of the greater mechanical wear caused by the higher printing speed of the web press, and the operating costs are somewhat higher for a heatset web press due to the fuel consumption of its dryer.

For a hypothetical 150,000 copies of a 320-page book printed in full color (four-color process), both the sheet-fed and the web presses would require 40 press runs (320 ÷ 8 pages per press run), as both presses can print the sheets in full color on both sides in a single pass. The major difference is that the web press produces folded signatures, while the sheet-fed press delivers sheets that have to be folded in a subsequent and separate manufacturing phase.

The total number of impressions is therefore 40 press runs multiplied by 150,000 impressions per press run or a total of 6,000,000 impressions. With the maximum press speed of the sheet-fed press being 15,000 impressions per hour, the job could therefore be completed in 400 hours (6,000,000 ÷ 15,000). Multiplying the 400 hours it takes to print the books by the budgeted hourly rate of \$361.72 for this sheet-fed press results in \$144,688 printing costs. If the job is printed on a heatset web-offset press, we use 44,619 and \$408.91 for the impressions per hour and hourly budgeted cost respectively, which results in only 134 hours of press time and total printing costs of \$54,793. Web press costs in this run-length scenario are therefore about a third of sheet-fed press costs.

While cost savings of this magnitude demonstrate quite a convincing economic advantage in favor of web printing, the practical reality is not quite as clear-cut. The lower costs in this example were for the most part attained because of the high web press printing speed, which in practice can only be exploited with extremely long runs such as the 6 million impressions in the foregoing scenario. Furthermore, the relative inflexibility of the web press in terms of accommodating a variety of different physical formats renders the web press more suitable for highly standardized products such as newspapers, periodicals and certain series book categories such as Harlequin's romance novels or the occasional blockbuster publications – of which there is no better example than the phenomenally popular Harry Potter series of books.

Considering, however, that such runaway success is relatively rare in book publishing and that 'the average book in the U.S. sells less than

2,000 copies in its lifetime' (Rosenthal, 2004: 13), it becomes clear that factors other than fast printing speed are far more important for the economic production of the majority of potential book titles.

Aside from the wide variety of physical formats that books could assume, which are difficult to accommodate on web presses with their fixed size in one dimension of the press sheet, the printing speed advantage of web-offset presses diminishes as run lengths decrease, to the point when the time saved for a 2,000-impression print run becomes negligible. The more significant factors are set-up times and format variability.

As run lengths decrease, the set-up consumes proportionally more time relative to the other production phases, simply because there will necessarily be a greater number of set-ups in a series of short-run jobs than in the same time it takes to print an extremely long run. There is a slight set-up advantage for sheet-fed presses, because hourly budgeted rates are somewhat lower than those for web presses of similar size and technical complexity.

The real advantage of sheet-fed offset presses over web-offset presses is their greater press sheet size variability. With the leeway of varying sheet sizes, a sheet-fed printing press can produce upright, oblong, square or extremely narrow book formats, as well as small, medium or large books, without causing undue waste. Moreover, sheet-fed presses offer more inline accessories, such as coating, foil stamping, perforating, scoring, die-cutting or numbering units to enhance the printed image without requiring additional manufacturing phases.

Knowing that a book will be printed on a sheet-fed press gives designers the creative freedom to design books that are reflective of their intentions, relatively unimpeded by the limitations imposed by the printing process itself.

Notwithstanding these sheet-fed press advantages, web presses in any of the conventional printing process categories, including web-offset, are unsurpassed in their capacity to print large volumes of books or other types of publications efficiently, and there is at this juncture no reason to believe that in the near future web printing will be superseded by another printing process for this type of work.

The principles of digital printing processes

The term 'digital printing', when juxtaposed with conventional printing processes such as rotogravure, flexography and the dominant

offset-lithographic printing, conveys the impression that digital technology is the exclusive domain of digital printing processes, but nothing could be further from the truth. No printing process used today could be competitively employed without digital technology, and the real difference between conventional and digital printing lies in the fact that the former processes use digital-electronic methods to create a physical image carrier, which serves as a matrix to duplicate the same fixed image again and again, while the latter processes use digital-electronic methods as well, but to the ultimate end of directly imaging a substrate from digital data.

In some digital printing processes, such as electrophotographic devices (laser printers), the image is first transferred to an intermediate physical image carrier before it reaches the paper; in other systems, such as inkjet printing, imaging is a process of channeling a colorant (fluid ink drops) directly to the paper according to an electronic charge modulated by digital data. In either case, digital printing always requires an image to be electronically refreshed for every successive print cycle, which does not preclude the possibility of refreshing the image with different digital information – thus for the first time in the long history of printing it is possible to print different pictures or text on to successive sheets. As previous discussions have shown, the costs of an image carrier can only be economically justified if they are distributed to a sufficient number of efficiently produced units. Therefore the typically slower digital printing processes, which require neither the material cost of a physical image carrier nor the cost to process it, are particularly competitive in the short-run print market.

It is thus the ability to print without a permanent image carrier that is changing the world of printing so profoundly, but otherwise digital printing still does what printing has always done, which is to reproduce images on a substrate.

While the underlying principles of the various digital printing processes vary greatly, there are certain conceptual similarities. All digital printing engines receive image information from a digital computer, and invariably electric potential differences (electric fields) are an integral part of their technology.

Ongoing research has seen the number of new and hybrid digital printing processes increase in the last 20 years, and possibly new ones will emerge in the future, but the processes which to date have found commercial applications are electrophotography, electrography, iconography, magnetography, inkjet printing, thermal-transfer printing and elcography. Of these electrophotography, often also called laser

printing, is the most widely used process, with inkjet printing being nearly equally common. Iconography and magnetography have to date not found applications in a broad spectrum of product categories, but they deserve special mention here because, among other single-color applications, they have been accepted for single-color book printing. Elcography has the potential of becoming a high-productivity digital process for a wide range of printing applications, but the company that manufactures these devices has in recent years not reported any new developments. Thermal-transfer printing and electrography are currently not used widely for commercial printing applications.

The creative, technical production and selling aspects of the book have always been interrelated to some degree, but never more so than today when electronic linkages between each phase are made possible by digital technology. Digital printing processes are a key component of this electronic workflow, and must be understood to exploit their productive potential fully. Anyone involved with the creation, production, marketing or selling of books must therefore have some technical understanding of these reproduction technologies. To this end the digital processes currently used for the printing of books will be discussed here at a technical level. Since electrophotography and inkjet printing are by far the most mature digital printing processes, they will be given more space.

Electrophotography

Electrophotography is based on the scientific phenomena of photoconductivity and static electricity. Certain semi-conductive materials such as metal oxides and selenium, and more recently cadmium sulfide and various compounds containing selenium, have a property that causes an electric charge to disappear when struck by light and to hold the charge when not exposed to light. The earliest copiers relied on the direct light reflection principle, where the white non-image areas of an original copy reflect light to a photoconductive surface and the dark image portions insulate the photoconductive surface from light, thus forming a latent image on the photoconductor. Static electricity is used in the process to charge a colorant, such as a toner, with an electric charge that has a polarity opposite to that of the photoconductive surface. Since electric fields of opposite polarities attract each other, the toner will adhere to image areas only. In early copiers the toner was transferred directly to substrates with a special coating, while in today's copiers the toner is transferred via an intermediate photoconductive drum or belt to

plain paper. The binary composition of any printed image – that is to say, there are only image and non-image areas – regardless of the printing process is thus created in electrophotography by the presence or absence of electric charges on a photoconductive surface.

In principle, digital electrophotographic printing still functions as described above. The major difference is that the photoconductive surface of a digital printer receives its electrical charge not via reflected light from a fixed hard copy, but from digitally modulated laser light impulses. Effectively, this means that the digital permutations of today's digital presses can produce either the same image repeatedly, or by way of a variable data stream a completely different image with each successive imaging cycle.

The term 'image carrier' in relation to electrophotography and other digital printing processes must be used judiciously, because at the exposure phase the photoconductive surface holds latent image information in the form of electric charges, unlike conventional printing processes where image and non-image areas are a function of physical or chemical differences. The latent image becomes a physical image only when finely ground pigmented toner particles approximately 8μ in diameter (liquid toners are used in some systems) adhere to the photoconductive surface.

The most significant difference between conventional and digital printing processes is that the former have a fixed image carrier content, whereas in digital printing the image information can vary in each successive imaging cycle. For this to be possible the photoconductive surface must be void of any toner particle remnants at the end of an imaging cycle.

Electrophotographic imaging proceeds in five stages: exposure, development, toner transfer, toner fixing and cleaning (see Figure 2.6). In the exposure phase a modulator receives electrical signals representing a bit stream in accordance with digital image data and emits laser beam pulses approximately 0.125–0.25 inches in diameter on to the photoconductive surface, by optically focusing the laser to a few thousandths of an inch. Alternatively, extremely small solid-state lasers, called light-emitting diodes (LEDs), are used in some systems.

An individual bit in the bit stream represents the smallest discrete image element, and a composite of these discrete elements creates the latent image on the photoconductive surface, which has a positive charge. The bits in a bit stream could be turned either on or off. A turned-on bit normally represents image areas and a turned-off bit represents non-image areas. Wherever the photoconductive surface is struck by the laser

Figure 2.6 **Electrophotography principle**

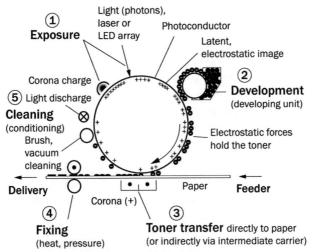

Source: redrawn and adapted from Kippan (2001: 689)

beam it will lose its electric charge due to its photoelectric properties, whereas the image areas retain their positive charge as they do not receive any light. This occurs at the level of discrete image elements as small as a six-hundredths of an inch in diameter (in 600 dpi printers, for example), which is not discernible without magnification. The image exists up to this point only in the form of electric potential differences, and is therefore referred to as a latent image.

In the development phase toner particles adhere to the photoconductive surface because they carry a negative and opposite electric charge to that of the remaining positive charges on the photoelectric surface. Those regions that lost their charges due to light exposure will not attract toner particles. It is only at this particular instant that the image becomes a physical reality and visible to the eye.

During the transfer phase the toner migrates to the paper by virtue of positive electric charges to the paper, which is traveling in contact with the photoelectric surface. Because these positive electric charges are greater than the positive charges that attract the toner to the photoconductive surface, electrostatic forces are again brought into play to transfer the toner to its final destination on the surface of the paper.

In some high-volume electrophotographic presses the transfer occurs not directly to the paper but via a blanket cylinder, similar to the indirect image transfer in offset-lithography. Indirect image transfer via an

intermediate blanket cylinder offers the advantage of printing on a wider variety of substrates because the rubber blanket more readily conforms to substrate irregularities than the rigid photoconductive surface. The use of blanket cylinders in offset-lithography is incidentally similarly motivated.

Since the electrostatic attraction between the toner particles and the paper is weak, the toner has to be bonded to the paper surface by exposing it to fusing temperatures of 300°F (150°C) (Nothmann, 1989: 45) and slight pressure during the fixing phase, which causes the toner to melt partially into the paper fibers.

Because toner particle transfer from the photoconductive surface to the paper could be as low as 80 per cent (ibid.: 44), some residual toner particles necessarily remain on the photoconductive surface. In conventional printing processes such as offset-lithography, residual ink on the image carrier occurs as a matter of course and does not have to be remedied, because the exact same image is printed with each successive print cycle in perfect register. This is not always the case with digital printing. If in subsequent imaging cycles different images are printed, residual toner particles from a previous image will interfere with and degrade the new image to be printed. In most digital printing processes (except inkjet and thermal-transfer printing, where there is no image carrier to speak of) it is therefore necessary to remove all remaining residual particles on the photoconductive surface at the end of the imaging cycle. To prepare the electrophotographic printing device for the eventuality of varying image information on successively printed sheets, during the fifth and last phase of the imaging cycle the photoconductive surface has to be cleaned by a combination of brushing, suction and alternating electronic fields.

The upper spatial resolution limit for electrophotographic printing is currently 600 dpi, but in some multicolor systems the addressability for black can be as high as 2,400 dpi ($600 \times 2,400$) in one imaging direction of the device (Xerox, 2006a). The productivity rates of electrophotographic systems are considerably lower for multicolor than for single-color systems, unlike conventional printing processes, where print speeds are not compromised by multicolor printing. Some continuous-feed (web) electrophotographic multicolor systems print four-color images on both sides of a 20-inch-wide web at a speed of 40 feet/min (Xeikon, 2007). This compares with printing speeds of 244 feet/min for single-color (black) systems of comparable web width (Xerox, 2005). Thus, multicolor productivity is about one-sixth that of single-color productivity.

Inkjet printing

Inkjet printing and thermal-transfer printing distinguish themselves as the only printing processes that image the substrate without requiring an intermediate transfer phase or image carrier, but inkjet printing stands alone as the only printing process in which there is no physical contact between the droplet-generating device (print head) and the substrate, as the colorant is virtually squirted from the print head to the substrate. These factors permit inkjet printing devices to be manufactured with a minimum of moving parts and a small footprint, which is one of the reasons why inkjet printers gained such a wide acceptance in the consumer printer market.

Originally, inkjet printers were designed for such mundane tasks as product identification, addressing and transactional printing applications well below acceptable commercial printing quality standards. The print quality of inkjet devices has since improved to levels that approach electrophotographic output, but inkjet printing speeds are somewhat higher than those of most other digital printing processes. When specially treated substrates that are compatible with the fluid inkjet inks are used, certain inkjet printing devices, such as proofing systems and systems for multicolor printing of large formats, can reproduce near-photographic quality, albeit at extremely low printing speeds which render these product-specific devices unsuitable for general commercial printing applications.

There are several technical inkjet variations, but all are based on the formation of ink droplets by spontaneous liquid surface tension effects using acoustic, piezoelectric or heat-transfer actions. Targeting of ink droplets is accomplished by a combination of the print head movement in the x direction and the substrate movement in the y direction, as well as electrostatic forces which deflect the droplets on single or multidirectional trajectories. High-speed industrial inkjet printing devices employ a page-wide stationary nozzle array where imaging across the paper is a function of closely spaced multiple nozzles, while the process direction of the paper is imaged by virtue of its movement. In a timespan of one second, these systems generate 100,000 droplets (Nothmann, 1989: 77) with finely gradated volumes of ink for each individual droplet and where a droplet with an ink volume of four pico-liters (4×10^{-12}) produces an image sphere of 20μ in diameter (Kippan, 2001: 715). Manufacturers have in recent years succeeded in developing inkjet print heads that produce ink droplet volumes as small

as one pico-liter – which bodes well for inkjet printing, because inkjet print quality depends in part on the print head's capacity to reproduce extremely small image elements.

In so-called continues inkjet systems, droplets which did not receive an electric charge are deflected to a gutter in order to be recirculated to the original ink reservoir (see Figure 2.7). In drop-on-demand inkjet systems, drops are formed only if they have received a digital image signal, which negates the need for droplet recirculation.

In large part, the absence of moving parts in inkjet systems equipped with a page-wide stationary nozzle array contributes to the considerable printing speeds that can be achieved on these devices. There are now continuous inkjet systems that print four-color-process images on both sides of the paper with running speeds of 328 feet/min (Kodak, 2007). While this puts inkjet printing ahead of the other digital printing processes in terms of speed, it still falls far short of the 3,000 feet/min printing speed of a heatset web-offset press. Certain product categories, such as extremely short book print runs, could always be printed more efficiently with digital systems despite their slow printing speeds, but with running speeds of 328 feet/min the scope for digital printing creeps to run lengths that were customarily in the realm of conventional printing processes. In the single-color and single-color-plus-spot-color categories of print jobs, which are typical of the vast majority of books printed today, printing speeds of 1,000 feet/min are now possible on

Figure 2.7 Continuous inkjet principle

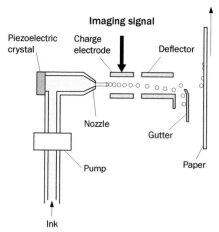

Source: redrawn and adapted from Kippan (2001: 712)

inkjet systems with web widths of up to 40 inches (Kodak, 2006). This level of productivity positions inkjet printing within the productivity range of non-heatset web-offset printing presses, on which the great majority of these types of books are currently printed.

The Achilles' heel of the inkjet printing process is the low-viscosity inks being used and the unique means of transporting the ink from the print head nozzles to the paper on an airborne trajectory. Standard inkjet printing inks, which are ejected from the print head nozzles at a velocity of up to 50 m/s, are either water or solvent based with a viscosity similar to inks used in fountain pens. An aggravating factor is the great affinity of paper for water and many liquids in general. The combination of the considerable speed with which ink droplets contact the paper surface, the relatively unstable physical structure of a low-viscosity droplet and the tendency of paper to absorb liquids can cause the ink droplets to disintegrate on impact with the paper surface and continue to spread upon absorption into the internal paper structure. For this reason inkjet printing devices often fail to produce the desired print quality if unsuitable types of paper are used. The best results are achieved with papers that have been especially formulated for inkjet printing, but for general commercial printing applications these papers could be either too expensive or not suitable from a functional or aesthetic point of view.

For book printing, for example, there exist a wide variety of paper types that can be selected on the basis of their printability, readability and aesthetic design. For four-color-process printing the preferred types of papers are matte or gloss coated papers, while for straight text printing uncoated bulky papers are often used. Unlike the conventional printing processes, such as offset-lithography, which can print successfully on a wide range of different types of paper, inkjet printing is limited to paper types that have the physical characteristics which are compatible with the peculiarities of the process.

Common inkjet printing problems are feathering, which implies the spreading of the image areas; strike-through, exemplified by the image printed on one side reappearing on the reverse side, and caused by paper types which are either too porous or too thin; and buckling of paper when images with heavy ink coverage are printed. That said, many paper types perform satisfactorily in the inkjet printing process, but the range of suitable papers is more limited than for most of the other printing processes.

Ongoing inkjet printing research and development holds the promise of achieving image resolutions in the 600 dpi range by means of a multi-line nozzle array, as well as novel scientific droplet formation principles such

as electrostatic inkjets, based on the 'Taylor effect' (Kippan, 2001: 722), but the most common image resolution of current high-speed inkjet printing presses is in the 240–300 dpi range.

Magnetography

The idea of using magnetism as an imaging instrument is not new, but it received renewed attention when it became possible to control a magnetized array on the surface of an imaging cylinder by a bit stream in accordance with digital image data. In magnetography a latent image is created on a complex multilayered imaging cylinder that can be magnetized through the application of magnetic fields. The imaging principles in magnetography are quite similar to magnetic disk and tape recording systems, where on or off signal information is stored by a change of polarity of magnetized particles. Since the imaging head in magnetography must be in physical contact with the magnetic print cylinder, the cylinder must have a hard and wear-resistant surface, unlike electrophotography where the latent image is created in a non-contacting manner. Like electrophotography, magnetography is a toner-based print technology. The toner particles in magnetography have a core containing iron oxide covered with a pigmented colorant, which is the reason why printing colors other than black is problematic: the dark toner particle core tends to produce impure colors, in particular in colors with light hues. Toner transfer to the paper occurs by nip pressure similar to an offset press, and the fixing of the toner to the paper is accomplished, as in electrophotography, by a combination of heat and pressure.

As with all digital printing systems that employ an intermediate image carrier, the imaging cylinder of a magnetographic system must be returned to a neutral state before the next imaging cycle begins. This requires the demagnification of the imaging cylinder as the last phase in the imaging sequence, and is done by a special erase magnet which effectively removes the latent image from the surface of the imaging cylinder (see Figure 2.8).

Image resolutions of 600 dpi are possible in magnetography, and resolutions as high as 1,000 dpi are under development. The process has found applications in product categories requiring only single-color (black) reproduction, which is typical for a large segment of the book market.

Some magnetographic devices will print in single color (black) on a web width of 20.5 inches at speeds of 410 feet/min, which puts them near the high end of productivity in the digital press category. A print resolution of 600 dpi is at the present time the best achievable quality for digital printing processes in general (Nipson, 2006).

Figure 2.8 Magnetography principle

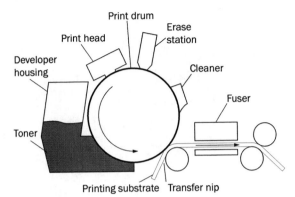

Source: redrawn and adapted from Nothmann (1989: 68)

Ionography

Ionography and electrophotography have certain commonalities, such as the use of dry toners and the requirement for an intermediate image carrier to hold a latent image – but this is where the similarities end. Unlike electrophotography, where light is the imaging agent, in ionography the imaging source is an ion stream that is generated in and around the print head through the application of high-voltage charges (see Figure 2.9). The ions then create discrete electric charges on an imaging cylinder, facilitated by the dielectric material of the cylinder.

The adherence of the toner to the imaging drum is brought about by electrostatic forces, as is the case in electrophotography, but unlike in electrophotograpy the transfer of the toner to the paper occurs in a single phase by way of direct pressure at the nip of the imaging cylinder and a pressure roller, as well as electric charge differences. No heat and consequential melting of the toner particles are required in the toner transfer phase. Although ionographic systems have very high toner transfer efficiency, it is not complete: about 5 per cent or fewer of the toner particles remain on the imaging cylinder. As is the case with all toner-based digital printing processes, the residual toner particles and the remaining electric charges on the imaging cylinder must be removed. In iconography this is effected by physical action for toner removal, and electrical actions to return the imaging cylinder to an uncharged state (see Figure 2.10).

With printing speeds of 500 feet/min (single-color black prints) on a web width of 19.75 inches, some ionographic presses are touted to be the fastest dry toner-based digital presses on the market today. Image

Figure 2.9 Ionographic print head

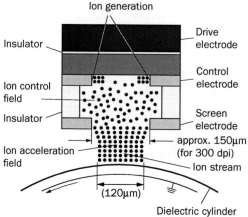

Source: redrawn and adapted from Nothmann (1989: 63)

resolutions of 600 dpi are now common in many ionographic systems (Delphax, 2004). Since most ionographic systems are currently built in single-color (black) configurations, they are less suitable for general commercial work, but single-color printing devices are a good match for the great majority of books that feature black text, line drawings and single-color halftones exclusively.

Figure 2.10 Ionography printing unit

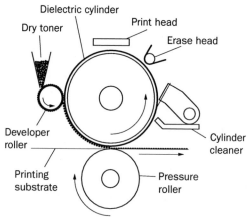

Source: redrawn and adapted from Nothmann (1989: 62)

Only digital printing processes can produce finished books

An ideal industrial process manufactures products without human intervention and operates in a continuous flow of interconnected mechanical sequences, starting with a relatively unprocessed raw material and ending with a saleable product. The more complex a product is, the more difficult it will be to design such a manufacturing system; and in fact few systems used today measure up to such an ideal.

Books are among the more complex products manufactured in the printing industry, because their manufacture extends beyond the pre-press and printing phases to binding. The production of books, which on certain digital presses begins with plain sheets or rolls of paper and ends with finished books, comes closer to the definition of an ideal industrial process than most other automated systems.

The reason why a continuous workflow for the production of books is not possible in conventional printing processes is directly related to their fixed image carrier design, which necessarily results in the same range of pages being printed in a given press run. If, for example, books consisting of 320 pages are printed in 32-page signatures per press run, then ten consecutive and separate press runs are required to complete the books. While web-offset presses have inline folding capabilities, this will not produce finished books, as the folded signatures still have to be joined and assembled with signatures from the other press runs before they can be processed further – which on conventional presses is an engineering and mechanical impossibility.

Conversely, digital printing processes do not have this fixed image carrier limitation and are therefore capable of printing the pages of a book in consecutive sequence until a finished book block is created, at which time the printing cycles are repeated for each subsequent block. The possibility to produce saleable books in a seamless and continuous operation thus exists if the appropriate finishing equipment is added to and synchronized with the press.

The operations necessary to finish book blocks produced on a digital press into saleable books are the binding, cover feeding and trimming phases. Digital press systems specifically designed for book manufacturing will invariably be equipped with adhesive binding technology, because the process of joining sheets of paper by means of glue, unlike thread-sewing technology, is easily integrated in the production flow of digital presses and can keep pace with the printing

speed. Joining the book cover with the book block is realized by a so-called cover feeder, where pre-printed (usually using offset-lithography) soft covers are scored, folded and glued to the back of the book block. The last phase is the trimming of books to their final size on the head, foot and face by a three-knife trimmer (see Figure 2.11).

This highly integrated book production workflow is driven by a stream of data that originates from a database which can be designed for output of consecutive identical books, or for that matter for different consecutive titles, without interruptions to the mechanical movements of the digital press. The only prerequisites for this to be possible are a database where the different titles to be printed are cued in sequence and the insertion of pre-printed generic covers in the cover feeder. Alternatively, pre-printed matching covers for each title could be stacked in the cover feeder in the same sequential order as the books will be printed.

Not since the time of the medieval scriptoria has it been possible to produce individual books on demand, but, unlike the handwritten books produced in the scriptoria of the medieval world, the production of individual books by digital printing presses is not dictated by necessity. Rather, the integration of the digital printing and bookbinding phases for the consecutive and continuous production of alike or different books revives the ancient, individualistic, but excruciatingly slow business model of the scriptoria without sacrificing the production speed of the manufacturing process. Some digital devices print 2,400 single-color 5.75 × 8.75 inch pages every minute, which is the equivalent of one 210-page book every 5.3 seconds (see Figure 2.12). This remarkable productivity, combined with the high level of customization afforded by digital printing processes, is unprecedented in the evolution of book printing technology, and like pivotal technological changes in the past it will require new ways to market, distribute and sell books. And new book categories and book features, such as personalized messages for which no practical or economical manufacturing methods previously existed, can be created by digital printing processes (see Figure 2.13).

Figure 2.11 **Workflow of book production on a digital press**

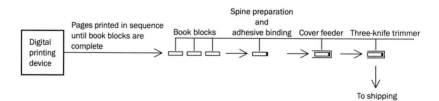

Figure 2.12 Front cover and printed endpaper of a digitally printed 210-page book promoting a digital press

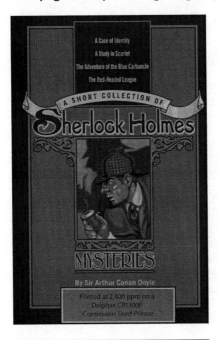

This book was printed in
5.3 seconds with a
Delphax CR1300P
printing system

Figure 2.13 Front cover and front matter of a digitally printed book with a personalized message

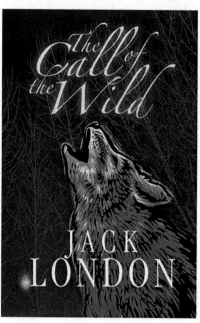

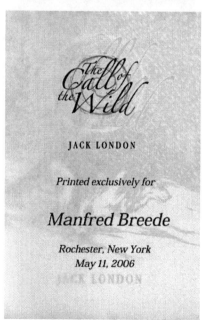

The economics of printing books on conventional versus digital presses

The reader of these pages is at this very moment handling an upright-formatted book measuring 6.125 × 9.125 inches. It is printed in single-color black, has a four-color-process printed soft cover and is bound by an adhesive binding method. Supposing 10,000 copies of this 240-page book (the exact number of pages was not known at the time of writing, so 240 pages is used in this example) had to be printed, the question of whether conventional or digital printing processes are the more economical choice will arise. The most recently published hourly budgeted rates for a conventional and a digital press with similar printable areas and financial investments will be used for an analysis of printing costs without consideration of pre-press, bindery, paper or consumable costs (Andrukitas, 2004a: 96; 2004b: 154). Also, the possibility of certain press inline functions, such as folding on a conventional web press or the production of finished saleable books on a digital press, will be ignored in this cost comparison, which effectively means that both the conventional and the digital presses deliver printed signatures which have to be processed into saleable books in subsequent offline processes.

Budgeted hourly rates are the costs charged to a customer to operate a machine, pro-rata for the time the machine is used. A vital part of hourly budgeted rates is the productivity level at which the machine is operated, which in more concrete terms means the time a machine is utilized for the productive activities that are necessary to manufacture products. For a quantitatively valid comparison, the productivity levels used in the following cost comparison were set arbitrarily at 75 per cent for the two presses under consideration.

The two presses studied were a Solna D300 conventional non-heatset web-offset press and a Delphax Technologies CR2000 digital web press (ionography). Both machines are two-printing-unit web-fed presses, printing the front and back of the web in mono-color with comparable print quality, as the 600 dpi resolution of the digital press is practically indistinguishable from offset quality. With its cut-off length of 21.5 inches and 39 inches web width, the Solna web-offset press produces 12-page signatures; while the Delphax digital press, which has an adjustable printable area in the process direction, produces 12-page signatures on a 19.75 web width if the process direction of the signature is adjusted to 39 inches (see Figure 2.14). Both presses will thus produce 24-page signatures when the web is printed on both sides; furthermore, the paper grain direction will be parallel to the spine of the book, which

Figure 2.14 12-page web-offset and digital press signatures

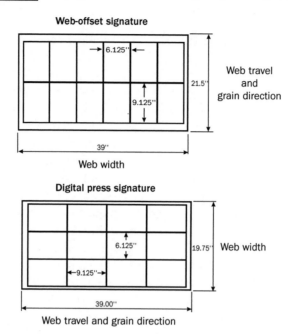

is preferred, as it improves the quality of adhesive binding and the ability of the book to stay flat when opened.

The dimensional adjustability in the process direction is possible for digital printing devices because it is governed by a digital bit stream, which in theory is infinitely variable, rather than by the fixed physical printing cylinder circumference of a conventional printing press. Since digital presses cover the web width direction with a print head array, web widths of approximately 19 inches are common for the majority of digital presses, as shorter imaging head arrays keep their manufacturing costs at more reasonable levels. The relatively short imaging distance in the width of the web is compensated for by variable and longer imaging distances in the process direction, which is not hardware-dependent, and consequently large square areas comparable in size to those produced on conventional presses can be imaged cost-effectively.

Cost analysis of printing 10,000 240-page single-color books on a web-offset press

The Solna D300 web-offset press has a purchase price of $950,000, which includes installation costs. The costs accrued for direct labor are

$76,789 and $53,587 for the salaries of two crews consisting of a pressman and a helper respectively in a two-shift, 37.5 hours/week operation that is running at 75 per cent productivity. The other major expense among sundry manufacturing costs is annual depreciation of $118,750. All-inclusive, the budgeted hourly rate for this press if operated under the assumed parameters is calculated to be $201.33.

If 240 pages are printed in 24-page signatures per press run, then 20 printing plates and ten press runs are required to print the book. A single-color text job is a relatively simple task, requiring no more than approximately 12 minutes' make-ready time per press run or a total of two hours. If the Solna press runs at its rated top speed of 1,400 feet/min, the number of signatures that can be printed per hour is $\frac{1,400 \times 12}{21.5} \times 60 =$ 46,883. The total number of signatures required to print 10,000 240-page books is $\frac{240}{24} \times 10,000 = 100,000$. Dividing the 100,000 signatures required to print 10,000 books by the 46,883 signatures that can be printed in an hour gives $\frac{100,00}{46,883} = 2.13$ hours of printing time; adding two hours' make-ready time determines a total chargeable time of 4.13 hours. Thus the total printing costs are calculated by multiplying 4.13 hours by the hourly budgeted rate of $201.33, which comes to $831.49.

Cost analysis of printing 10,000 240-page single-color books on a digital web press

The Delphax CR2000 digital press has a purchase price of $900,000 plus $12,000 for installation, which brings the total investment to $912,000. With all other working conditions and productivity rates being equal to the Solna web-offset press cost analysis, the costs of direct labor are $63,069 (the Delphax CR2000 can be worked by one operator), while annual depreciation costs are $114,000. Based on these cost factors and work condition and productivity assumptions, the calculated hourly budgeted rate for this press is $141.59. There are no noteworthy make-ready costs associated with the press, because its operation consists of programmed instructions – not significantly different from operating a home computer printer. Because the Delphax CR2000 is a roll-to-roll digital press, it would be technically inaccurate to refer to a cut-off length and the term must be understood in the context of the signatures being cut to the desired length in a separate offline procedure.

If the press runs at its rated speed of 450 feet/min the number of signatures that can be printed per hour is $\frac{450 \times 12}{39} \times 60 = 8,307$. The total number of signatures to be printed is still 100,000, since both the

conventional and the digital press runs print 24-page signatures. Therefore, dividing the 100,000 signatures that are required to print 10,000 books by the 8,307 signatures that can be printed in an hour gives $\frac{100,000}{8,307}$ = 12 hours of printing time. Thus the total printing costs are calculated by multiplying 12 hours by the hourly budgeted rate of $141.59, which comes to $1,699.08.

Reasons for cost differences

To print 10,000 240-page mono-color books on a digital press costs $1,699.08, or $867.59 more than printing the books on a web-offset press. Although the web-offset press has a higher budgeted hourly rate, this is compensated for by its greater productivity. The productivity advantage of conventional printing processes can, however, only be exploited if run lengths are sufficiently large, which in essence means the longer a run length is the more compelling the reason for printing books by a conventional printing process becomes. Likewise, as run lengths decrease the cost differential between conventional and digital printing processes progressively diminishes to the point when it will be more cost-effective to print books on digital presses. A trend analysis of 14 different run lengths ranging from one to 10,000 books produced by otherwise identical production parameters, as in the foregoing cost analysis, shows that the crossover point where one or the other printing process is the better economic choice is at an approximate run length of 3,000 books (see Figure 2.15).

Converting the total printing costs for each of the 14 press runs to costs per unit (books) shows much the same result, but additionally demonstrates that conventional and digital printing processes have different trends as run length changes from short to long (see Figure 2.16).

The single most significant reason for web-offset's high and low costs for short and long print runs respectively is the time required to set up the press (make-ready) prior to a production run. Regardless of the length of a press run, new plates have to be mounted, ink fountains have to be adjusted and trial runs have to be made to verify the position and quality of the printed image. This means a run length of one unit requires the exact same make-ready time as a run length of 1 million units, to state two extreme examples at the opposite ends of the scale. The difference between the two is that in the run length of one the entire make-ready costs are born by this one unit, while in the 1 million run the make-ready costs are distributed over 1 million units. If the make-ready time and hourly budgeted rates of the foregoing book printing scenario are used as the basis of this discussion,

Figure 2.15 Crossover of web-offset and digital press costs when printing 240-page mono-color books

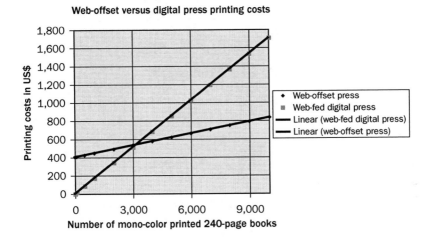

Figure 2.16 Printing costs per 240-page mono-color book

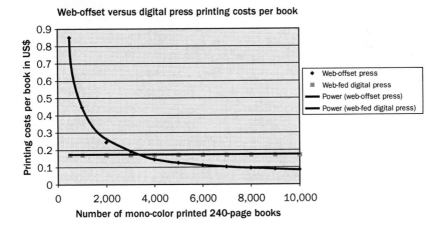

then the printing costs of a single book in a run length of one would be prohibitively expensive at $402.66, while in a 1 million run the cost per unit would be reduced to the insignificant amount of $0.000403.

To demonstrate the relative significance of the considerable printing speeds attained by a web-offset press in relation to short and long run lengths, the analogy of a sports car when used for short- or long-distance driving can be used. If the car is used for shopping in a store one block away, the difference between fast and slow driving speeds would be a matter of a few seconds.

On the other hand, if the car is taken on a trip across the country the difference between slow and fast driving speeds could result in hours if not days of traveling time saved. In the same vein, the printing speed advantage of web-offset presses progressively diminishes as run lengths decrease.

In contrast, digital presses require no on-press preparations beyond some trivial tasks such as activating the press from a computer interface; moreover, because the pages of books are printed in a perpetual sequence from the first to the last pages until the required number of books have been produced (see Figure 2.11), there are no interruptions due to repeated image carrier changes, such as is necessary when books are printed by a conventional process. The relatively simple operational procedures of a digital press are also the reason why it can be worked with less manpower and considerably reduced technical skills and manual dexterity. This is further demonstrated in the foregoing cost analysis, where total annual labor costs for the web-offset press are $130,376 and those for the digital press are less than half that, at only $63,069.

The lack of an appreciable time period needed to ready a digital press for a print run is thus the underlying reason why the costs per unit for jobs printed on digital presses are always the same regardless of the length of the run, as the printing costs are composed exclusively of the press run time. Printing projects that particularly benefit from this peculiarity are books, because they require frequent image carrier changes if printed in a conventional printing process.

The counteracting productivity factor is the much slower printing speeds of digital printing presses. High-volume projects such as blockbuster bestsellers, if printed by a digital process, would not only be unable to produce the books in a timely fashion, but the lengthy production cycle multiplied by the fixed and variable hourly charges of a digital press would result in prohibitively high unit prices.

The calculated crossover point of 3,000 books, above and below which web-offset and digital presses are the more economical choice respectively, is a good average, but it applies only to the presses compared in the cost analysis. Some digital presses, in particular inkjet presses, have higher printing speeds than the Delphax described in the study, albeit at somewhat reduced print-quality levels. This would necessarily push the crossover point to a higher run length; while presses specifically designed for multicolor printing have significantly lower printing speeds than mono-color presses, which would tend to lower the number of units at which the price per unit produced by conventional and digital printing processes converges.

A new business model requires a new means of production

The long tail in book publishing

In 2004 Chris Anderson, the editor-in-chief of *Wired* magazine, wrote an article in his publication entitled 'The long tail', where he discussed the emergence of a new business model in online commerce activities that is diametrically opposed to the conventional media and entertainment industry business model in general and the bookselling business model in particular (Anderson, 2004). For the title and essence of his essay, Anderson borrowed the statistical term 'long tail', denoting the part of a frequency distribution that tails off from a high-amplitude distribution. The long tail frequency distribution graph shows that the combined effects of selling relatively obscure items in small quantities from a large selection can be a major source of revenue (see Figure 3.1). This business model has proven to be particularly successful in the book and music retail sectors, where online merchants such as Amazon and iTunes have pioneered the long tail business model and are now enjoying a commanding market share advantage.

The conventional bricks-and-mortar bookselling business model features yet another long tail effect known as Pareto distribution, originating from the Franco-Italian economist Vilfredo Pareto who observed in the 1800s that 80 per cent of the wealth in Italy was owned by 20 per cent of the population, an axiom also known as the 80/20 rule. Since that time, Pareto analysis has been used to model many real-life phenomena. In its very essence, Pareto analysis aims to distinguish between the *vital few* and the *trivial many*, so that resources can be committed more cost-effectively.

An idealized Pareto analysis is seen in Figure 3.2, where the first two, or 20 per cent, of ten book categories are shown to generate 80 per cent of a hypothetical bookseller's sales. In the conventional business model

Figure 3.1 The long tail of diversity

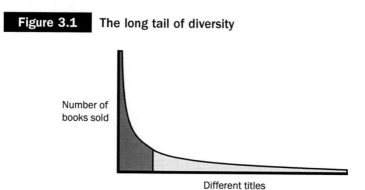

Number of
books sold

Different titles

the bookseller might reduce or even drop the inventory of the eight, or 80 per cent of, categories that account for only 20 per cent of sales, because they take away valuable shelf space which could be used more profitably for the minority of book categories that generate the greatest revenues.

In the real publishing world, general fiction and genre fiction have about 15 per cent each of the market share, followed by pre-school and picture books (approximately 9 per cent), children and young adult fiction (around 9 per cent), biographies and autobiographies (7 per cent), atlases/maps and travel (6 per cent) and humor/trivia and puzzles (5 per cent), before the distribution falls below 5 per cent for the next six genres. The largest market share with 18 per cent of sales is taken up by a category that defies description and is therefore called 'others' (Daniels, 2006: 14). The aggregate value of the 'others' book category and a multitude of obscure titles in any of the distinct genres could be in the order of several million book titles if out-of-print titles, books in the public domain and second-hand books are included. Given that bricks-and-mortar bookstores have a limited physical capacity to stock books, the 80/20 rule dictates the exclusion of several million titles that are populating the long tail, which are consequently lost as a potential source of revenue. In his article Anderson (2004) aptly calls this inherent limitation of bricks-and-mortar businesses 'the tyranny of physical space'.

The new business model represented by a long tail distribution is the exact inverse of the conventional business model as represented by a Pareto distribution. This has significant implications for how most businesses, among them book publishing, bookselling and printing, will be conducted and how books will have to be manufactured.

Figure 3.2 Idealized Pareto analysis and graph showing number of books sold by category in a hypothetical bookstore

Pareto for Excel – March to December
Total = 327

Books sold	Total	%	Cumulative %
E category	204	62.39	62.39
C category	58	17.74	80.12
A category	20	6.12	86.24
D category	17	5.20	91.44
B category	9	2.75	94.19
F category	5	1.53	95.72
J category	5	1.53	97.25
G category	4	1.22	98.47
H category	4	1.22	99.69
I category	1	0.31	100.00
All categories	327		

Bricks and mortar versus online selling of books

The extent to which physical space limits selection becomes clear if one considers that large independent bookstores carry about 40,000 unique book titles, while the average Barnes and Noble super-bookstore has an inventory of 100,000 titles and the reportedly largest bookstore in the world, a Barnes and Noble super-bookstore in New York, carries as many as 250,000 unique book titles. As impressive as these figures are, they are dwarfed by the internet bookseller Amazon, which with an internet book market share of 70 per cent has an inventory of 2.3 million unique book titles. To put this in perspective, the quantity of unique book titles available from Amazon is 23 times higher than the inventory of an average Barnes and Noble super-bookstore, and more than 57 times more book titles are available from Amazon than a large independent bookstore can carry (Brynjolfsson et al., 2003: 2, 14 and 18).

By not being able to offer the same breadth of selection as online booksellers, the loss of sales to bricks-and-mortar bookstores in the USA alone has been estimated to be $578 million. Also significant is the fact that the average price of obscure books is higher than that of mainstream books. It has been estimated that books in the Amazon sales rank above 100,000 (i.e. the less popular books) sell on average for $41.60, as opposed to $29.26 for books below that sales rank (ibid.: 20–1). If the Amazon sales rank ranges above the inventory capacity of the aforementioned bookstores are used as a yardstick, they generate sales of 29.3 per cent, 39.2 per cent and 47.9 per cent in the >250,000, >100,000 and >40,000 sales rank ranges respectively, which means that almost half the books sold by Amazon are relatively obscure titles (see Figure 3.3) (ibid.: 18).

The long tail is as much a cultural as an economic phenomenon, which probably has always been a significant factor in economic environments where an abundance of resources exist. The difference between times past and now is that electronic networks have removed the physical barriers to searching for an item of interest. Anyone with access to this network, called the internet, has the wherewithal to search for the availability of resources; furthermore, it is utterly immaterial whether an item is stored across the city, across the country or across the world – it can be found quickly and conveniently if it resides on a server that is linked to the internet.

Online companies such as Amazon have taken advantage of this unprecedented ability to search for items via electronic networks and created a virtual marketplace to fulfill orders for these items in a timely and

Figure 3.3 Number of book titles available from bricks-and-mortar bookstores and Amazon

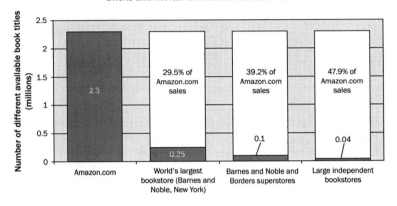

Bricks-and-mortar and online bookstore inventories

cost-effective manner – especially if the item requires no physical storage, as is the case with digital-content products such as books, music, video games and movies. Music, games and movies are downloadable as pure digital products, and the same is possible for books if they are intended for some type of e-book publishing format or reading device. Likewise, physical books can be produced and distributed through the same electronic channels if a digital printing device is part of the electronic network.

The capability for taking orders for physical books and integrating their manufacture via electronic networks makes books and other printed products unique among product categories. For that reason, Amazon has expanded its services from being a virtual marketplace for publishers, booksellers and book buyers to being a producer of books, through the acquisition of established print-on-demand operations such as BookSurge (www.booksurge.com).

Since the size of the online market is inextricably linked to the growth of the internet, it can be expected that online commercial activity will continue to grow as more customers gain access to the internet. Online commercial activity is also likely to grow because an economy and culture of abundance is fostering the fragmentation of formerly homogeneous product categories. This can be witnessed especially in the publishing industry. While in the past news-stands carried only a few mainstream magazines and newspapers, there is now a plethora of magazines catering to every esoteric interest imaginable, and more newspapers are focusing on increasingly smaller geographic regions and ethnic communities. The same trend can be observed for the book

publishing sector, where more titles are being produced now than during any time in history (see Figure 1.6), in large part because digital print-on-demand technology lowered the threshold for authors to get their writings printed and published unencumbered by the commercial imperative of high sales per title.

If the trend of the *New York Times* bestseller list is an indication of contemporary consumer behaviors, then today's readers are more fickle than the readers of previous generations. In the 1970s the average time that a bestselling novel remained on the bestseller list was 13.9 weeks. This dropped to 7.2 weeks in the 1980s, 5.5 weeks in the 1990s and is now only three weeks. While the blockbuster still exists in book publishing and can be witnessed in the recent and aforementioned Harry Potter publishing phenomenon, the replacement cycle continues to decrease because of the public's expectations for new content at an accelerated rate. This appetite for more content is also demonstrated by the near doubling of numbers of books published in the USA, from 104,124 in 1993 to 190,078 in 2004 (Fenton, 2006: 20). These increases are especially strong for special-interest titles, as was observed by a senior book publishing analyst:

> Blockbuster books aren't enough to lift the industry. Recognizing this, publishers are exploiting the market opportunity of producing books targeted to small audiences who are passionate about the subject. For example, books on vampires, auto racing, and paranormal romance are a few of the small and vibrant categories out there. (Norris, 2007)

Book publishers are understandably coy when it comes to revealing the size of their book editions, and consequently primary statistics on average run lengths are not easily obtained. Some sources have estimated that in the USA the average book sells fewer than 2,000 copies (Rosenthal, 2004: 65), but it does not take a leap of the imagination to deduce that books written on esoteric or extremely narrowly focused subjects must necessarily be printed in limited numbers, as these types of books are not likely to attract middle-of-the-road readers.

There is obviously a market for this profusion of publications which cater for the tastes and interests of an increasingly diverse readership, but this is not a new cultural phenomenon. While in the past the range of available publications was much smaller than now, this in no way indicates that a desire for greater diversity did not exist; rather it means there were no practical technological means to produce book titles with limited appeal to the mainstream reader economically.

The concrete implication of these developments is that an increased diversity of niche titles will cause the long tail in publishing to grow even longer.

The long tail of backlists

Most publishing houses maintain backlists that can make them handsome profits, because expenses such as advances to authors and fees for book design and editorial work have already been paid when a title was first released. Backlists are not likely to make it to the national bestseller list, but what they lack in mass appeal is made up for by their longevity. Bricks-and-mortar bookstores simply do not have the physical space for their growing numbers, and must therefore be very selective as to which backlist titles they will carry. Consequently a great majority of backlist titles never make it to the shelves of bricks-and-mortar bookstores. Online bookselling has had a markedly positive effect on backlist sales, with some publishers reporting a 12 per cent increase in the sales of backlist titles (Brynjolfsson et al., 2003: 3).

Thus far the discussion of the long tail has revolved around the diversity of supply, but the dynamics of backlist titles also follow the long tail model if the diversity axis is substituted with a time axis. Most books are better sellers soon after they have been released, because of the greater attention given to new titles in catalogs and various promotional events leading up to their release. But even bestsellers do not remain on a bestseller list for a protracted period of time, as interest in them wanes and the focus shifts to the next flavor of the month.

This early stage in the life of a book forms the high-amplitude segment of the long tail curve, which then gradually tails off, but never really disappears if it is on a publisher's backlist (see Figure 3.4). The combined effects of longevity and multiple backlist titles are often a publisher's mainstay, and frequently the single most important source of revenues.

There is an interesting, if extreme, example of a book that took almost 200 years to sell out. In 1907 Oxford University Press sold the last copy of the Coptic New Testament of Wilkins, first printed in 1716 (http://clausenbooks.com/bible2000htm). Although technically this was not a backlist but an overstock example, it nevertheless demonstrates the remarkable longevity of some books. With a recorded history of at least 2,000 years, an even better example of some books' longevity is the Bible itself.

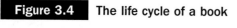

Figure 3.4 The life cycle of a book

Such a long product life cycle is almost unheard of in many other industrial sectors. The apparel, consumer electronics and automotive industries, for example, have to change the styling and substance of their products on a yearly basis to keep up with cultural trends, the vagaries of contemporary style and technological innovation. While the book publishing business is also subject to trends, this applies more so to fiction and topical non-fiction dealing with technology, popular culture or current events. Classics in literary fiction, such as Mark Twain's *The Adventures of Huckleberry Finn* or Leo Tolstoy's *War and Peace*, or works on philosophy such as Thomas Hobbes's *Leviathan*, will probably never be out of print. But many lesser-known biographies, works on history or science and how-to books are often just as timeless in their appeal.

While backlist titles and the multitude of niche titles that populate the long tail vary widely in their content and appeal to different people, the one common denominator is the relatively small quantities in which they are consumed. Small editions have always been an economic challenge for publishers, but with the advent of digital print technology 'small is beautiful' (Schumacher, 1973), and small rather than large editions may be the future of book publishing in the digital age.

The digital printing advantages

If one thinks of books as manufactured goods, then the economics of book publishing are no different from the economic implications of any other manufactured article – that is to say, the costs per unit continue to decrease as the quantity of units produced in a given production run increases. This was demonstrated in the previous chapter, where the cost of printing a 240-page book was shown to be $0.80 per unit for a print

run of about 50 copies and less than $0.10 for a print run of 10,000 copies (see Figure 2.16). Economies of scale do not necessarily result in increased profits for the publisher, however, unless all or a great majority of books printed are actually sold. Thus the potential for the commercial success or failure of a book project rests in large part on a publisher's sales projections.

Predicting the sales prospects of a new book has been a perennial problem for publishers ever since it became possible to produce books in quantity, and judging by the large number of returns that certain sectors of the book trade experience, these predictions are more often than not far off the mark. In the mass-paperback sector approximately half of all books shipped to wholesalers remain unsold (Dessauer, 1981: 47). In other industrial sectors, such as automotive or consumer electronics manufacturing, 50 per cent return rates would conjure nightmarish scenarios, yet in the book trade this is considered normal.

While one solution is to offer the overstock to the highest bidder as remainders, the most a publisher can hope to recover from such a transaction is the cost of manufacturing the books; short of remaindering the overstock, the books will have to be turned into pulp.

This distribution process is often tenable only because in some economies of scale the manufacturing costs are reduced to relatively insignificant amounts, but nonetheless it is a process that is inherently inefficient and wasteful with regard to material resources. Furthermore, the book publishing supply chain is not limited to manufacturing alone, but also entails inventory maintenance, distribution and the aforementioned cost of unsold inventory, the combined cost of which could be 30–50 per cent of the cost of a book (Fenton and Romano, 1998: 55).

Save for the above-discussed concerns, economies of scale are nevertheless a sound business concept without which people in the industrial world would not enjoy today's high standard of living. Indeed, it would be a folly to dismiss the benefits, because a return to the pre-industrial one-off custom-made manufacturing process would obviously be a regressive step in the wrong direction.

The paradox of digital manufacturing, including digital printing, is that both extreme customization and economies of scale are possible. In the early digital manufacturing stages (pre-press stages in printing) a product exists virtually in the form of bits and bytes, which are transformed into atoms only when a digitally compliant manufacturing device, such as a digital press, produces hard copies. Since the bits and bytes can be stored on a computer storage device in any sequence, three different printing production scenarios are possible.

In the first scenario the same page or range of pages is printed in succession as many times as is required. There is only one set of digital data describing the images being printed, which is then programmed to be printed repeatedly, similar to printing the same book signatures multiple times on a conventional printing press. For multiple-page documents there is a significant workflow difference, however, because unlike conventional printing processes, a digital press can print *all* the pages of a book in succession.

When digital processes are used to print the exact same product repeatedly, such as the pages of a book, they are competitive only up to a certain crossover point, beyond which it becomes more economical to use conventional processes due to their greater printing speeds. The reader is once more referred to the cost comparison made earlier, where this crossover point was calculated to be 3,000 copies under certain production conditions. The fact that 3,000 books is probably very close to the average size of book editions released today renders digital printing the most economical choice for a great number of book titles.

The capacity of digital devices to print an indefinite range of successively different pages in sequence is a significant workflow contraction for book printing in particular, because it eliminates page assembly as a separate operation. This is the fundamental reason why the printing and binding of finished and saleable books in one continuous operation is possible only on digital printing devices.

In the second scenario, the content of one or more printed pages changes dynamically at the time of output and at the rated speed of the digital printing device. An entirely new type of text manipulation technology, called variable data printing (VDP), allows text, graphics, colors, charts, layers, fonts, backgrounds and entire pages to be changed dynamically during the print run. Insurance companies, financial corporations and the finance departments of governments use VDP in order to provide their clients with personalized financial statements, including numeric data, graphic representations of the data and personal information that is wholly unique to an individual.

Variable data printing projects are created with authoring tools wherein the variable content of a document is formatted and user-generated logical expressions interact with a database. A simple result of such interaction can be seen in Figure 2.13, where the name of a book's owner was queried from a database and dynamically printed as part of the book's front matter. Much more visually interesting and content-specific applications, such as personalized story lines and images, could be created for books, but because of VDP's relative newness its full

potential has not yet been exploited by authors and the book publishing industry. If a printing project includes variable data, digital printing processes are the only option, as conventional printing processes are capable only of static image reproduction.

And finally, the third production scenario for digital printing leverages its facility for extreme customization while at the same time printing books in quantity, thus combining the seemingly diametrically opposed one-off and mass-manufacturing business models. The VDP illustration given in Figure 2.13 could again serve as an example. Supposing that not one but 1,000 books were printed, each with a different owner's name printed in the front matter, then each book features a unique, albeit modestly unique, component. Because the amount of variable content does not change or slow down the process, there is no productivity difference between books that vary minutely, as described above, or books that vary to the extent of entirely different titles being printed in succession. The difference between changing only the first and last name of a book's owner as opposed to changing to an entirely different title is in essence a database and digital storage issue. In the first instance a database is queried for names, and in the latter instance the digital files of different book titles are queued in the order that they will be printed.

Digital printing's ability to print any number of entirely different book titles in succession at the rated speed of the device has at once returned the book publishing and printing businesses to the medieval one-off business model while maintaining the advantages of economies of scale, which themselves are boosted by the enormous selection available from internet booksellers, the ease with which titles can be searched and the increasing number of people who avail themselves of online shopping services.

In more concrete terms, this means an order for a single book that has never been printed before can be economically fulfilled, simply because this book, when printed on a digital press, is merely one unique unit among many others in a production run, thus economies of scale are achieved by many different rather than many alike products.

When books are printed by conventional processes there will not only be interruptions due to the changeover from one book signature to the next, but also from one book title to the next, which lowers the utilization rate of a press. Fixed costs such as depreciation, rent and energy can be recovered only when the press produces saleable copies, not when it is idle during changeovers. Digital presses, on the other hand, can print entirely different titles in succession without interruptions between printing one title and printing the next, thus the utilization rate is high. Put in other words, the digital press is used

continuously, producing uninterruptedly a large number of pages for a multitude of different titles.

Both conventional and digital printing processes benefit from economies of scale, but the significant difference is that the large number of identical books printed by a conventional press may or may not be sold, while the printing of a large number of different books in small quantities by a digital process is initiated only once orders for the books are actually received, which precludes costly overstock and returns due to unsold copies, as well as eliminating the costs associated with warehousing.

Furthermore, the demand for books is more than ever before driven by a large number of titles that were previously not available to readers, because they either could not be produced economically by conventional means or were not stocked due to limited shelf space in conventional bookstores. Also, internet search engines and steadily increasing cyberspace traffic have increased the pool of available books and widened the customer base.

Digital printing processes more closely match the new supply and demand realities of the internet age because of their direct integration with electronic networks, which also facilitates searching for books and processing orders. For example, if a digital press is networked to a database storing tens of thousands of books and an online ordering system, the production of a finished book could in theory be initiated by a request from anywhere in the world. Digital printing processes are ideally suited for this new business environment, where the requirement to respond to an increasing demand for a multitude of diverse titles in smaller quantities calls for flexibility rather than fast printing speeds.

The digital printing disadvantages

While digital printing processes meet many requirements of the digital age, they are not without shortcomings, which will be discussed here in relation to the performance characteristics of conventional printing processes.

Slow printing speeds must be placed at the top of a list of digital presses' disadvantages, which is best illustrated when they are compared to the productivity of the modern offset-lithographic blanket-to-blanket full web press that is often used for high-volume book printing. The comparison is based on the number of pages that can be printed per hour, where a page is defined as one side of a leaf or sheet of paper. The square area printed on a web-offset press is the equivalent of 16 letter-sized pages

per printing cycle. If the press runs at its top speed of 2,500 feet per minute it will produce 654,240 leaves or 1,308,480 pages per hour. This is in addition to inline folding of sheets into book signatures, for subsequent assembly and binding into finished books as separate operations. Conversely, one of the fastest digital presses on the market can be configured to print a square area equivalent to four letter-sized pages per print cycle. At its rated speed of 500 feet per minute, this press will produce 65,400 leaves or 130,800 pages per hour. The productivity of one of the fastest digital presses on the market is thus about one-tenth that of a conventional printing press.

The productivity deficit of digital presses is thus quite significant, but, as previous discussions have shown, it is a critical issue only at a particular run-length threshold, which was calculated to be 3,000 single-color books and is lower still when books are printed with multicolored images. Digital printing speeds, particularly inkjet printing speeds, have risen steadily and are likely to continue their upward trend, but whether they will reach current conventional printing speeds remains to be seen.

The print quality for text must be considered equal for both conventional and digital printing, if somewhat higher for digital printing because of greater density consistencies across pages and from one page to another. Halftones reproduce equally well in both printing processes, except for gradient fills, which can exhibit visible tonal steps, also known as banding. Images, in particular solid images printed on electrophotographic devices, are prone to cracking when scored, which is a concern for cover printing.

Digital printing processes can now print on a wide variety of substrates, but due to their relatively unsophisticated paper-forwarding mechanisms, problems with extremely light or heavy paper weights can be experienced. This is particularly true for sheet-fed digital presses. Toner-based digital printing devices are generally compatible with a wider range of substrates than inkjet printing. The inkjet printing process uses very fluid inks, which tend to spread when printed on porous and absorbent papers – a problem known as feathering.

Paper-based communication media have in recent years attracted a lot of attention from environmental protection agencies and lobbies, as a result of which paper recycling is now a common practice. A critical stage of paper recycling is the de-inking process, without which sufficiently white paper cannot be produced. Since the vast majority of printing paper is currently consumed by conventional printing processes, paper manufacturers have developed de-inking processes that are effective for the offset-lithographic process in particular, but less so for other printing processes, including toner-based digital printing.

Toner-based printing processes have recently also been found to release extremely small toner particulates to ambient environments, which presents a health hazard for workers. As digital printing processes gain in popularity, their environmental impact is likely to come under greater scrutiny; among other digital printing constituents, paper manufacturers will have to find effective de-inking processes for the steadily increasing proportion of recycled waste that is imaged by digital printing processes.

Bookbinding

A book does not serve its purpose as it should without joining the pages, shaping the book block into its time-honored form and packaging it between decorative and protective covers. But a meaningful analysis of potential quality issues in relation to the binding of digitally printed books must be preceded by a brief discussion of bookbinding in general. There are a number of different binding methods, but only the thread-sewing and adhesive binding methods are cut out for the rigors of handling and shelving books while at same time maintaining a high degree of user-friendliness.

In thread sewing the bond between the pages is primarily achieved by fabric threads and secondarily by reinforcing elements such as gauze-like materials that are glued to the spine and main stress areas of a book block. Thread sewing, in spite of its ancient standing, is still the strongest and most user-friendly binding method. But these qualities come with increased costs, mainly because the thread-sewing process is relatively slow and complex and cannot be integrated with other binding phases, such as signature assembly and trimming.

The connection of pages to each other by adhesive binding methods is achieved primarily by glues. Like thread sewing, in adhesive binding methods the book block is secondarily reinforced by gauze-like materials. Although adhesive binding methods are not as strong as thread sewing, new hot-melt glues such as ethyl vinyl acetates (EVA) or polyurethane-reactive (PUR) glues, as well as cold emulsion polyvinyl acetate (PVA) glues, have narrowed the quality gap between thread-sewn and adhesive-bound books considerably.

A critical phase in adhesive binding technology is the preparation of the binding edge of a book block by alternately roughing and grooving the binding edge to improve the adhesive bond between the pages. This tends to restrict the flexibility of pages when opened somewhat, and must be accepted as an unavoidable consequence of adhesive binding methods. The reason why adhesive binding has been accepted so widely in spite of some quality detractions is the great economy the process affords,

because all phases of binding, from signature assembly to binding, cover inserting and trimming, can be executed in one continuous manufacturing line.

When book signatures are printed by conventional processes, the binding phase is always an offline manufacturing process, which is to say printing and binding are executed as separate manufacturing phases. Book signatures printed by digital processes can also be bound by a separate offline binding line, in which case binding quality differences are not an issue, as both conventionally and digitally printed books benefit from the same offline binding system.

The unique ability of digital presses to print all pages of a book in sequence offers the option to print and bind books in one continuous operation, which can in practice be achieved by adding third-party binding equipment to a digital press. As advantageous as an integrated system capable of printing and binding may be, the quality of binding is not nearly as good as offline binding quality. Firstly, it is not possible to integrate the superior thread-sewing process in any type of printing press, because of its mechanical complexity; this leaves adhesive binding as the only possible option. Secondly, integrated adhesive binding modules are not nearly as technically sophisticated as offline binding systems, which could cost in excess of $1 million. Consequently, the binding produced on integrated binding systems is limited to adhesives and does not have the additional strengthening materials added by offline binding lines. Also, integrated binding systems are limited to soft-cover production. In short, the binding quality of books printed on digital presses with mechanically integrated binding modules is significantly inferior in strength and added value compared to the binding quality produced by sophisticated offline binding systems.

Book format

One of the endearing esthetic qualities of books is the wide variety of formats in which they can be produced. To suit the content, design and volume of a book, sizes can vary from extremely small to extremely large. Shapes can assume various rectangular proportions, and page orientations can be upright or landscape. Books can also range in thickness from extremely thin to extremely thick. Digital presses can in general not accommodate such a variety of formats, because their maximum press sheet sizes tend to be much smaller than those of some of the conventional printing presses, which limits pagination variability. Format variability is further limited when books are printed on digital

presses with integrated binding systems. An automatic workflow that integrates both printing and binding, though extremely efficient, does not lend itself easily to format changes, as a result of which books printed on such systems tend to be highly standardized.

Chapter conclusion

The answer to the question of whether to print a title by digital or conventional processes depends on run length, print quality and book format requirements. Since the factors contributing to the final appearance of books could be extremely variable, it is difficult to make a general recommendation other than to cite two examples at the extreme opposite ends of the spectrum of possibilities. A book printed with an upright format measuring 6 × 9 inches, consisting exclusively of single-color text and line drawings, to be bound by an adhesive binding method and fitted with a soft cover, is almost certainly produced more economically on a digital printing press than in conventional offset-lithography if the run length does not exceed 3,000 copies. But a thread-sewn hardback art book measuring 10 × 14 inches in a landscape format, featuring four-color-process reproductions, could simply not be produced on a digital press with inline binding capabilities.

Advances are being made on an ongoing basis in both digital and conventional printing processes, thus the performance characteristics of both are likely to improve in the future. Inkjet printing in particular shows promise of higher resolutions by the application of electrostatic fields, ultrasonic effects or using staggered nozzle arrays (Kippan, 2001: 720–5). Printing speeds in excess of 10 m/sec (1,968 feet/min) are being discussed for some other digital printing systems (ibid.: 754), which would raise digital printing productivity very close to current web-offset press printing speeds.

Conventional printing speeds are probably very close to practically achievable limits, because the laws of physics impose a ceiling on how fast paper can be forwarded and how fast a printing cylinder can rotate. The productivity gains made in conventional printing technology are in the areas of set-up times between plate changes by robotized plate-changing systems, automatic pre-setting of ink flow calculated directly from a digital image file and automatic blanket-cleaning devices. This high level of automation allows conventional printing to be competitive with digital printing processes in the short-run printing range, where

digital printing has an ostensible advantage. An example of the considerable productivity gains in sheet-fed offset press technology was demonstrated by a German printer setting out to establish the world record for changing the most printing plates in a given time period: Rösler Druck in Schondorf, Germany, used a Roland 700 six-color sheet-fed offset press to print 1,000 copies of a full-color 2,800-page catalog in a 24-hour time period. Printing the catalogs required 103 set-ups, involving a total of 412 plates (Weiss, 2007: 25).

While set-ups between plate changes will always be a necessity for conventional presses, unlike on digital presses, automation reduces delays between print runs to such short periods of time that in many circumstances the zero set-up advantage of digital printing processes is significantly diminished.

The state of digital printing and integrated book manufacturing systems

Overview

The large number of multinational digital printing equipment manufacturers and the even larger number of digital press models that are competing in the printing equipment market today do not permit an all-encompassing survey; therefore, in keeping with the objectives of this discussion, the focus will be on a small sample of digital printing presses that reflect extant technological diversity as well as potential for book printing now and in the future.

As interior book pages can be printed in black or multiple colors, a survey of digital presses must likewise differentiate between single- and multiple-color devices, because there are considerable productivity dissimilarities between single-color and multicolor digital printing presses. Additional consideration must be given to the inline finishing capabilities, which range from presses with the sole purpose of printing to systems that produce saleable books in an integrated manufacturing line.

If book pages are printed on dedicated digital presses, binding quality differences between digital and conventional printing are not an issue, because the offline manufacturing phases to convert the pages into books are essentially the same for both processes. However, books that are produced on integrated manufacturing systems, which by definition must be printed on digital presses, will suffer some quality detractions as integrated binding systems are not as technically sophisticated as multimillion-dollar offline bindery equipment.

Like most products, depending on their end use, books can be produced at different quality levels. Expensive coffee-table and art books

may demand the highest quality in terms of paper, print and binding, whereas less expensive mass-market soft-cover fiction may not require much more than tolerable readability and a lifespan of a few readings. Accordingly, both lower and higher print and binding quality presses and systems are equally important, because regardless of their technical capabilities each press and system can find a useful application in the manufacture of a wide variety of books.

An important criterion when evaluating different presses is their productivity in terms of processing speeds. Sheet-fed and roll-fed productivity are measured differently. In roll-fed systems processing speeds are measured by the linear length of paper printed in one minute. For example, a processing speed of 410 ft/min means that a length of paper measuring 410 feet has been printed in one minute. This in itself does not indicate how many pages have been printed, as this will depend on the length of the book page in the process direction of the press and the number of pages that fit in the width direction of the web. Therefore, if two letter-sized pages (8.5 × 11 in) fit in the width direction of a web and the pages measure 11 inches in the process direction of the press, the number of pages that can be printed in one minute if the press is running at a production speed of 410 ft/min is $\frac{410 \times 12}{11} \times 2 = 894$. For valid productivity comparisons the output of all presses under consideration must be identical in terms of the area printed. For this reason, the productivity for each press will be based on its output of letter-sized leaves (8.5 × 11), imaged on both sides of the leaf.

The print quality produced on digital presses is a measure of the density of the smallest image element per unit area that a given device can generate. The higher the density of these image elements, which are variably called pixels, spots or dots, the better the image quality is. For example, a digital printing device that is rated to have a spatial resolution of 600 dpi refers to the number of distinct adjacent dots that can be placed without overlap within a distance of one inch in a linear array. The minimum resolution for acceptable commercial print quality is generally considered to be 400 dpi (Nothmann, 1989: 25). In some imaging systems it is possible to increase the density of dots in a linear array by allowing them to overlap partially. This is called addressability, which has a noticeable and beneficial effect on the quality of a reproduced image without reducing the size of the dots. Such systems produce the rated spatial resolution in the process direction of the imaging system and considerably higher dot densities along the linear array. As the dot densities of these systems is different in the x and y

directions of the area to be imaged, two different numeric values, such as 600 × 4,800 dpi, are used, where the first value specifies the spatial resolution and the second value specifies the addressability of the device.

Single-color digital presses

Although the use of color is on the rise in book categories with rich graphic and pictorial content, in other major book categories such as genre fiction and general fiction the interior text pages are almost always printed in single-color black. Hence, it would probably not be far off the mark to surmise that as a percentage of the whole the total number of black-only pages printed globally far outnumbers multicolor book pages, and consequently single-color printing presses occupy a dominant position in the book printing industry.

Nipson VaryPress 400

This dry-toner digital printing system utilizes the magnetography imaging principle (see Figure 4.1) and flash-fusing technology. Flash fusing implies that no heat is required to achieve a permanent bond between the toner particles and the substrate. The exposure of paper and other substrates to high temperatures, used in some other systems, can have negative effects, such as shrinkage and distortion of the sheets, as well as static electricity, causing sheets to cling to each other.

Figure 4.1 Nipson VaryPress 400

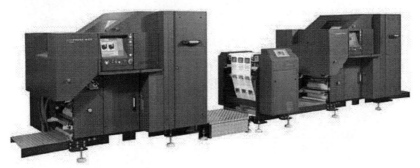

Source: reproduced courtesy of Nipson Digital Printing Systems

At its maximum production speed of 410 ft/min (125 m/min) this press prints every minute 894 letter-sized leaves (8.5 × 11 in) imaged on both sides, when two pages are positioned across the maximum web width of 20.5 inches. The maximum imaging length in the web width direction is 18.45 inches (468 mm). The quality of the image as a function of spatial resolution is 600 dpi, which is generally considered to produce good print quality for text and line art. Being a web press, it is roll-fed; depending on the type of delivery options used, printed products can be delivered in roll or sheet format. The imaging length in the process direction can range from two to 35.75 inches (50.8–908 mm), and coated as well as uncoated paper weights ranging from 40 to 240 g/m^2 can be printed (Nipson, 2006).

Delphax CR2000

The print engine of this digital press is based on ionography (see Figure 4.2), also known as electron beam imaging. Similar to the Nipson VaryPress 400, it requires no direct heat application to fuse the dry-toner particles to the substrate but uses a combination of radiant heat and pressure, thus ruling out some of the problems associated with a substrate's exposure to extreme heat.

At its maximum speed of 450 ft/min (137 m/min) this press prints every minute 981 leaves (8.5 × 11 in), imaged on both sides, when two pages are positioned across the maximum web width of 19.75 inches. The manufacturer of the CR2000 declares it to be the fastest toner-based press and foresees substantial productivity upgrades in the future.

| Figure 4.2 | Delphax CR2000 |

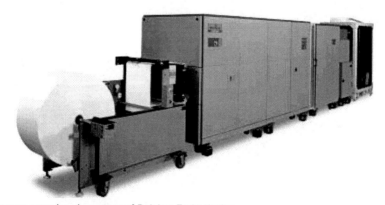

Source: reproduced courtesy of Delphax Technologies

The quality of the image produced as a function of spatial resolution is 600 dpi. The roll in-feed system of this web press can deliver the output in sheet or roll form, depending on the type of delivery options used. The imaging length in the process direction can range from six to 60 inches (152–1,524 mm) and paper weights ranging from 40 to 226 g/m^2 can be printed (Delphax, 2004).

Kodak Versamark DS3700 Printing System

While the 300 dpi spatial resolution of this high-speed inkjet printing system falls short of the printing quality requirements for some book projects, its remarkable printing speed of 1,000 ft/min (304 m/min) and its 40-inch (1,016 mm) imaging capability across the web rival the productivity of many conventional web-offset presses. The Kodak Versamark DS3700 (see Figure 4.3) is typically used for projects with functional purposes, including transactional printing and mass mailings requiring variable data printing (Kodak, 2006), but some printers in the USA have successfully used it for book printing applications.

If the rate of progress made in digital printing technology over the last two decades is an indication of future developments, it is probably not unreasonable to expect further image resolution improvements in high-speed inkjet printing technology. If some of the projections made by experts in the field materialize, inkjet printing could well become the preferred process for medium to long book printing runs, where currently conventional processes such as web-offset printing have a productivity advantage.

Figure 4.3 Kodak Versamark DS3700 Printing System

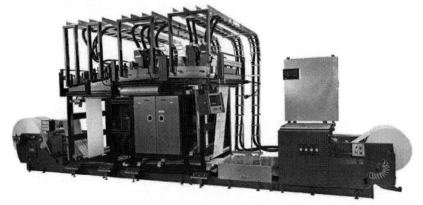

Source: ©Kodak (reproduced courtesy of Eastman Kodak)

Multicolor digital presses

The use of color in all media types is now so well entrenched that single-color black is often seen as a novelty. Almost all households worldwide receive color TV programming exclusively, the internet is viewed on color monitors, the majority of movies are now shot in color and reproduced in color on DVDs, and virtual-reality video games would certainly not be possible without the use of color. In short, we live in a world of color, and for the print medium to remain a viable communication choice it must be able produce attractive and lifelike color images, as otherwise publications such as travel and art books, cookbooks, children's books and other illustrated material where color is an essential element to convey ideas will not be the preferred communication medium of contemporary consumers.

Conventional printing presses have been able to reproduce colored photographs for at least 100 years by the four-color process. In recent years, technical innovations such as stochastic screening, so-called high-fidelity printing systems and gloss coating processes have resulted in a level of image and color fidelity that often cannot be matched by other media types. What is more, these high levels of print quality are achieved by web-offset press productivity rates that can exceed 2,500 ft/min.

Given these impressive conventional printing press capabilities, the quality and productivity standards against which multicolor digital presses must be evaluated are necessarily quite demanding.

Xerox iGen3 110

The dominant digital printing process for commercial high-speed color printing is electrophotography, which is often also called laser printing (see Figure 2.6). The historical standing of Xerox as the pioneering company in bringing the electrophotographic printing process to commercial fruition had the lasting effect of Xerox becoming a leading multinational digital press manufacturer with a continuing concentration on electrophotography.

The Xerox iGen3 110 is a full-color digital press, capable of imaging four-color-process images on both sides of a leaf (see Figure 4.4). Its output per minute is 50 leaves imaged on both sides with four-color-process reproductions if two pages are positioned beside each other in the web width direction. This represents a 95 per cent decrease in productivity relative to the productivity rate of the high-speed

Figure 4.4 Xerox iGen3 110

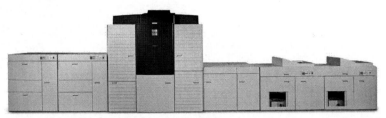

Source: reproduced courtesy of Xerox Corporation

single-color digital presses discussed above. In digital printing, full-color printing is thus significantly slower than single-color printing and vastly slower than four-color-process printing on conventional presses.

The printing resolution of the Xerox iGen3 110 is 600 × 4,800 lpi, and halftone screen values of 100, 175 and 200 lines per inch and stochastic screening are possible, which together with 256 gray-level capacity is quite comparable to commercial offset print quality. The maximum sheet size this press can process is 14.33 × 22.5 inches and paper weights can range from 60 to 350 g/m² for uncoated paper and 90 to 350 g/m² for coated papers (Xerox, 2006b).

HP Indigo Press 5500

This digital press, built by the multinational company Hewlett Packard, also utilizes electrophotographic imaging principles, but it is unique in that liquid inks rather than dry-toner particles are used (see Figure 4.5). The press has four-color capability, but two extra colors for the Pantone licensed HP IndiChroma six-color process can be printed optionally. If two letter-sized pages are printed beside each other in the web width direction, then 33 leaves imaged on both sides in the four-color process can be printed on this press in one minute. This represents only 3.36 per cent of the productivity of some high-speed single-color digital printing presses. The print resolution of this press is adjustable to 800, 1,200 and 2,400 × 2,400 dpi. At the resolution of 2,400 × 2,400 dpi in combination with the six-color mode it is possible to reproduce near-photographic quality.

The maximum sheet size for this sheet-fed press is 13 × 19 inches, and paper weights ranging from 59 to 325 g/m² for uncoated paper and 81 to 352 g/m² for coated papers can be printed (Hewlett Packard, 2007).

Figure 4.5 HP Indigo Press 5500

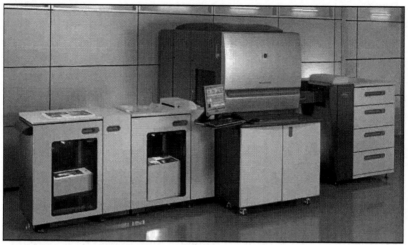

Source: reproduced courtesy of Hewlett Packard

Integrated book manufacturing systems

Until about the late 1990s the technical book production sequence always followed the same path. It starts with the set-up of a conventional press, including the mounting of printing plates and sundry adjustments to the press in order to print a range of pages per press sheet, e.g. page 1 to page 16, followed by folding the press sheets into book signatures either inline on a web press or offline on a folding machine if the printing was done on a sheet-fed press. If a customer's order is for 5,000 books then 5,000 signatures are run. This cycle of events is repeated for subsequent signatures until all the pages of the book are printed. Then the folded signatures are transported to the bindery department or the binding of the books is subcontracted to a trade binder, where the folded signatures are converted to books by either thread-sewing or adhesive binding methods. In other words, the printing and binding of books were distinctly separate processes without mechanical or electronic connections to each other. The inherent inefficiencies of this workflow are the delays caused by image carrier changes when printing signatures anew, the storage of signatures, the transport of signatures to the bindery and the unbundling and feeding of signatures into the binding equipment. Notwithstanding these inefficiencies, the vast majority of books are still produced this way, and while in this workflow delays between production phases are unavoidable, these have been minimized

by the use of automation discussed in the previous chapter. It must be remembered, however, that automation is not cost free, and as a general rule benefits the long-run more than the short-run business model.

The opportunity to combine both printing and binding books in one unified workflow presented itself with the advent of digital printing, because only digital presses can print any number of pages in succession, thus unlike conventional printing presses where sections of books are printed in repeated press runs, a digital press produces a book block, albeit unbound, at the end of a printing cycle. The assembly of pages to produce a book block is therefore an inherent feature of digital presses, and is the fundamental reason why it is possible to bind books in the same manufacturing line that prints them. The prerequisite for binding books inline does thus exist in a digital press, and can be materialized by making mechanical and electronic connections to all necessary bookbinding operations, suitably synchronized with the output of the press.

The process begins with blank paper, dispensed from a roll at the in-feed end of the system, and continues by printing the pages on both sides of the web, which is followed by converting the pages into finished and saleable books. Such a continuous, integrated manufacturing process is unprecedented in the evolution of book printing, and raises the possibility of producing books in an on-demand workflow. On-demand manufacturing at its most ideal implementation implies the initiation of a manufacturing process by a request for a single unit, and as a manufacturing concept is probably more advanced in on-demand printing systems than in most other industrial applications.

Throughout the evolution of the book, printing and bookbinding have led quite separate existences. Consequently, in typical book printing facilities one speaks of the printing and the bindery departments, and often these essential book production phases are separate businesses altogether. Integrated book manufacturing systems, on the other hand, require a different set of technical skills and a mindset that sees the printing and binding of books as a single unit.

On the equipment manufacturing side, much the same development can be observed. Different historical developments and technical complexities spawned distinctly separate printing and bindery equipment business sectors.

The requirement for digital printing-and-bindery modules led to hybrid manufacturing systems that are composed of digital printing devices manufactured by such companies as Xerox, Océ, Kodak, Delphax, Nipson, IBM, Ricoh, Hewlett Packard, Canon and others plus bindery modules from a variety of companies, foremost of which are Muller Martini and C.P. Bourg.

Two different on-demand book printing systems

Xerox

One of the first integrated book manufacturing systems to be introduced to the printing equipment marketplace was the Xerox 6180 Book Factory, now marketed as the Xerox Manual+Book Factory (see Figure 4.6). The system was developed in a partnership with several leading digital printing and post-printing equipment manufacturers, where Xerox supplies the printing components and Lasermax Roll System, C.P. Bourg and Challenge Machinery provide the roll in-feed, binding and three-knife trimming modules respectively. The system is modular in design and can include both the stitched (stapled) and adhesive binding methods, or each binding method could exist in the system exclusively.

The Xerox book manufacturing system is compatible with 14 Xerox digital presses, including the iGen3 full process color press, but in principle digital presses originating from other manufacturers can also be integrated by way of protocol converters.

The electronic linkage of this book manufacturing system to all components within the system itself and to other electronic networks, including local or wide area networks as well as the internet, permits the creative, managerial, editorial, pre-press, press and consumer constituents to communicate with each other and to have a direct influence on the different book production phases (see Figure 4.7).

New orders or reprints can be submitted from remote sites; source files including PostScript and PDF images can be uploaded locally or remotely from any computer storage devices, with electronic job tickets recording the vital product specifications; remote proofing and downloading of high-resolution files for printing are possible; while the technical

Figure 4.6 Xerox Manual+Book Factory

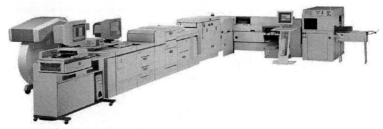

Source: reproduced courtesy of Xerox Corporation

Figure 4.7 Integrated book manufacturing workflow

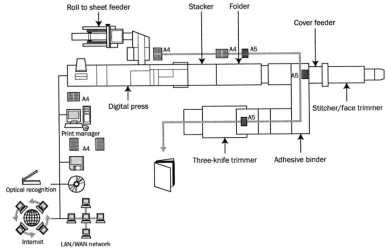

Source: adapted and redrawn from a C.P. Bourg product brochure

production aspects of a job are controlled from a central print manager module, which automates production management, spool management, production optimization, form integration and PDL (page description language) conversions.

Figure 4.7 shows a complete workflow of all input and output options, as well as the technical production sequence. Digital image data from the various remote or local sources are imposed in the print manager module into four-page signatures and transferred to the digital press, where a ribbon of paper dispensed from a roll is imaged on both sides. The ribbon is cut into individual A4 sheets and assembled in a stacker if no further finishing is required. For book and magazine printing the sheets are transferred to a sheet-turning device in order to be perforated and folded into A5 format. The spines of the folded and assembled signatures are then milled and glued in the adhesive binder, a pre-printed wraparound cover is affixed by a cover feeder and the face, head and foot of the books are trimmed by the three-knife trimmer. Alternatively, if the adhesive binder module is bypassed, the signatures can be redirected to a stitcher module, where the assembled signatures are joined with a wraparound soft cover from a cover feeder, in order to be stitched and face trimmed. Binding books by the stitching method is only used in the rarest of cases, because stitching is generally perceived as a somewhat unsightly binding method, and moreover severely limits

the number of pages a book can have (www. xerox.com/digital-printing/printing-press/Xerox-iGen3-110-90/book-binder/enus.html; www.cpbourg.com/products/Online/BBF/bourg_ book_factory.html).

Muller Martini

The reality that in integrated book manufacturing systems both bindery and printing equipment are equally essential is evident in a system developed by Muller Martini, a manufacturer better known for bindery than for printing machines. Muller Martini's SigmaLine book manufacturing system (see Figure 4.8) consists exclusively of its own bindery modules, while the printing component can be supplied by a variety of different sources, including Nipson and Xerox.

In the SigmaLine the printed web is first folded longitudinally on a former folder, followed by two right-angle folds on a knife-folding unit, which offers the option of delivering up to 16-page signatures to the adhesive binder.

Sets of folded signatures are then assembled in the SigmaCollator, from where they are delivered to the SigmaBinder. Here the signatures are adhesive bound and a cover, fed from a cover feeder, is affixed to the book block at a processing speed of up to 1,000 books per hour.

The ability of digital presses to print different books in succession is matched by the adhesive binder and three-knife trimmer modules, which

Figure 4.8 **SigmaLine by Muller Martini**

Source: reproduced courtesy of Muller Martini

adjust themselves to different book sizes and thicknesses ranging from 3 to 40 mm ($\frac{1}{8}$" to $1\frac{9}{16}$"). A unique SigmaLine feature is a buffer zone between the binding and trimming modules, which is created by a component called the SigmaTower. The buffer zone provides additional time for the freshly glued book blocks to dry thoroughly before the final trimming phase (www.mullermartini.com/us/desktopdefault.aspx/). This is particularly important when printing books with low page counts, as their relatively short printing cycles may not allow enough time to dry the hot-melt adhesives that are used in the process.

While a processing speed of 1,000 books per hour is not nearly as fast as offline soft-cover adhesive binding systems, which have productivity rates as high as 18,000 books per hour, this is offset by this integrated book manufacturing system's flexibility to adjust to different book titles, including varying book sizes and thicknesses, without causing interruptions in the manufacturing sequence. Thus the technical ability to produce books one at a time exists, while at the same time maintaining a high degree of mass-manufacturing efficiency – or, put in other words, printing is entering an age of mass customization.

New book genres and book architectures made possible by digital printing

Digital printing returns the book to its early beginnings

The textual and pictorial uniformity of books that readers today accept as normal evolved from the limitation of the early printing processes to produce variability. Prior to the invention of printing, manuscripts were actually created with the expressed purpose of presenting non-generic and personalized information.

There are many examples of personalized medieval manuscripts, but few with a greater clarity of purpose than one with a full-page inscription recording its donation to the Benedictine monastery of Mont Saint-Quentin in 1229:

> In the name of the Father and the Son and the Holy Spirit, Amen. In the one thousand two hundred twenty-ninth year from the incarnation of our Lord, Peter of all monks the least significant, gave this book to the most blessed martyr, Saint Quentin, If anyone should steal it, let it be known that on the Day of Judgment the most sainted martyr himself will be the accuser against him before the face of our Lord Jesus Christ. (Shailor, 1991: 20)

In the late Middle Ages no books were produced in greater quantities than so-called *books of hours*. These devotional texts were often lavishly illustrated with miniatures depicting scenes and images relating to the patron who ordered the work. One such exquisitely illuminated manuscript is the *Très Riches Heures* commissioned by the French Duke

Jean de Berry and painted by the Limbourg brothers around 1413 (Musée Condé, Chantilly, 1962: 7–27). The personalized nature of the manuscript is best exemplified in the calendar pages preceding the devotional and liturgical text pages, where many of the scenes representing a month are dominated by portraits of the duke, as well as by views of his residences and palatial estates.

In time, as all aspects of imaging book pages became mechanized, the personalization of text and images was no longer technically possible and necessarily led to the static book form we are accustomed to today.

With the emergence of digital printing processes in the 1980s, personalized content of the kind practiced in the late Middle Ages becomes a possibility once again, because variable image generation is, unlike in conventional printing processes, inherently rooted in the digital imaging principle, thus creating opportunities for novel book genres and forms.

Course packs and customized textbooks

Some types of publications, such as the classics in literature, are timeless in their relevancy or appeal, while other publications obsolesce so rapidly that annual updates are required to fulfill their intended purpose. The latter easily dated types of publications are an especially fertile ground for print-on-demand production, because of digital printing's relative flexibility to accept text or pictorial changes. Additionally, frequently updated publications are usually more common for works with limited audiences and consequent short print runs, where digital printing processes have the economic advantage over conventional printing processes.

So-called course packs or customized textbooks are such changeable publications, often printed in quantities of less than 200 copies. They are hybrid textbooks of selective book chapters or an assortment of chapters from different books, because from year to year different instructors may be teaching the same course with changing emphasis or new developments in technology or science may require adjustment to the course content.

Customized textbooks *per se* are not new, but in the past they were reproduced from hard copies by means of office duplication and scanning equipment, with less than professional results. Ever since digital image files became the source for all image reproduction, hard-copy scanning diminished in importance, as the extraction of digital data for reprints in another form became an infinitely more efficient method of content management. Digital presses further shortened the product

development cycle, and consequently almost all course packs and customized textbooks are now printed on digital presses.

The printing and publishing of course packs and customized textbooks have spawned new businesses specializing in this type of publication. XanEdu Custom Publishing is one company providing such services, including access to databases of already copyright-cleared materials, customized tables of contents, renumbered pagination and customized title pages including teacher and institution contact information, as well as course information (www.XanEdu.com).

To create a course pack an instructor provides information on the content that should be included in the pack. The company then negotiates copyright clearance for material that did not originate from its own database. The entire process can be completed online, allowing the instructor to preview the course pack and modify it as the need for new course content arises. The output options that the company offers are digital online access and/or printed copies using the plastic comb, three-hole, tape or stapling binding methods.

The advantages of course packs for students is their tailor-made content, which better reflects the material covered in the course as it was specifically selected by the instructor teaching it. From the publisher's point of view course packs are desirable, because unlike textbooks, course packs change from year to year, which discourages the revenue-losing trade of second-hand textbooks.

Photo books

While digital photography has now been accepted as the primary image-capturing technology by most amateur and professional photographers, for much the same reasons that the physical book remains a preferred medium, digital photography has not diminished the desire to own and collect hard copies of favorite pictures. The high value placed on personal hard-copy pictures is time and again demonstrated when people are forced to make choices between material and sentimental possessions in the unfortunate event of catastrophic house fires. Many if not most people will save personal pictures rather than more costly material possessions, or they lament the loss of pictures if they were unable to save them or did not have the presence of mind to salvage them. It is thus clear that tapping into the market of converting digital pictures into a variety of value-added products, of which photo books are but one example, has good business potential.

There are a number of online businesses that allow photographers to store digital pictures on their servers so they may be shared with other people online. Usually this service is free, but these companies also offer additional fee services that convert pictures into a variety of products. One such internet-based company is Shutterfly (www.shutterfly.com). The online submission system used by this and similar companies provides templates with hundreds of backgrounds and layouts for such products as collage calendars, personalized horoscopes and photo books. The process of creating a photo book, for example, requires customers to drag and drop pictures residing on the company's server or pictures that have been uploaded to it, and typing personalized captions into the appropriate sections of the submission form.

The created layout is then printed on multicolor digital presses, and the printed sheets are bound and affixed with a hard cover embellished with personalized titles. In its basic purpose, the photo book resembles family photo albums, and, like the photo albums of old, digitally printed photo books hold the promise of continuing the time-honored tradition of recording pictorial family histories.

Self-published books

At one point or another in many people's lives they want to tell their stories by writing a book. The desire to be noticed is a deep-seated human feeling that exemplifies itself in casual conversations, formal speeches or letter writing, but to reach a wider audience a conduit to disseminate one's thoughts is needed, which is most readily available through the medium of print. It can be said that the technological potential to duplicate text and images gives impetus to the writing of books in the first place, and there is historical evidence to support this view.

From its inception the art and craft of printing was the purview of printers, who by virtue of their specialized knowledge and equipment monopolized print production. It was not until the 1800s that the large and unwieldy wooden press of Gutenberg's design was superseded by cast-iron presses and miniaturized presses suitable for use by amateur printers. Some of these presses were delivered with drawers of type and miscellaneous tools and implements of the printing trade that allowed people inexperienced in the craft to produce printed matter at home, giving rise to a boom of amateur printing activities that reached its zenith between the years 1875 and 1885. While this movement was mainly a middle-class phenomenon, some notables such as Thomas Edison and

Rudyard Kipling were also known to pursue the craft of printing (Cave, 1971: 110–32).

Not all printed matters emanating from this movement and time period were literary in nature, but a substantial number of books were authored, printed and published independent of any intermediaries – somewhat akin to the practice and proliferation of self-publishing in our age, which also springs from new developments in print technology.

The problem faced by contemporary authors, especially unpublished first-time authors, is their exceedingly slim chance of getting published, because traditional publishing houses are extremely wary of the financial risk involved in accepting the work of authors without a track record. The considerable demand for publishing services is underscored by the Association of Canadian Publishers, which reported that publishing houses are inundated with inquiries, book proposals and manuscript submissions (Driscoll and Gedymin, 2006: 43). Most of these unsolicited manuscripts end up unread on what is called the *slash pile*. The unfulfilled desires to see their work in print of what appears to be a considerable number of aspiring authors have led to a growing self-publishing industry, which is in large part driven and made economically viable by online and digital print-on-demand technology.

One of the established players in the self-publishing arena is a company called iUniverse (www.iUniverse.com). Services offered by iUniverse include editorial support, ISBN assignment (with an iUniverse prefix), cover design, index preparation, printing, marketing and publicity. Editorial support ranges from core editing services to advanced and post-production services, with corresponding fees reflecting the level of editorial service provided. All books are printed exclusively on digital presses by companies such as Lightening Source, which also handles the worldwide distribution of books (http://lightningsource.com). Titles published through the services of iUniverse are automatically available on its own online bookstore, and for additional fees may be made available by other major online booksellers such as Amazon.com.

iUniverse publishes about 400 books per month and is a leader in the burgeoning out-of-print books segment (Driscoll and Gedymin, 2006: 147). Other self-publishing companies of note are Lulu.com, which has about 120,000 titles for sale, and AuthorHouse, which publishes between 500 and 600 titles per month (InterQuest, 2007: 10).

The advantages of self-publishing are the editorial control for authors, as they do not have to answer to anybody but themselves; the virtual certainty that their work gets published; and if a book becomes a success the financial gains do not have to be shared with other stakeholders,

such as a publisher or an agent. The disadvantages are that a lack of editorial control could result in substandard literary quality; the costs of producing books are entirely borne by the author; and there is somewhat diminished prestige for the author, as the lack of selectivity has tended to diminish the reputation of self-published works.

Although not typical, some self-published books become bestsellers. For example, Dave Chilton's book *The Wealthy Barber* was first self-published, before selling more than 2 million copies through conventional channels of printing and distribution. Sometimes self-publishing is a stepping-stone to an iconic writing career, as was the case with Margaret Atwood, who self-published her first poetry title, *Double Persephone*, which sold only 200 copies (Driscoll and Gedymin, 2006: 70).

The goal of many self-published authors is not to write bestselling books, however, but to write for an audience that is by definition limited in numbers. This could include the histories of families, social organizations, neighborhoods and other local communities, thereby recording minutiae of the human condition that are usually not captured by mainstream literary works.

Books with variable content

Digital printing's capacity to image entirely different content on successively printed sheets opens the door to new product categories that are not within the ambit of conventional printing processes because of their reliance on static image carriers. Because of the relative newness of digital printing processes in general, and the software that is required to implement content variability in particular, non-static printing has not yet found widespread acceptance. Currently, the main application for what is often called *variable data printing* is personalized advertisements, where the degree of customization can range from simple personalized salutations, for example *Dear Mrs Variable Name*, to complex pieces, such as personalized catalogs that display products which are of special interest to the recipient. Although achieving variable content in books is technically no different from personalized and targeted advertisements, it is even less common than these commercial applications. The discussion will therefore be based on VDP's potential to enhance the literary value of certain book categories, rather than on the few implementations that may already exist.

Probably, a category of books that stands to benefit from variable content more than most other book categories is children's textbooks

and fiction. The homogeneous content that is usually presented in children's textbooks has been a cause of concern for some educational researchers, because in today's multicultural and multi-class educational environment it may contribute to disaffection among some children, as the textual and pictorial content of a book may not be representative of a child's own life experience and milieu (Watkins and Coffey, 2004). Some of the biases in textbooks include references to race, nationality, citizenship, gender, sexual orientation, social status, economic status, type of domicile and type of family unit (Baitz and Breede, 2004: 1). VDP can eradicate such references to specific conditions that do not apply to an individual reader without changing the core concept of a story line.

Other than a digital printing process to reproduce the book pages, variable content requires specific software to insert the personalized content in the variable data fields of an otherwise static boilerplate document. Often but not always the boilerplate content is saved as a PDF file. There could be as many variable data fields as necessary, including both textual and pictorial data. The variable data reside in a database from where they are pulled using the logical programming commands provided by the variable data software. For example, if the main characters of a story are Jane, Tom and Harry, these could be substituted by Hispanic names if the intent is to give the story the air of a Hispanic neighborhood by a command line such as '*If* student = Hispanic *then* Jane = Maria, Tom = Carlos, Harry = Julio'. Or if some pictorial content in a textbook depicts a suburban middle-class residence it could be substituted with a command line that links the postal codes of individual students with the typical residential housing of the area in which they live.

Such preparations not only require programming and database know-how, but also add considerable time and consequently pre-press costs to variable data printing projects. During the actual printing stage, however, it makes no difference whether the output of a digital press is static or variable – production speeds will be at the rated speed of the press for both modes of printing.

The usefulness of VDP in children's fiction is straightforward. It stands to reason that the appearance of meaningful facts in a story, such as a child's own name and the names of family members and friends, as well as personalized pictorial content will motivate young readers to read on with more enthusiasm, because they can relate to the familiar characters in a story-line more intimately (see Figure 5.1 – the variable content is surrounded by dotted-line borders).

| Figure 5.1 | Concept page of a children's book with variable content |

Once upon a time, there was a little prince named Kurt, who lived in the far away kingdom of Toronto.

One day, Prince Kurt was out playing with his friends, Princess Marie and Prince Phillip in the royal park, when all of a sudden, the town drunk, mean Mr. Jones, stumbled upon them.

Mr. Jones cried out, "What are you doing playing in my garden?!"

The royal children looked at one another puzzled. "This is not your garden," replied Prince Kurt, "this garden belongs to my father, King George!"

The accordion book

Up to this point, discussion has focused on novel book genres made possible by digital printing processes, but beyond novel content, such as variable data, digital printing processes also have the potential to reintroduce an ancient book form with a long tradition in the Oriental

world. The stitched or adhesive-bound book has been the standard book form in the Western hemisphere ever since it superseded the roll some 2,000 years ago, but in other geographic regions, notably in Central and East Asia, the roll coexisted with another book form that resembles the folding pattern of an accordion's bellows, hence the term accordion book. In Japan, where the accordion book has a long tradition, it is called *orihon* (from *ori* – fold and *hon* – book). *Orihons* are traditionally made by manual methods for Buddhist sutras and albums of calligraphy or paintings (Ikegami, 1986: 52).

The only practical method of imaging rolls or accordion books is by manual means, and consequently the decline and eventual demise of both the roll and the accordion book forms came as a direct result of mechanized printing methods which are incapable of imaging areas beyond a certain length. This is still true for all conventional printing processes, even though printing takes place on web presses where web lengths in excess of 20,000 feet are processed, because the same image area (40 x 22 inches for typical full web presses) must necessarily be printed repeatedly in the process direction of the press.

Digital printing processes, on the other hand, can theoretically print an infinite number of different images in the process direction of the press, as every imaging cycle always ends with the complete erasure of all traces of previously printed images, thus readying the device for the next successive pair of pages on the front and back of the web.

Current digital printing devices are not yet specifically designed for the production of accordion books, but they have the technical prerequisite to do so. Although most digital presses do in fact limit the imaging length in the process direction of a press, this is an artificial rather than a fundamental limitation effected by the software that controls the device.

The most substantive addition and modification to a digital press capable of printing accordion books is a mechanism that scores the web in alternating directions after each page was printed, so that the web automatically forms the accordion folds by gravitational forces. As well, a cutting tool to sever the web after the last page of a book has been printed is required to separate successive books from each other (see Figure 5.2).

The advantage of digitally printed accordion books is drastically reduced manufacturing costs, while maintaining most of the functional qualities of traditionally stitched or adhesive-bound books. This is easily apparent when comparing the integrated book manufacturing lines shown in Figures 4.7 and 4.8 with the design concept of an accordion book producing press shown in Figure 5.2, which is much simpler and

Figure 5.2 Design concept of a digital press with accordion book printing capabilities

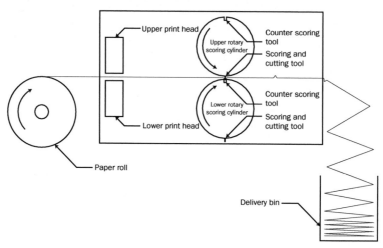

consequently less costly. Furthermore, two-page or multi-page spreads are esthetically more pleasing in the accordion book form where there are no binding materials to obstruct the image areas, which particularly benefits designs with panoramic views (Breede and Lisi, 2007: 82).

The disadvantage of accordion books is the reduced stability they provide, because of the ever-present likelihood of pages unfolding when not handled carefully (see Figure 5.3).

Accordion books derive the most benefits whenever low-cost production is the primary objective, as is the case for disposable books which are purchased strictly for their content only, rather than for their visual appeal or intrinsic value as a physical keepsake. As well, the much-reduced manufacturing costs and the relatively simple design of an accordion book producing digital press may make this book form suitable for in-school printing of textbooks in economically challenged areas of the world.

The major accordion book shortcoming is its lack of a protective cover and a common spine that permits a book to be identified when shelved. This can be remedied by deviating from the alternating accordion-fold pattern toward the end of the folding sequence. In order to create a wraparound cover, the next to the last fold must be made in the same direction as the previous fold, and the last fold yet again will have to be made in the same direction as its predecessor. These last two folds

Figure 5.3 Unfolded prototype of a 96-page accordion book

Source: printed and co-produced by the author on an Agfa Sherpa inkjet plotter

effectively form the spine and the front cover, while the panel ahead of the spine forms the back cover of the book (see Figure 5.4).

The folding mechanism of a machine that is capable of producing accordion books with a wraparound cover is somewhat more complex than the previously proposed design concept for coverless accordion books, because the last two folds, by virtue of deviating from the alternating accordion-fold pattern, necessitate a second scoring mechanism, which could probably be housed in the same scoring cylinders that produce the accordion folds. Moreover, because the additional scoring mechanisms produce the spines of books, they must be adjustable to varying book thicknesses. Unlike coverless accordion books, which are formed in the delivery bin by gravitational forces alone, the cover-forming phase will require a mechanical system in close proximity to the delivery bin, which wraps the cover around the accordion-folded book block, possibly by a mechanical arrangement of grippers and pressure elements.

Accordion books with a wraparound cover are functionally not significantly different from adhesive-bound soft-cover books, but their manufacturing costs will be considerably lower, because the mechanically

Figure 5.4 Accordion book with a wraparound cover

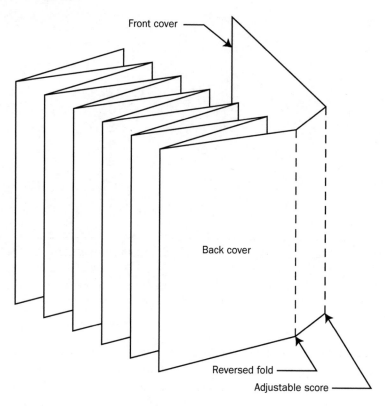

Front cover

Back cover

Reversed fold

Adjustable score

complex binding phase of book production is completely bypassed. Also, since the front and back covers are printed from the same digital file as the interior pages of the book, no separate cover-feeding station is necessary, which reduces the mechanical complexity of the manufacturing system and eliminates the sorting of covers in the correct order when different titles are printed in succession.

Digital printing and the internet complement each other

Consumer behaviors are changing

Discussion on how the internet has influenced commercial activities is a hot topic, but fundamentally the seeds for a shift away from traditional bricks-and-mortar stores to e-commerce were sown some 50 years ago when the concept of do-it-yourself was first introduced to the marketplace. In the late 1950s many retailers began to transform their businesses from over-the-counter selling of goods to self-service supermarkets; do-it-yourself home improvement markets made inroads in the technical service industries; buffet and cafeteria types of restaurants started to compete against traditional sit-down venues; and stores selling furniture that had to be assembled by customers sold their products for a fraction of the price charged by traditional furniture stores. In other words, a trend to engage customers to a much greater degree on the service side of various business activities was set in motion, and continues unabated to the present day.

In the past, the printing industry was too technologically obscure to allow the average customer to participate in technical print production – a state of affairs that changed rapidly with the advent of computer technology and later with the proliferation of the internet. It is now quite commonplace for the average person to generate text and graphics on a personal computer using word processing and graphics software, and to capture press-ready pictures by way of digital photography – to a point where formerly skilled printing professions such as typesetters, film strippers and reproduction photographers have become extinct job categories. Thus a whole generation of people accustomed to the do-it-yourself business model have been given the tools to participate in the technical production of printed matters, and as a result the way printed objects, including books, are produced is changing significantly.

The pre-press stages of print production were transformed from physical to digital processes in about the early 1980s, and the potential to exchange data electronically was almost immediately realized by many printers of the day, putting them at the forefront of digital communication, first with bulletin-board systems and later with the emergence of the internet. FTP sites became printers' mainstay to exchange digital data in the various constituents of print production.

Since these early days, internet communication has advanced from static to interactive mode, allowing users to elicit responses to their queries almost as though they were interacting with a human being. The extent to which such interactive online communication has been leveraged by some printers gives us a glimpse of how the printing business may be conducted in the future. But fundamentally, in spite of their technological sophistry, these systems could not be implemented successfully without a general shift in consumer behavior that tolerates much greater participation in the technical production of printed work.

Leading companies leveraging web-to-print technology

One of the most successful printers conducting worldwide business on the internet is Vistaprint, which according to its annual report increased its customer base from 500 in 2000 to over 7 million in 2006, having received orders from more than 120 countries with total revenue of $152.1 million (Vistaprint, 2006: 3). Fundamentally, Vistaprint's business model is realizable only because of the global reach of the internet, which permits it to aggregate print runs from multiple online orders received from all corners of the world. For example, business cards are printed on conventional 40-inch multicolor offset presses in aggregated print runs consisting of 143 separate customer orders (ibid.: 10).

The interesting observation that can be made in this respect is that Vistaprint's business model is similar to Amazon's bookselling business, in that both organizations rely on an enormous customer base, without which the former could no more fulfill orders of 143 business cards per print run on an ongoing basis than the latter could sell obscure books profitably.

Vistaprint's predominant use of conventional as opposed to digital printing equipment is also noteworthy, because it demonstrates that offset presses can be competitively employed if their productive capacity is consistently maximized by a sufficient number of small orders.

The core of Vistaprint's technological infrastructure is an array of patented proprietary software that automates the entire process from design conceptualization to product shipment. The design phase of a print job is handled by a customer, although toll-free telephone advice is available. Customers require no software, as Vistaprint provides access to its own web-based design and editing software and a keyword-searchable database containing over 70,000 stock images. Customers also have the option to upload their own photographs, logos or complete designs. Customers can select from thousands of design templates for each product category, such as business cards, brochures or flyers. As well, the system automatically generates product categories based on the text and graphic input supplied. For example, if a customer submits the design for a business card, an accompanying design for a letterhead is automatically generated for his consideration.

The project management software driving the system includes an application that enables customers and design professionals to develop projects cooperatively while simultaneously maintaining voice communication; software that prepares customer files for high-resolution printing; optimization software that maximizes print runs; and workflow software that tracks jobs produced in two printing plants located in Canada and the Netherlands.

As impressive as Vistaprint's proprietary suite of software is, it ties up considerable human resources and has a huge price tag attached to it. According to Vistaprint's annual report, more than 70 of its employees were engaged in research and development at accumulated costs of $34.9 million (ibid.: 11). A capital investment of this magnitude all but precludes the use of proprietary software by a great majority of printers, who do however have the option of implementing similar capabilities with the much less costly off-the-shelf software discussed later in this chapter.

It should be noted here that Vistaprint is not a book printer but a printer of commercial materials such as business cards, brochures, invitations and holiday cards, typically consumed by small businesses and individuals. In some respects these types of products represent a greater technological challenge than many book printing applications because of their short run lengths and varying design, color, size and substrate requirements, but more significantly the Vistaprint model demonstrates that the business of printing can be operated globally via the internet.

A company specifically dedicating its services to publishers, booksellers, self-publishing houses and libraries is Lightning Source,

which has book manufacturing and distribution services in the USA and UK. Lightning Source uses digital presses exclusively, as this technology is ideally suited for on-demand printing of books for reasons discussed at length in previous chapters. The capacity of Lightning Source to manufacture a large number of books in extremely small quantities per title is best exemplified by its claim to print on average 1 million books per month with an average run length of 1.8 units per title, and having to date manufactured an aggregate number in excess of 33 million books for over 4,300 publishers (www.lightningsource.com). In part the extremely short runs printed by Lightning Source are attributable to the large number of self-published titles processed, which represent about 30 per cent of its business (InterQuest, 2007: 10). As well, Lightning Source provides the printing and distribution backbone for many self-publishing houses, such as the aforementioned iUniverse.

Lightning Source will accept both hard-copy and digital submissions for on-demand printing. While almost all new books and most books printed in the past ten years will in all likelihood have been produced digitally, those titles that have no digital file repository because of age or neglect will be scanned by Lightning Source, but they have to meet certain minimum standards, short of which they will be classified as custom books, which are priced at a higher rate.

Digital file submissions must be print-ready and conform to certain requirements, as no pre-flighting (checking and verification of electronic image files before they are sent to the RIP) is performed prior to processing. Some major requirements are that both the cover and the interior pages of the book block should preferably be in PDF/X1a:2001 format, and they must have been created with the Acrobat Distiller program because other PDF creators are not necessarily compatible with the Lightning Source software architecture. Also, unripped PDF files with eight-bit halftones have to be submitted, as ripped PDF files will diminish print quality. PDF output resolution must be set to 600 dpi for black and white and 300 dpi for color reproductions. The files can be uploaded via Lightning Source's website, or alternatively sent by CD or DVD; the latter removable storage devices must always be used if file sizes exceed 250 megabytes.

For the book cover the customer has to complete a form that provides the ISBN, select a combination of book size, binding method and paper type from a pull-down menu, enter the page count and select the file types QuarkXPress, EPS, InDesign or PDF from a pull-down menu. The spine width is calculated with an online spine calculator based on the number of pages, the size of the book and the paper that is used. Once the form is

submitted, Lightning Source will e-mail back a template and support files to build the cover. Any resubmissions of files will incur additional charges.

Submitted files are archived in Lightning Source's digital library, which currently holds over 400,000 titles. For orders or subsequent reorders as small as single copies of a book, the digital library is searched for the file to be printed and it is transmitted via electronic networks to the print queue of a digital press with an integrated binding accessory, where finished books are manufactured in one continuous operation for direct shipment from Lightning Source to any of the book supply-chain constituents.

A major difference between the Vistaprint and Lightning Source software architectures is that the former is designed to run on the customer's computer with Vistaprint's proprietary suite of software, while the latter system allows customers to build files with commercially available page-layout software programs like QuarkXPress or InDesign.

The price for printing a 168-page, 6 × 9 inch paperback charged by Lightning Source as opposed to the costs for printing the same book by conventional offset technology were investigated in a study, which made some interesting findings (Rosenthal, 2004: 53–64). Lightning Source prints any number of copies, from single copies upwards, and the printing charge for the sample book in the study was $3.09 per copy regardless of how many copies are ordered; there is no need to maintain an inventory of books as they are printed only if an order is received. If the books were printed by offset technology, the cost will depend on the number of copies, for reasons that are amply discussed in Chapter 2. Accordingly, the prices obtained for the study from an online print broker were $5.26, $4.50, $2.60, $1.04 and $0.83 respectively for book runs of 200, 500, 1,000, 2,000, 5,000 and 10,000 copies.

This means that books in quantities of up to 750 copies are in this scenario printed more economically by digital technology. But if the costs of maintaining an inventory are factored in, the digital printing cost advantage could well extend to considerably higher print volumes, especially if a large number of books remain unsold or the return rate of books is high.

The overriding commonality of print-on-demand providers such as Lightning Source and ColorCentric, which prints the majority of books for the self-publishing company Lulu, is their utilization of digital printing presses. Only digital processes can be networked seamlessly to the software backbone of these companies, and only digital presses can react to the request for a single copy of a book.

For publishers this is a tremendous advantage, because unlike the conventional printing workflow, which is economically viable only for volume printing and requires publishers to estimate the demand for a title,

Figure 6.1 Conventional and print-on-demand book publishing workflows

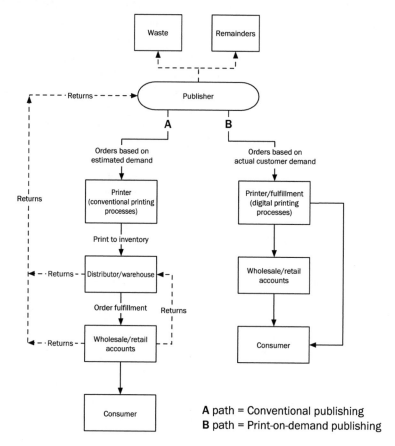

A path = Conventional publishing
B path = Print-on-demand publishing

in the digital workflow a print order placed by a publisher corresponds exactly to the number of books that are actually sold. This means warehousing of books to be sold, as well as costly overstocks that have to be destroyed or sold on the remainder market at highly discounted prices, will become unprofitable practices of the past (see Figure 6.1).

Web-to-print software

Often many technological innovations are first characterized by a catchphrase or buzzword. Such was the case when the term *desktop*

publishing was coined with the emergence of the first page-layout programs in the mid-1980s. Today, hardly anybody uses the term desktop publishing any more, because the electronic pre-press stages of print production are so commonplace that special phrases to draw attention to their utility are outdated.

In some years from now the term *web-to-print* may similarly be destined for the dustbin of obsolescence, because given the enormous growth of the internet it is not unreasonable to surmise that in the not-so-distant future most commercial activities will move from the physical sphere of bricks-and-mortar businesses to the virtual space of the online world.

But these are still early days for printers to conduct their business on the internet and most of them have been prevented from being active participants in e-commerce, to mention yet another buzzword that is making the rounds, by the enormous development costs associated with the underlying software infrastructure driving these systems. That web-to-print works has been amply demonstrated by the previous examples of Vistaprint and Lightning Source, but it must be remembered that these companies are highly capitalized, which affords them the financial and human resources to develop their own software solutions.

In recent years the web-to-print phenomenon has captured the imagination of quite a few software development companies, which has resulted in dozens of off-the-shelf web-to-print software packages that allow mid- to small-sized printing companies to conduct some or all of their business on the internet.

The abundance of existing systems, their relative newness and their varying and multiple functionalities do no always permit objective qualitative evaluations, nor is the establishment of a taxonomy useful at this time as it is prone to arbitrariness. Instead, a brief survey of web-to-print functionalities will give the reader an idea of the broad range of activities that can be conducted on these systems.

As the main preoccupation of any commercial enterprise is to look for new business, most web-to-print solutions emphasize procurement of print jobs by way of online forms. Tied in with print procurement are automatic quote functionalities, as well as secure and encoded payment options. Uploading of digital files is a standard option provided by most systems. Template-based printing is often implemented, because it allows greater standardization, which in turn permits greater optimization of a printer's manufacturing facilities. Template development options are often provided, as these will allow a printer to customize templates in accordance with typical jobs processed at a given company and the

available production equipment. Some systems incorporate VDP software and the required connectivity to various databases; others emphasize workflow automation, which is often tied in with a company's management information system (MIS). Everything from electronic job ticket creation to transferring vital data from one production phase to the next, shipping and billing can be handled by some other applications. The general idea is to reuse data for all internal operations of a company that were initially recorded at the entry point of a job. In contrast to many of the off-the-shelf systems, which exchange data by way of the job definition format (JDF), the proprietary systems discussed earlier rely on their own data exchange solutions (InterQuest, 2007: 26).

With a comprehensive web-to-print system and compatible hardware it is theoretically possible for a customer to create a complex multi-page or multicolor printed matter from a personal computer and control a digital press by placing an electronically submitted job in its print queue, which for all intents and purpose could be located on a different continent. The customer will then be automatically billed, at which time he has the option to transfer the amount due via a secure online payment transaction. Other than the customer's actions and the delivery of the product by conventional modes of transportation, none of the production and billing functions would have required a single human intervention.

A small but by no means exhaustive list of off-the-shelf web-to-print software solutions includes Agfa's Delano, Bluetree Direct's Bluetree2007, Dev Zero G's PrintSure, EFI's Digital Storefront, Kodak's Insite Storefront System and MarketMover, Bitstream's Pageflex Storefront, Print-Quote's Software Inc., Saepio Technologies' Agilis, Press-Sense's iWay, Printable Technologies' PrintOne and Xerox's Freeflow Digital Workflow Collection, including XMPie PersonalEffect to create cross-media personalized documents.

Currently the dominant players, holding 3,500 users among them, are Bitstream, Press-Sense, Printable Technologies and XMPie, which was recently acquired by Xerox (Wallans, 2007), and the single most significant factor driving web-to-print software is the increasing sales of digital presses by companies such as Xerox.

While systems such as PrintSure sell for as little as $3,200, other systems could command prices of $100,000 and more (McKibben and Shaffer, 2007: 23, 66), allowing printing companies of all sizes to leverage the opportunities that the internet potentially provides.

A recent US printing industry survey indicated that about 24 per cent of printers offer some type of web-to-print service, but the web-to-print

adoption rate by printers already operating digital printing devices is significantly higher at 43 per cent (ibid.: 9). The higher web-to-print use by the latter group should perhaps come as no surprise, because digital printing devices are much more readily interfaced with electronic networks as well as being more functionally enhanced by electronic network connectivity than conventional presses. In another survey it was found that of those printers who already provide web-to-print services, 61.2 per cent considered it to have a positive effect on their business. In the same survey, 78.8 per cent of printers considered digital printing to affect their business positively (National Association for Printing Leadership, 2007: 9, 11).

The Amazon.com phenomenon

Perhaps Amazon has popularized the concept of e-commerce more than any other company or organization. Although Amazon now has 28 product categories listed on its website (www.Amazon.com), when the company was founded in 1994 it began as an online bookstore; and books have remained a core product ever since. Today Amazon is the third-largest book retailer, and with a 70 per cent share of the internet bookselling market, Amazon.com is the world's largest online book retailer (Ehrens and Adrian, 2000; Driscoll and Gedymin, 2006: 187).

In essence, Amazon has created a virtual marketplace where potential buyers can search for items that have been made available by sellers of goods, and the fees Amazon charges sellers depend on the level of service they require.

For customers requiring a relatively high level of service, Amazon offers a program called *Advantage*. The *Advantage* program is geared toward the product categories of books and DVDs/videos and requires membership on the part of seller. The cost of membership is an annual fee of $29.95, which entitles the participant to put an unlimited number of titles for sale on the Amazon website. Amazon keeps 55 per cent of the list price, which is determined at the sole discretion of the vendor, and consequently the vendor receives 45 per cent of the list price. While Amazon reserves the right to sell a title at a discounted rate, the customer will still receive his portion of the payment based on the list price.

Other than being a *bona fide* member, the three basic requirements to sell books through the *Advantage* program are that the seller has the distribution rights for a given country, an e-mail address and internet access, and the book cover must have a scan-ready ISBN/EAN universal product code.

Booksellers ship books to Amazon's fulfillment centers at their own expense, while Amazon replenishes the stock according to the frequency of sales. Amazon keeps as few as two copies of a title in stock, requesting vendors to send additional copies when the stock is running low. Worldwide shipping, invoicing, payments and returns are handled by Amazon and vendors are paid on a monthly basis for the books sold during the previous month.

Another program operating at a lower level of service, but giving sellers a greater share of the revenues, is called *Marketplace*. In *Marketplace* the seller is responsible for listing items for sale and all customer services, including shipping orders and returns, while Amazon handles payment processing for items sold. Vendors are charged a per-transaction fee of $0.99, which is waived for certain preferred members, a closing fee of $1.35 and 15 per cent of the sale price.

While these programs are vehicles to sell books that have already been printed, Amazon now also offers on-demand book printing services through its recently acquired print-on-demand company BookSurge, with a technical approach to book printing similar to that of Lightning Source.

The entry of the largest online bookseller into the on-demand book printing arena signals the convergence of a global clientele and bibliographic database on the one hand and digital printing technology on the other. The synergies of a burgeoning worldwide customer base, a huge and growing bibliographic database and the ability to respond to queries by book buyers via electronic networks to which digital printing presses are connected are unequaled by almost any other industrial or retail sector, and open immense opportunities for book buyers, sellers, printers and publishers.

Following the lead of Amazon, all major bookstores now have an internet presence, which contributes to the fact that books are now one of the most common commodities traded on the internet. The first online entrepreneurs could have decided to sell almost any product via the internet, but the fact that their choice fell on books was probably not a coincidence, because few items lend themselves better to online selling. The online saleability of books is attributable to three major reasons.

The bibliographic database that existed even before the emergence of the internet is the primary reason why books were an obvious product choice of early online entrepreneurs. No other product category has been cataloged as comprehensively as books, and no other product database comes anywhere close to the magnitude of bibliographic databases. The sheer number of entries and meticulous organization of these databases made them by the far richest source of product information.

Furthermore, the databases could be accessed by internet search engines to provide automatic, instantaneous and comprehensive descriptions of millions of books.

A more mundane but equally important reason as to why books are ideally suited to trade on the internet is their physical attributes. Books have regular box-like shapes, are shock and temperature resistant and on average have a moderate weight, which are all facilitating factors for shipping and mailing. An interesting aside in this regard is that shipments from e-commerce activities became a godsend for many declining postal services around the world, as they now provide the bulk of deliveries of books and other products purchased from online merchants.

And lastly, because the intrinsic value of a book is perceived visually, its desirability can be evaluated on a computer screen nearly as effectively as when handling the physical book itself. This makes it possible to provide browsing customers with online tables of contents and sample illustrations and chapters. Thus *caveat emptor* is much less of an issue with online selling of books than with almost any other product category.

The print-on-demand phenomenon would not have been possible without the evolution of digital printing devices from simple office document reproduction systems to printing systems with a level of technical maturity that allows them to compete in some product categories head to head with conventional processes. Nowhere is this more apparent than in the book sectors of the printing industry.

Digital printing is currently well on its way to capturing the single-color and multicolor short-run book market; and, depending on one's definition of medium-run length, digital processes are likely to become dominant in this segment of the printing industry as well. Digital printing's current market share of only 2.5 per cent of the total volume of books printed underscores the enormous potential for growth that still exists in the digital book printing sector (InterQuest, 2007: 12).

The overall growth rate of digital printing has been estimated to be 7–20 per cent per year depending on the book category, and the projected growth for digital color printing in trade, education, professional and photo books between the years 2006 and 2011 is 24, 25, 29 and 30 per cent respectively (ibid.: 8–9). The fastest-growing digital book printing sector, with projected growth rates of 20 per cent per annum, is black-and-white trade books, whereas the full-color trade book volume, which is only 1 per cent of the total current trade book output, is not projected to increase to more than 2 per cent of total output by the year 2010 because of high digital color printing costs (ibid.: 14).

When digital printing processes first arrived in the marketplace a concept called *distribute and print* was coined. Distribute and print was meant to differentiate digital printing from conventional processes, and usually operates on the basis of the exact opposite principle of *print and distribute*, which is where printing occurs in centralized plants, from where printed products are distributed to customers. Distribute and print implies that digital files can be distributed via electronic networks to a multitude of small digital presses located in diverse geographic regions. The distribute-and-print concept was thought to reduce shipping rates, as the digital presses were located close to consumers. A related and novel concept is *kiosk printing*, where small digital presses connected to networked databases print books at the level of bookstores, public libraries, schools or universities (Epstein, 2001: 29–30). The concept of kiosk printing has been proposed for some years, but has to date not found wide acceptance.

At the present time the major print-on-demand companies, including Amazon with its acquisition of a print-on-demand facility (BookSurge), operate at most one or two centralized printing plants in different geographic areas, because of the enormous equipment cost involved in setting up such facilities. While these companies do in fact receive digital files from all around the world, these files are transmitted to a centralized printing plant from where products are shipped to customers by mail, not unlike the centralized printing plants that operate conventional printing presses.

The book industry supply chain is currently in a state of flux, because of changing customer behaviors and the emergence of new technologies. While the companies that are operating successfully in this new technological environment may not have written the final chapter on what the nature of the book publishing industry will look like in the future, their tremendous output and customer-base growth cannot be ignored and may well be indicative of a general trend toward a production and commercial environment that will increasingly be dominated by digital printing technology as well as online marketing and bookselling activities.

Conclusion

Given its ancient origins some 2,000 years ago, the book can be considered one of the oldest artifacts surviving in our age. Unchanged in its basic construction for all those years, it is still serving its purpose exactly as its unknown inventors intended.

The key to the book's remarkable longevity is first and foremost attributable to its industrial design features, which render it user friendly, portable, easily searchable, extremely durable, recyclable and relatively economical, because the principal material books are made of is paper, which can be manufactured from a renewable resource.

Trees, the main raw material of paper, may not be as abundant as in the past, but they can be economically exploited if harvested responsibly. Also the increased utilization of recycled paper in the papermaking process greatly decreases the burden on the natural environment. In short, successful products, such as books, are characterized by their efficacy and economic availability. A lack of either of these factors will invariably cause obsolescence and consequent replacement by newer technology.

Arguably, the book reigned supreme for such a long time because during much of its existence there were no alternative forms of communication. This started to change, first with the introduction of radio communication in the nineteenth century, then television in the middle of the previous century and a plethora of electronic non-paper reading devices in the last ten years.

In part, books were able to endure the onslaught of new technology by the invention of new materials and means of production. Most of all, it was Gutenberg's invention of movable type that propelled books to their position as the premier form of visual communication. Papyrus and parchment were replaced by paper hand-made from rags, which was stronger and more durable than papyrus and more economical than parchment. A potential death-knell for book manufacturing was overcome by the use of wood as a raw material for paper, because in the nineteenth century the demand for rags by far outstripped the supply.

The inventions of photography and the halftone principle permitted more realistic and economic reproductions of pictorial content, which made books much more desirable for the less literary-inclined segment of the population, and mechanized typesetting and bookbinding improved book manufacturing productivity by several magnitudes, making them affordable for just about anyone inclined to purchase them.

The past and present constants of the book are its basic architecture and the changing technologies underlying its production and distribution. Today we have digital processes with the capability of printing books economically in quantities as low as single copies, and the selling of books is no longer confined to narrow geographic areas but has expanded to include the entire world through the global reach of the internet. This not only changes the means of production and dissemination of books, but also creates new opportunities for publishers to market a much wider variety of obscure titles that heretofore could not have been printed economically because of the run-length constraints of conventional printing processes. It is now also possible to print various types of personalized books economically, and the ancient accordion book architecture could be revived by the technical peculiarities of digital printing processes.

Contemporary society is far less homogeneous than in previous generations, expecting individual aspirations to be accommodated in all realms of life, including the expectation of finding books that match an individual's esoteric taste. Digital printing processes are ideally suited to producing titles of limited demand, while the internet facilitates a search for the availability of such titles. Essentially, at the core of the new book publishing business model lie the combinatory factors of digital printing processes, because of their flexibility to produce varying content, and internet connectivity, which facilitates both the search for a title and the fulfillment of an order for that title.

The proliferation of digital printing processes does not, however, spell the end of their conventional counterparts. The vast majority of book pages are still printed by conventional processes, because of their superior printing speed and print quality. As long as blockbuster novels are being published, we will need the unmatched productivity of web-offset presses, and sheet-fed offset presses are still very much required for a wide variety of non-standard book sizes and high-end publications, such as coffee-table, art and children's books.

Unlike radio or television, which were never in direct competition with books, the relatively recent introduction of electronic reading devices is a defining event in the long history of the book. These devices are aimed

at taking a significant market share away from physical books, if not to replacing them entirely. Electronic reading devices have several advantages that could make them an alluring choice for many readers. They can hold an astonishing amount of content, and feature automatic search abilities and book marking, typeface enlargements and note-marking facilities in the margins of a virtual book.

Some shrill voices are predicting or even wishing the death of print, and by logical corollary the demise of the physical book. Proponents of these views are often from certain quarters that are excessively enthralled by new technology. The validity of their views nevertheless deserves to be examined. Sometimes the argument that books kill trees is used to dismiss the physical book, and undeniably many human activities, including the printing of books, necessitate the use of precious natural resources. Unlike many other product categories that are based on non-renewable hydrocarbon or mineral resources, however, the principal raw material for books is trees, which can be harvested in a similar fashion as other agricultural crops. Harvesting trees has a neutral effect on global warming provided that a balance between harvesting and replanting is maintained, and it can reduce global warming if more trees are planted than harvested, because of the beneficial effects of photosynthesis. For example, in Sweden, which is a major producer of the fibrous content of paper, the replanting of trees exceeds the annual harvest by 35 per cent. The possibility of recycling paper to make new paper is another big plus of physical books, for obvious reasons. In this respect the corrugated-board manufacturing industry serves as an example to be emulated by book printers: in some countries up to 80 per cent of the principal raw material to manufacture corrugated board consists of recycled paper and board.

Electronic reading devices, on the other hand, are made from non-renewable resources which cannot be recycled easily, and their relatively short life span, often planned for intentional obsolescence, compounds the problem. In addition to the difficulty of recycling these electronic devices, they often contain heavy metals and other toxic materials which present a serious danger to the natural environment. Conceivably, if these devices were to replace books, almost every literate man, woman and child on the planet would own one, conjuring up nightmarish images of huge graveyards of expired electronic components.

Most experts agree that earlier reading devices based on emissive display technology caused excessive strains on the human visual system. More recent electronic reading devices have come deceptively close to an ink-on-paper reading experience, because, like ink on paper, they are

based on reflective display principles. The developers of electronic reading devices essentially strive to mimic the characteristics of physical books, and conceivably some time in the near future they may succeed. But the basic fact remains that a replica will never be quite the same as the original. An electronic device could probably never be handled as naturally and intuitively as a physical book – its robustness is difficult to equal and its non-requirement for energy is impossible to duplicate in electronic devices. While the shortcomings of electronic devices may be acceptable for short-term use, for the reading of a book, which is by definition a sustained activity, such repeated occurrences of seemingly minor inconveniences may be objectionable to most readers.

In addition to conveying information, the physical book has also had the important function of preserving content for posterity; and to the best of our knowledge, books and the information contained in them will last indefinitely, provided that they have been manufactured from quality materials.

The same cannot be said for electronic reading device technology and the media types on which the digital data are recorded. The devices themselves go through periodic iterations of technical change, requiring the redesign of hardware, media types and data structures, which in time become incompatible with previous versions of the devices. Also, the longevity of current digital storage media is untested, and we know from previous magnetic storage media that their life expectancy is finite. The long-term storage of digital information is therefore of questionable reliability, in particular at the level of individual users who may or may not have the technical understanding or discipline to update their systems regularly during their lifetimes. Beyond an individual's lifetime, the likelihood of successive generations being willing or able to maintain the technical integrity of the inherited data diminishes at an accelerated rate. If a majority of books were to migrate to digital storage media, the long-term prospects for their continued existence would be far from assured – unlike the physical book, for which there is demonstrated evidence of archival longevity that in some instances exceeds 2,000 years.

No meaningful progress can be made without access to the accumulated knowledge of the past. Physical books have served us well in preserving this wealth of information, on which our current understanding of the world and beyond is based. The prospect of losing this cultural and scientific heritage, or not being able to pass it on to future generations, because of unreliable digital storage technology would indeed be a tragedy of immense proportions.

By far the greatest threat to all text-based communication systems, including the physical book, is not a matter of technology but of education, simply because the effective interpretation of text-based communication is entirely dependent on the level of literacy a reader possesses. In the developing countries great strides to improve literacy levels are being made, but paradoxically many industrially developed countries, in particular countries in the Western hemisphere, are experiencing alarming literacy level declines. While a comprehensive discussion of the underlying reasons for declining literacy levels would be the subject for another book, the increasing reliance on non-text communication and the de-emphasis of reading instruction in our schools seem to lie at the core of the problem.

People with inadequate literacy skills are far less likely to purchase a book, because the reading of a book becomes a chore for them. Moreover, as the palette of communication technologies is growing, a poor reader has the option to get informed through other communication channels such as radio, television, movies, videos or the internet, which require minimal to no literacy skills at all.

For the book to thrive and continue its long run, the people and organizations that write, publish, print, bind, market and sell books have therefore a vested interest in promoting environmentally sustainable means of production and literacy programs.

Digital technology poses both a threat and an opportunity for the continuing viability of books. On the one hand, digital technology has made it possible to emulate the experience of reading a physical book in a virtual environment, and on the other hand it permits printers and publishers to respond to the varied tastes of an increasingly fragmented and heterogeneous society.

The overriding advantage of the physical book is its low-tech architecture, which is not an easy concept to defend in a world that seems to be obsessed with new technology, but nevertheless it appears that most people will intuitively consider books an essential part of their lives.

The most fertile environment for the book trade is a free and vibrant society; for our own sake and that of future generations, let us hope that the physical book prevails for another 2,000 years.

References

Anderson, C. (2004) 'The long tail', *Wired*, 12(10); available at: *www.wired.com/wired/archive/12.10/tail.html* (accessed: 22 April 2008).

Andrukitas, J.A. (ed.) (2004a) *Budgeted Hourly Cost Studies for Sheetfed Press Operations*. Paramus, NJ: National Association for Printing Leadership.

Andrukitas, J.A. (ed.) (2004b) *Budgeted Hourly Cost Studies for Web Press Operations*. Paramus, NJ: National Association for Printing Leadership.

Baitz, I. and Breede, M. (2004) 'Creating customized textbooks: using variable data printing to engage readers by reducing biases', *International Journal of the Book*, 2: 41–51.

Blagden, C. (1960) *The Stationers' Company: A History, 1403–1959*. London: George Allen & Unwin.

Breede, M. (2006) *Handbook of Graphic Arts Equations*, 2nd edn. Pittsburgh, PA: Printing Industries of America/Graphic Arts Technical Foundation.

Breede, M. and Lisi, J. (2007) 'The accordion book: an old idea reinvented for digital printing', *International Journal of the Book*, 4(1): 75–83.

Breuil, A.H. (1979) *Four Hundred Years of Cave Drawings*. New York: Hacker Art Books.

British Museum (1973) *Oriental Manuscripts*. London: Trustees of the British Museum.

Broudy, D. and Romano, F. (1999) *Personalized & Database Printing: The Complete Guide*. Torrance, CA: Gama Micro Publishing Press.

Brynjolfsson, E., Hu, Y. and Smith, M. (2003) 'Consumer surplus in the digital economy: estimating the value of increased product variety at online booksellers', *Management Science*, 49(11): 1580–96.

Carter, T.F. ([1925] 1955) *The Invention of Printing in China and Its Spread Westward*, 2nd edn. New York: Ronald Press.

Cave, R. (1971) *The Private Press*. London: Faber and Faber.

Daniels, M. (2006) *Brave New World: Digitisation of Content: The Opportunities for Booksellers and The Booksellers Association.* London: Booksellers Association.

Davenport, C. (1907) *The Book, Its History and Development.* London: Archibald Constable.

Davis, P. (1972) *Photography.* Dubuque, IA: Wm C. Brown Publishers.

Delphax (2004) *Continuous-Feed Digital Print Systems CR2000/ CR1300/CR900,* product brochure 0973004-300. Minnetonka, MN: Delphax Technologies.

Dessauer, J.P. (1981) *Book Publishing: What It Is, What It Does,* 2nd edn. New York: R.R. Bowker.

Driscoll, S. and Gedymin, D. (2006) *Get Published! Professionally, Affordably, Fast.* Lincoln, NE: iUniverse.

Ehrens, S. and Adrian, M. (2000) 'Amazon.com: there is an "r" in etailing', *Epoch Partners Consumer Internet Company Report,* 13 November: 4.

Epstein, J. (2001) *Book Business: Publishing Past Present and Future.* New York: W.W. Norton & Company.

Febvre, L. and Martin, H.-J. (1976) *The Coming of the Book: The Impact of Printing 1450–1800.* London: NLB.

Fenton, H.M. (2006) 'Digital book technologies may reshape all production', *NAPL Business Review,* 1(2): 18–20.

Fenton, H.M. and Romano, F.J. (1998) *On-Demand Printing: The Revolution in Digital and Customized Printing,* 2nd edn. Upper Saddle River, NJ: Prentice-Hall PTR.

Füssel, S. (2003) *Gutenberg and the Impact of Printing,* translated into English by D. Martin. Burlington, VT: Scolar Press, Ashgate Publishing.

Gartner (2006) 'Hype Cycle for Printing Markets and Management 2006', ID No. G00139889; available at: *www.gartner.com* (accessed: 22 April 2008).

Gartner (2007) 'Hype Cycle for Printing Markets and Management 2007', ID No. G00148158; available at: *www.gartner.com* (accessed: 22 April 2008).

GATF (1996) *Web Offset Press Operating,* 4th edn. Pittsburgh, PA: Graphic Arts Technical Foundation.

Hall, H. (1887) *The Tribune Book of Open-Air Sports.* New York: Tribune Association.

Harris, B. (1972) *Johann Gutenberg and the Invention of Printing.* New York: Franklin Watts.

Hauser, E. (1993) *International Directory of Company Histories*, Vol. 64. Farmington Hills, MI: St James Press/Thomson Gale.

Hayes, R.M. (1987) 'The magnitude, costs, and benefits of preservation of brittle books', report on Preservation Project prepared for Council on Library Resources; available at: *www.clir.org* (accessed: 21 April 2008).

Heidelberg Druckmaschinen (1986) *Heidelberg Web*, 1 August. Heidelberg: Heidelberg Druckmaschinen.

Hewlett Packard (2007) *HP Indigo Press 5500*, product brochure 4AA 1-0917ENUS 03/2007. Atlanta, GA: Hewlett Packard Development Company.

Hussain, M.A. (1972) *Origins of the Book*. Greenwich, CT: New York Graphic Society.

Ikegami, K. (1986) *Japanese Book-Binding: Instructions from a Master Craftsman*. Boston, MA: Weatherhill.

InterQuest (2007) *High Growth Segments of Digital Book Printing: Market Analysis & Forecast*. Charlottesville, VA: InterQuest.

Kilgour, G.K. (1998) *The Evolution of the Book*. New York: Oxford University Press.

Kippan, H. (ed.) (2001) *Handbook of Print Media*. Berlin: Springer Verlag.

Klemm, F. (1964) *A History of Western Technology*. Cambridge, MA: Massachusetts Institute of Technology.

Kodak (2006) *Kodak Versamark DS3700 Printing System*, product brochure U.CIJ.034.1106.en.01. Rochester, NY: Eastman Kodak.

Kodak (2007) *Kodak Versamark VX50000e Printing System*, product brochure U.CIJ.025.1206.en.01. Rochester, NY: Eastman Kodak.

Lehmann-Haupt, H. (1966) *Gutenberg and the Master of the Playing Cards*. New Haven: Yale University Press.

Lyman, R. (1993) *Binding and Finishing*. Pittsburgh, PA: Graphic Arts Technical Foundation.

McKibben, S. and Shaffer, J. (2007) *Web-to-Print Primer*. Pittsburgh, PA: PIA/GATF Press.

Musée Condé, Chantilly (1962) *The Très Riches Heures of Jean, Duke of Berry*. New York: George Braziller.

National Association for Printing Leadership (2007) *Digital Services Study 2007*. Parasmus, NJ: National Association for Printing Leadership.

Nipson (2006) *The Nipson VaryPress 400*, product brochure 22 A8 15NS REV3. Dartford: Nipson Digital Printing Systems.

Norris, M. (2007) 'Bowker reports U.S. production rebounded slightly in 2006. New juvenile titles plunge, adult fiction titles climb', press release, 31 May; available at: *www.bowker.com* (accessed: 22 April 2008).

Nothmann, G.A. (1989) *Nonimpact Printing*. Pittsburgh, PA: Graphic Arts Technical Foundation.

PrintCom Consulting Group (2007) *Printing Impressions*, April. Waxhaw, NC: PrintCom Consulting Group.

Rebsamen, W. (1983) *The New Library Scene*. Jupiter, FL: Library Binding Institute.

Rosenthal, M. (2004) *Print-on-Demand Book Publishing*. Springfield, MA: Foner Books.

Rowling, J.K. (2002) *Harry Potter & the Chamber of Secrets*. New York: Arthur A. Levine.

Schiffrin, A. (2000) *The Business of Books: How International Conglomerates Took Over the Way We Read*. London: Verso.

Schumacher, E.F. (1973) *Small is Beautiful: A Study of Economics as if People Mattered*. London: Bond and Briggs.

Senefelder, A. ([1818] 2005) *Senefelder on Lithography*, unabridged republication of original translation of Senefelder's treatise published under the title *Vollständiges Lehrbuch der Steinndruckerey*. Mineola, NY: Dover Publications.

Shailor, B.A. (1991) *The Medieval Book*. Toronto: University of Toronto Press.

Shapiro, C. (ed.) (1974) *The Lithographers Manual*, 5th edn. Pittsburgh, PA: Graphic Arts Technical Foundation.

Steinberg, S.H. (2001) *Five Hundred Years of Printing*, revised and expanded by J. Trevitt. London: Oak Knoll Press/British Library.

Tedesco, T.J. (ed.) (1999) *Binding Finishing Mailing: The Final Word*. Sewickley, PA: GATF Press.

Vistaprint (2006) *Annual Report on Form 10-K for the Fiscal Year Ended June 30, 2006*. Hamilton, Bermuda: Vistaprint.

Wallans, B. (2007) 'Silent sales: web-to-print is becoming essential', *Canadian Printer*, March: 14.

Watkins, M.W. and Coffey, D.Y. (2004) 'Reading motivation: multidimensional and indeterminate', *Journal of Educational Psychology*, 96: 110–18.

Weiss, J. (2007) 'Makeready world champ', *expressisverbiss*, 23: 25.

Wertz, W.F. (1994) 'The Brotherhood of the Common Life', *Fidelio Magazine*, III(2): 42–9.

Xeikon (2007) *Xeikon Family, Mastering Digital Printing*, form 610P726890 Doc_XEICONfamily_EN_01_01/07. Lier: Punch Graphix International.

Xerox (2005) *Xerox DocuPrint 525/1050/1050X Specifications*, form 610P719370A. Stamford, CT: Xerox Corporation.

Xerox (2006a) *Xerox DocuTech 125/155/180 Highlight Color Systems Specifications*. Stamford, CT: Xerox Corporation.

Xerox (2006b) *Xerox iGen3 110*, product brochure 711P00127C. Stamford, CT: Xerox Corporation.

Index